Scotland's Chronicles of Blood

Norman Adams has spent much of his working life as a journalist in Scotland. He began his career with the *People's Journal* and was a news reporter with the *Daily Record* and *Scottish Daily Express*. He edited the respected Aberdeen magazine, *Leopard*, and now writes features and scripts for video documentaries. He is the author of several books on ghosts, mysteries and legends, including two novels for Robert Hale, *Bloody Tam* and *Blood Dirk*. He is married and lives near Aberdeen.

Scotland's Chronicles of Blood

Torture and Execution in Bygone Times

NORMAN ADAMS

ROBERT HALE · LONDON

Copyright © Norman Adams 1996
First published in Great Britain 1996

ISBN 0 7090 5821 7

Robert Hale Limited
Clerkenwell House
Clerkenwell Green
London EC1R 0HT

2 4 6 8 10 9 7 5 3 1

Photoset in North Wales by
Derek Doyle & Associates, Mold, Clwyd.
Printed in Great Britain by
St Edmundsbury Press Ltd, Bury St Edmunds, Suffolk.
Bound by WBC Book Manufacturers Limited,
Bridgend, Mid-Glamorgan.

Contents

Illustrations

ILLUSTRATION CREDITS

Acknowledgements

Many people gave unstinting help with my research for this book. Special mention must go to the librarians and their staff at the Mitchell Library (History and Glasgow Room) in Glasgow; the National Library of Scotland (Reference Services); Borders Regional Library, Selkirk; Central Library, Dundee; Edinburgh Central Library (Edinburgh Room); Carnegie Library, Ayr; North-east of Scotland Library Services; Banchory Public Library; Ewart Library, Dumfries; Inverness Library; City of Aberdeen Library; A.K. Bell Library, Perth; Stirling Central Library; the Signet Library, Edinburgh; Scottish Record Office (West Search Room); Mr Bob McCutcheon, Stirling; Dr David H. Caldwell, National Museums of Scotland; Mr Ninian Reid; Mr James U. Thomson; Mr Fraser Henderson; Mr John Weatherley; Mrs Fay Paton; Mitzi Dando, Inveraray Jail, and the staff of the John Hastie Museum, Strathaven; Dumfries Museum; Smith Art Gallery and Museum, Stirling; St Andrews Museum, Kinburn House; Aberdeen Tolbooth Museum; Aberdeen City Council Publicity and Promotions and to archivists in Stirling and St Andrews.

In the course of my research, I also referred to reports which appeared between 1809 and 1889 in the following publications: *Kelso Mail*; *Kelso Chronicle*; *Dumfries & Galloway Standard and Advertiser*; the *Scots Magazine*; *Perthshire Advertiser*; *Perthshire Constitutional*; *Dundee Courier and Argus*; *Dundee Advertiser*; the *Weekly News*; *Stirling Observer*; *Stirling Journal & Advertiser*; *Inverness Courier*; *Inverness Journal*; *the Fife Sentinel*; *Glasgow Herald*; *Glasgow Chronicle*; *Edinburgh Evening Courant*; *Edinburgh Advertiser*; *Aberdeen Journal*; *Aberdeen Chronicle*; *Aberdeen Herald*; *Aberdeen Observer*; *Ayr Advertiser*; *The Times*; *Caledonian Mercury* and the *Scotsman*.

Introduction

The grim gallows frame has long vanished from the streets of Scotland. The wind no longer whistles through the bones of the gibbeted criminal, his rotten flesh picked clean by birds and the elements. Death by the beheading sword, axe and the 'Maiden' (a crude machine that pre-dated the French guillotine by two centuries) and punishment in the thumbikins, cashielaws, jougs and branks have been confined to the dustbin of judicial history. But the dark deeds of the hangman, headsman and torturer are still remembered. And the tools of their grisly trade can be seen in museums and refurbished old jails, where tourists fleetingly experience life behind bars, or gaze in awe at the death mask of a hanged felon or at the beam of a nineteenth-century scaffold.

Maps also serve as pointers to the bloody events of the past. The Gallowgate in Aberdeen is a road that once led to the gibbet. Sinister names, such as Hangman's Ford on the River Lossie; Hangman's Brae, Hangman's Brig and Heading Hill in Aberdeen; the Beheading Stone in Stirling; Hangman's Craig in Edinburgh; and the Gallows Tree o' Mar in Royal Deeside – all evoke an age when justice was swift and brutal. If you stroll down the granite bow of Justice Street in Aberdeen you are on the trail of witches burned at the stake. The Witches' Stone in Forres, and the Witches' Pool in the River Isla, Keith, remind the passer-by of the fate of wretched women suspected of being in league with the Devil.

But the street maps, old and new, gibbet stones and other macabre relics do not tell the whole gory story.

Norman Adams
Banchory, 1995

9

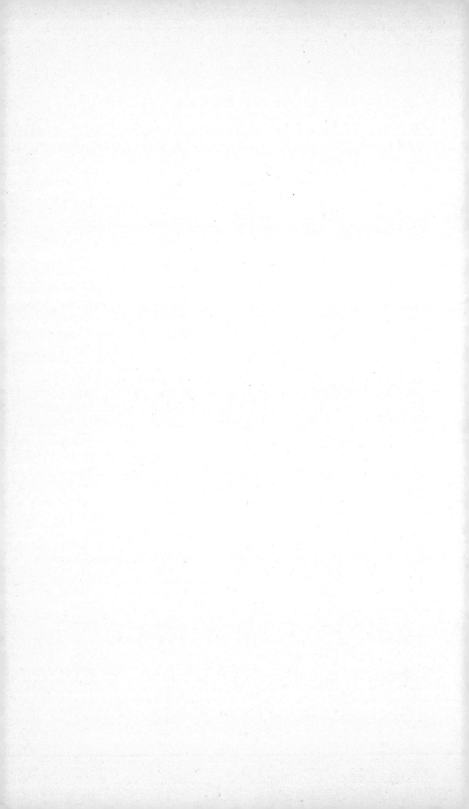

1

Blood Money

The common hangman, colloquially called the 'commoune burreour', 'basar' or 'burrio' throughout Scotland, or the 'lockman' in Edinburgh, the 'staffman' in Stirling, 'hangie' in Aberdeen and the 'marshal' in Banffshire, was both feared and despised and yet remained an important figure within the community. What qualifications were needed for such grisly work?

The hangman of Berwickshire was a reformed sheep-stealer. Edinburgh's Jock Heich pilfered poultry and thrashed his wife without mercy. When not building drystone dykes in the Aberdeenshire hinterland Johnny Milne stole beehives. In Glasgow John McClelland was a habitual thief while John Cameron of Banff rustled horses. Like their early English counterparts executioners in Scotland were recruited from a rogues' gallery of desperate men who had escaped the hangman's noose by the skin of their rotten teeth.

The dirty work of carrying out the law's ultimate sanction was handed over to criminals, who took up the post with the sole aims of 'cheating the widdie' – escaping the gallows – and to collect 'blood money'.

After being confined in Greenlaw prison for seven months while awaiting trial at the High Court of Justiciary on sheep-stealing charges John Watson applied for the vacant post of hangman for Berwickshire. In June 1751 he presented a petition to the Justices of Peace for the County of Berwick acknowledging his guilt and the misfortune he had brought on himself and his family, not to mention the financial burden on the county.

Watson said he was willing to undertake the office of hangman all the days of his life and find sufficient security for his good

behaviour, if their honours 'shall think fit to admit him to that office'. It was a shrewd career move, for to be convicted of sheep-stealing would have meant certain death. The reply to the petition was favourable.

> The justices, considering the voluntary confession of the petitioner, against whom they do not find that there is any other evidence, considering also that the crime was not committed in Scotland, and that the office of hangman is absolutely necessary for the execution of justice and long wanted, the petitioner should be dismissed upon giving sufficient bail at the sight of the Clerk of the Peace, not only for his good behaviour in time coming, but also that he should faithfully exercise the said office during his life within the county.

Two local men paid the £30 bail and John Watson became hangman, residing in Greenlaw, the county town of Berwickshire until 1903, on a croft known as Hangman's Acre.

John High, nicknamed 'Jock Heich' by the citizens of Edinburgh, undertook the job of hangman in 1784 in order to escape punishment for stealing hens, although Jock would maintain he was blackmailed. He and his wretched wife lived in the 'Deemster's [Doomster's] Hoose', a mean dwelling at the top of Fishmarket Close, a narrow lane between High Street and the Cowgate, and home to several hangmen over the years. The Doomster was a name formerly applied to the public executioner but in time the 'doomster' came to refer to the court officer who intoned the official sentence to the criminal in the dock. The Edinburgh hangman was better known as the 'lockman', because of a 'lock', the small measure of meal, and other foodstuffs he was entitled to on market day. Because of his tunic of grey and white he also earned the derisive nickname 'magpie'.

Jock Heich drew his fees from the Royal Bank, near the hangman's house, which was demolished in the last century. He was twice married and beat his second wife. He was sacked for some misdemeanour and died in 1816.

His predecessors also had evil reputations. On 16 January 1682 Sawney Cockburn, who had been appointed hangman six months earlier, was tried for the murder of a blue-gown, or privileged beggar. He had previously been executioner in Stirling, where he had managed to get the incumbent, one Mackenzie, sacked. Despite slender evidence Cockburn was found guilty and was duly hanged – the execution being carried out by Mackenzie, the deposed Stirling hangman!

Two years later another Edinburgh hangman, Donald Monro, and his assistant, were thrown into the 'Thieves' Hole' for beating a beggar to within an inch of his life.

The capital's hangmen were not all disreputable characters, however. Monro was succeeded by the Ormistons, father and son, who were in turn executioners for almost twenty years. John Ormiston, senior, was descended from a landowning family in the Lothians.

The 'commoune burreour' fulfilled other duties. In November 1578 the hangman was ordered to slaughter swine roaming the streets of Aberdeen, and to sell the carcases in order to swell council funds. In Banff in 1714 the hangman's other duties included sweeping dung from the streets and preventing dogs from disturbing church services on a Sunday. He was given the power to destroy dogs and was paid forty pennies for each skin. He also wore a special uniform on market days and holidays.

A prisoner in Banff Jail, Robert Young, volunteered to be burgh hangman in 1725, and his duties, other than compulsory attendance at court hearings, and carrying out various statutory punishments, included sweeping streets, banishing beggars – but not those who were infirm or blind – and to ensure no dogs entered the church on the Sabbath. Young, a vagabond tinker, had little choice in selecting his new career for he took up the appointment 'under paine of death' – an arrangement that gives a new meaning to the term 'tied job'.

In January 1728 John Cameron, the horse thief, was set free from jail, on the strength of a letter from Colonel William Grant of Ballindalloch, to become the Banff hangman for life, or face dire consequences. He served as executioner for only a short time, for two years later William Cruickshank, of Waterside of Glass, on being convicted of several offences, 'bound himself to serve the burgh in the station of a servant and executioner during all the days of his lifetime and that he shall not desert the said service, under pain of being banished from the kingdom and prosecuted for his crimes'. One of Cruickshank's first duties was to go to Aberdeen to execute a criminal. He was escorted by a guard of four men to make sure he did not shirk his duties. He was advanced £17 8s.

By 1731, the very next year, Cruickshank no longer held office. Alexander Panton, a chapman from Turriff, was appointed executioner with the proviso that should 'he desert or withdraw from the town without leave, the magistrates have power to inflict

the punishment of death upon him' – but, 'on the other hand the magistrates and council hereby entitle him to the whole profits, emoluments, and casualties belonging to the said office, according to custom'.

It was the same story in other parts of the country. In Stirling the staffman's appointment was also for life. If the hangman quit the town without the magistrates' permission it could mean death. On 20 May 1633: 'Thomas Grant, borne in Glenalmond, under David Murray of Bulhindye, ressavit and sworne servand and executionar to this town of Stirling his lyfe tyme, and sall not remove nor absent himself aff the toune, but license of the Magistrates under the pane of daithe.'

In 1605 John McClelland faced the gallows when arrested in Glasgow on several charges of theft. But because the town was 'desolat of ane executour' McClelland was given a second chance. The magistrates shielded him from rowdy citizens and he in return gave his word that he would remain in office for life or risk being 'hangit to the deid by ane assyse'.

The wages of blood led some rogues to abandon their old thieving habits. In August 1530 the Edinburgh 'lokman' was paid 14 shillings for hanging 'certane theifis' in Linlithgow and an extra 8 shillings for 'watching' them before the execution.

At Banff in September 1637 Willie Watt, scourger, hangman and dempster of the assize, hanged Francis Brown, 'ane boy of ane evill lyiff', for theft, after passing sentence. Watt's annual salary of £13 6s 8d was paid on Whitsunday.

Banff hangman Arthur Kellie's wage was 6s 8d a month when he took up the job in 1653. His perks were half a peck of meal every week, one peat from every load sold on market day and one haddock or whiting out of each basket of fish landed at the port. In 1695 the Banff hangman, Brown, was paid £9 12s, representing sixteen weeks' wages at 12 shillings a week, and a pair of shoes costing 15 shillings. Murieson, his successor, was paid twenty-six week's wages of £15 12s, with new shoes costing 13s 4d.

In 1730 Cruickshank, the converted criminal, received the following emoluments: a salary, a rent-free house, a new coat every two years, and a pair of new shoes and stockings annually.

In 1744 the hangman received a free coat and breeches. His uniform was tailored in Banff from cloth and thread sent by carriage from nearby Turriff. The total cost of labour, materials and transportation was £7 7s 7d.

In 1700 the Banff records briefly note an entry: 'Payed to the

executioner for tows [rope] att executione of McPherson and Gordon, £1.' Both were freebooters, with the former being second only in fame to the legendary Rob Roy. A fine song by Robert Burns, 'Macpherson's Lament', set to the fiddle tune 'Macpherson's Rant', immortalized the Highland freebooter James Macpherson, who was hanged at Banff Cross on Friday 16 November 1700. Macpherson himself was said to have composed the lament as he lay under sentence of death in the town jail. After escaping justice numerous times he was cornered at Keith fair by a local laird, Duff of Braco, and his men. Macpherson put up stiff resistance but was arrested after a sword fight in the kirkyard. Tradition has it that Macpherson, a talented musician, played the fiddle on his way to the gibbet on Gallowhill at Banff. On the gallows he offered to give the fiddle to any member of his clan who would play it over his body at his lykewake (the ritual of keeping a nocturnal watch over the dead). But when this offer was greeted with silence by the assembled crowd he smashed the instrument over the executioner's head and then hanged himself! Some contend that a reprieve was on its way. When the magistrates were told that a messenger had been seen from Gallowhill crossing the Bridge of Banff, they apparently put forward the hands of the town clock to hurry along the execution. It was said that because of their action the magistrates were stripped of their powers of trying and executing malefactors.

But the facts are these: The execution took place at Banff Cross between two and three in the afternoon of a market day, in accordance with the sentence of the court. The magistrates would not have taken the chance of conveying such a high-risk prisoner all the way to Gallowhill. He was accompanied to the scaffold (the town's Biggar Fountain occupies the site of the gallows) by an equally notorious associate, James Gordon, a member of his gang.

Macpherson would not have been able to play the fiddle if, as was customary, his hands were bound. Moreover the Bridge of Banff had not been built in his day, and the burgh continued to hang criminals long after his death. Even so, the freebooter's fiddle, or what remains of it, can still be seen at the Clan MacPherson's Museum in Newtonmore, Inverness-shire. And his name and exploits live on through the words of Robert Burns and Sir Walter Scott.

At the Glasgow Exhibition in 1888 one of the exhibits was the hangman's 'caup', a wooden bowl which had belonged to the Stirling 'staffman'. Each market day the bowl, which is eight

inches diameter, and fitted with a lid, was filled with a 'lippie' (to the brim) of corn and collected as a perk by the 'staffman'.

The Stirling hangman lived in a ramshackled two-storey building with a crow-stepped gable in St John Street. His title (staffman) was linked to his insignia of office. According to the burgh treasurer's accounts in June 1652: 'Item, to William Lapsley, quha undertook to be hangman, for ane staff as in arrillies [salary], 8s.'

In April 1651 the 'staffman', one Martin, received the following inducements: a free house, with various furnishings, coal, candles and so on. His uniform consisted of a half-grey cloth doublet and breeches with a bonnet. Martin was paid 10 shillings a week. Patrick Miller was paid an initial fee of 6s 8d when he was appointed 'staffman'. He also received a free pair of shoes, a bonnet, straw for his bed, plus minor repairs to his home. After each hanging he was entitled to a free dinner. In 1708 the 'staffman' was presented with a new blue bonnet and a pair of gloves and his dues for hanging Elspeth Park. A year later it cost 12 shillings to clean the chimney of his house, which was demolished in 1922. When the town council hired an executioner from Culross in 1652 they also provided him with a pair of breeches. But two men were foolish enough to deride and mock those sent to escort the hangman to Stirling for a sitting of the Justice Court. When word reached the magistrates they ordered the mockers to accompany the hangman home to Fife and to pay his travelling expenses, or face a £100 fine.

Town councils were also prepared to foot the bill if the hangman died in office. In 1693 Banff Town Council paid the burial expenses of their late hangman, including the cost of his shroud, coffin and pallbearers and provided ale at his lykewake. In 1723 Stirling Town Council paid for the burial of their staffman's illegitimate child: 'Item, for a coffine to the staffman's bastard, and a winning [winding] sheet: £2.'

The small Banffshire coastal town of Cullen had its own executioner. On 28 August 1675 Andrew Wilson was appointed official hangman to Lord Findlater and the town. His perks were one fish out of every fishing boat for every day it went to sea; £3 out of the common-good fund to buy a suit of clothes once a year and one peat and a piece of firwood out of every load of peat and fir sold in the town. Two years later the hangman's salary was £6 13s.

In 1696 George Cobban lost the hangman's job at Cullen after being arraigned for stealing a 'wedder' – a ram – and being

implicated in several other petty crimes. The charge was found not proven but because of his bad reputation he was banished from the burgh, under pain of death if he returned. As an additional punishment it was decided to have him taken to Banff where he was scourged through the streets by the local hangman. Cobban's last official act was to hang a man on the gibbet at Clunehill, Deskford, for stealing a cow. The thief's skull and bones were unearthed by Banff historian William Cramond in 1887, at which time the stones supporting the gibbet could still be seen.

In 1700 Cobban's shoes were filled by George Milne, a thief from Keith. He was convicted of stealing a peck of 'shilling', the grain removed from the husk, from the Laird of Glengerrack's mill. The sheriff decided his crime deserved death – or, as the legendary eighteenth-century Scots judge Lord Braxfield might have said, 'Ye wad be nane the waur o' a hangin' – but he relented on condition Milne undertook the office of 'marshall' in the burgh of Cullen.

Scottish towns had great difficulty retaining the services of their hangmen. Old records show that they were often hounded from office by vengeful mobs or because they themselves broke the law. But magistrates did everything possible to hold on to their 'hangie'.

There is a tradition that a Melrose gentleman who fell on hard times was appointed to the post of Edinburgh hangman. But he could not forget his former tastes and habits and would pose as a man of wealth and leisure as he mingled with golfers on Bruntsfield Links. But he was recognized and chased off the course. The next day his body was found at the bottom of a cliff at Arthur's Seat and to this day the rock is known as 'Hangman's Craig'.

At the end of the sixteenth century Aberdeen was unable to solve a knotty problem. In 1588 James Spaldeston was hanged from his own gibbet after murdering John Wishart, a cordiner (shoemaker). The hangman's head was spiked on the Justice Port (gate). The authorities could not find anyone suitable to enforce judicial death, banishment, scourging, branding and torture. Hangmen came and went. When the town council met on 18 February 1596 they were forced to admit that 'malefactouris, theiffes and ressettaris' had gone unpunished for too long.

No sooner was a suitable candidate recruited than townsfolk 'of the meanest and simplest sort' chased him out of the burgh, hurling insults (the term 'hangman' was anathema to the council)

and stones, causing him injury and his employers extreme embarrassment.

The new executioner was John Justice, who was made of sterner stuff than his predecessors, because he was still in office a year later when he played a bloody role in the execution of more than a score of witches in Aberdeen. At first glance the name could be taken to be a pseudonym, but the name is not uncommon even today. Justice occupied the 'little house under the tolbuyth stair.' It would appear the dwelling was in a state of disrepair, for the council agreed to mend the door and provide a new lock.

A proclamation posted at the market cross warned that any person, no matter their sex or age, who forced the new executioner to quit his post by offending him by word or deed, would be severely punished.

A famous painting of Aberdeen Castlegate, Robert Seaton's *View of Castle Street, 1806*, shows the public hangman, Johnny Milne, choosing a fish from a creel. He presents a squat, unkempt figure in a blue greatcoat with a walking stick under his arm. A

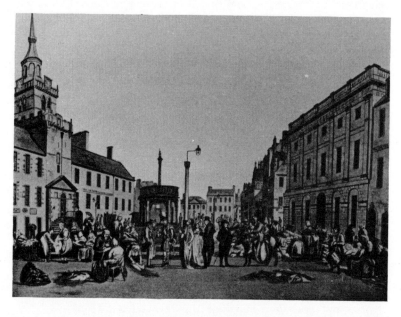

Aberdeen executioner Johnny Milne chooses fish, the
hangman's perk (*left*) in Robert Seaton's *View of Castle Street,
1806*, which also shows the steepled Tolbooth

blue Tam o' Shanter bonnet with a red pompon is pulled down over his straggly grey locks. He is accepting one of his perks – a fish out of every creel on market day – and his brooding presence has not escaped the attention of the baleful fishwives. Milne was also entitled to a peat out of every cart at the market.

Milne had worked as a drystone dyker around Aberdeen and in 1806 was convicted of stealing beehives at Tillyskukie on Donside. He was sentenced to seven years' transportation, but because Aberdeen magistrates were having difficulty in finding a replacement for the late Jock McDonald they offered Milne the job. He accepted. He was paid £7 10s for a half-year's salary to October 1806, plus perks. Milne lived in a house, known as 'Hangman's Hoose', on the east bank of the Aberdeen–Port Elphinstone canal. A steep brae leading to the house was dubbed 'Hangman's Brae' and the bridge that crossed the canal, 'Hangman's Brig'.

After being appointed to his new position Milne visited his old haunts around Tillyskukie. The hangman had a nasty streak and when he tried to get lodgings for the night he was shown the door. Fearful the hangman would seek revenge by setting fire to farm

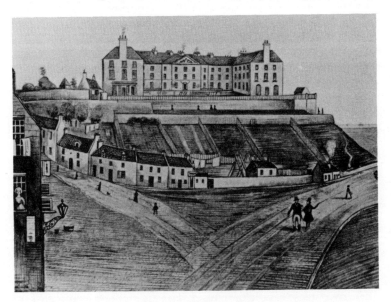

Hangman's Brae, Aberdeen, in 1830 (*left*). Note tavern sign showing hanged man

buildings around their ears the local farmers kept watch till dawn.

Milne's first execution was almost his last. The culprit was Andrew Hossack, caught red-handed while robbing a house at Rubislaw on the outskirts of Aberdeen. Hossack was suspected of the brutal murders of an old man and his daughter at Upper Auchinachie, near Keith, in 1797, but he declared his innocence as he stood on the scaffold in Castle Street on 15 June 1810. Hossack died 'penitently', but the occasion resembled a black comedy. It was arranged that the corpse be carted to the Gallow Hill for burial but every effort by local authorities to hire a conveyance was thwarted. Eventually the magistrates borrowed the cart and pony belonging to the new hangman. When Milne heard how his daughter had been manhandled as she tried to prevent the hijacking of her father's property at their home in Hangman's Brae he resigned on the spot. The crowd cheered his decision. Hossack's body was eventually cut down, buried at the gallow's foot at Gallow Hill – and promptly stolen during the night by medical students. Milne had second thoughts about his 'one-man strike' and was persuaded to carry on as public hangman.

In November 1821 the Montrose magistrates hired the Aberdeen executioner to hang the notorious Mrs Margaret Shuttleworth, who was convicted of battering her husband to death with a poker in their wine shop in the town's Castle Street the previous April.

A new scaffold was erected outside the jail at a cost of £30, and the hangman's fee was set at £10. A petition for clemency, and nagging doubts about her guilt, led to a brief respite while fresh investigations were instigated. After the hanging was postponed, Milne was paid £2 expenses and escorted back to Aberdeen. He returned to Montrose the following month to finish the job.

Milne, as mentioned, became Aberdeen hangman in April 1806, a year after the death of Jock McDonald, who, unlike his predecessor Robbie Welsh, never hanged anyone. Welsh was the burgh's longest-serving executioner with at least twenty-eight years service. Within a few weeks in the job he asked for a rise – his request for a new wage of 13s 4d a month was granted. His son, James, would also earn his living with his hands. A highly skilled craftsman, James was responsible for many of the votive ships that hang in Aberdeen churches.

Today's traveller who pauses on the hilltop road east of Earlston, in Berwickshire, is rewarded with breathtaking views of the Border country. The vista has changed little since the autumn

of 1823 when Robert Scott, a 36-year-old gamekeeper, after downing a glass of wine in the condemned cell at Jedburgh Castle, was led by a detachment of Roxburghshire Yeomanry Cavalry as far as the Leader Bridge, where mounted militia of the Berwickshire Yeomanry took over and escorted him the rest of the way to the scaffold. During the journey Scott sat in a chair on a horse-drawn cart, with his back to the driver. Scott was hanged for the brutal murder of two Greenlaw men, James Aitcheson and Robert Simm, as they returned from Earlston Fair the previous June. In a drunken quarrel at a small plantation east of the steading of Fans Farm he bludgeoned them to death and then cut off their noses with a knife. He was a powerfully built man with a fiery temper. He was also an indefatigable 'pedestrian', who was known to have kept pace with the stagecoach from Edinburgh to Gordon, a distance of thirty-four miles, at a rate of seven miles an hour!

In passing sentence Lord Pitmilly ordered that the execution take place at the nearest spot to where the murders were committed – and on the chosen day, Wednesday 29 October, Scott nimbly climbed the ladder to the fatal platform. He coolly untied his neckcloth and stuffed it into his hat, which he threw over the edge of the scaffold. He gave the signal to the hangman and died without a struggle. After the hanging, on a hill near Fans Farm, Scott's body was carted off to Edinburgh for dissection.

The cost of Scott's imprisonment and execution has been left for posterity. The huge sum of £243 2s 7d was mostly spent on providing the gallows (£150), which was later stored in Greenlaw at an annual rent of £6.

The archives make curious and chilling reading. While Scott was a prisoner in the 'Thieves' Hole' in Greenlaw, before being transferred to Jedburgh for his trial, a local blacksmith was paid 2s 10d for making his leg irons and an additional 3s 6d for removing them 'sundry times'. Barber George Robertson was paid 1s 10d for shaving Scott eleven times, at tuppence per shave. He also cut the prisoner's hair for tuppence. Early on the morning of the execution the hangman and a policeman went to the scaffold on the instructions of the sheriff. They supervised the watch on the scaffold, adjusted the rope and noose and gave other orders relevant to the hanging. Their fee was 16s 9d but this did not include the (unknown) hangman's fee. Refreshments were provided for the men who guarded the scaffold and for special constables who attended on execution day. Scaffold guards ate

bread and cheese (3d) and drank whisky (2s a bottle) as they passed the time playing cards by candlelight (cost of bread and candles: 11s 6d), using Scott's coffin as a table. Walter Dickson from Fans Farm served breakfast for seven men at one shilling apiece. A joiner earned 3s 6d for fixing Scott's chair in the cart.

Scott's body was sent to Dr Alexander Monro, Professor of Anatomy of Edinburgh University, to be dissected. (Six years later Dr Monro publicly anatomized the corpse of the infamous murderer William Burke, partner in crime of William Hare.)

The transportation of the corpse to the capital meant additional expense – from tolls and corn for George Pringle's horse and cart (1s 2½d) to the hire of a lanthorn (3d). One man was paid 1 shilling to keep guard on the corpse while the carters rested at Carfrae Mill. On reaching Edinburgh a porter was paid 1 shilling to escort the cart and its grim load to Dr Monro's, and an extra shilling to find a surgeon to take charge of the corpse.

Hangmen's dues were frowned upon by farmers, grain dealers and the disgruntled public, particularly during times of food shortages. In 1781 the hangman of Dumfries, Roger Wilson, faced violence when he attempted to dip his ladle into John Johnston's meal sack at the weekly market. On top of his annual salary of £6 and the sum of £1 13s 4d for his house rent Wilson was entitled to a ladleful from every sack of oatmeal, peas, beans and potatoes at the town's Wednesday market. The trader was imprisoned for his action but was soon liberated; he then threatened the magistrates for wrongful imprisonment.

The town council, realizing that opposition to the hangman's dues could gather support, consulted a distinguished advocate, Andrew Crosbie of Holm. A memorial laid before Crosbie admitted that the reason for the custom or tax was lost in time. And it went on: 'As there appears a fixed resolution and conspiracy to resist and forcibly obstruct the levy of this usual custom, and as it is of some importance, being, accordingly to the executioner's account, worth upwards of £13 yearly, the magistrates and council request the advice of counsel how to act in the business.'

Crosbie told the council that Wilson had a clear right to the market dues 'that have been levied by himself and predecessors in office from time immemorial'. Although he approved of the action taken against Johnston he counselled a more formal course of procedure towards future delinquents, adding: 'If the officers, when assisting the hangman in his exactions, are deforced, the

deforcers may be committed to prison and tried criminally by the magistrates for the deforcement.'

Litigation resulted in Johnston being sent to prison and his eventual ruin. Actions against the town council were dismissed and the defenders awarded all expenses. The exact amount is not known, but they must have been heavy as the extract of proceedings fills hundreds of closely written pages.

Hangman Wilson was a respectable man who kept a herd of dairy cows and sold milk. He was also father of two beautiful daughters, who would follow him with open bags as he collected his dues on market day. Because of the notoriety of his office Wilson's wife had a breakdown and hanged herself. Their daughters left Dumfries: one wed a wealthy London trader, who laughed off her confession that she was a hangman's daughter.

The controversy over the Dumfries hangman's dues rumbled on for years. In the spring of 1796 the town was hit by further food shortages, resulting in serious disturbances in the burgh and district. Oatmeal was the staple diet – and its price rose to 2s 6d a stone, at a time when a labourer earned less than one shilling a day. The town council pleaded with farmers to send spare stocks of meal to Dumfries for sale in the marketplace. The farmers of Dumfries-shire and the Stewartry of Kirkcudbright had already signified their readiness to supply the burgh but objected to the way in which 'certain dues' were levied at the market.

According to Dumfries historian William McDowall: 'No sooner were the sacks of meal, pease, beans and potatoes set down there for sale, than in came the Calcraft of the day [see p. 140] armed with a capacious iron ladle which he dipped into each sack, and depositing what was drawn from them in a wallet of his own, walked off.'

The town council, no doubt anxious to avoid renewed riots, approved Provost Staig's proposal to scrap the 'obnoxious tribute', and Wilson's successor, Joseph Tait, a discharged bankrupt, was given an increase of £2 a year in his salary to soften the financial blow. Tait, who was being paid £18 a year, remained in office until 1808, at which time the post was abolished altogether.

Civic celebrations were held before or after an execution in many Scottish towns. Edinburgh magistrates gathered in Peter Williamson's tavern in the Luckenbooths to partake of the 'deid-chack', a post-execution dinner paid for by the city. (The practice was scrapped by Lord Provost Creech.) Aberdeen magistrates adjourned to the Lemon Tree Inn, situated in a nook

around the corner from the gallows. The cost of hanging Thomas Potts at Paisley in 1797 was £33 5s 3½d. Expenses included £13 8s 10d for the civic feast and £1 14s 3d for entertaining the executioner and his henchmen.

At their final monthly meeting of 1833, Inverness Town Council appointed a new jailer, sold thirty old street-lamps to the town of Nairn at four shillings apiece – and sacked their veteran hangman Donald Ross. Ross executed only three men during his term, two of whom were Andrew Cullen, a child murderer (1813) and Hector Macleod, who robbed and murdered a pedlar at Assynt (1831). He was made redundant after twenty-one years of service, but it was agreed he could stay in his rent-free house until the following Whitsunday.

In its Christmas Day edition the *Inverness Courier* announced the hangman's redundancy in a story with a tongue-in-cheek headline: 'CHANGE IN THE EXECUTIVE – PUBLIC OFFICER SUSPENDED', and calculated that the three executions had each cost the burgh a massive £400.

It appears that Donald Ross, the common executioner of the town has been 'thrown off', not by some brother of the trade, but by the ordinary operation of the law and equity, which, in cases of the last importance, Donald in his own person enforced for upwards of twenty years.

Retrenchment being the order of the day, the Council conceived they could dispense with the services of the executioner, which are seldom required here, and have hitherto been paid for, like the services of other high legal functionaries, at rather an extravagant rate. Donald Ross was appointed executioner in 1812, with a salary of £16 per annum. As most public appointments of a rare and difficult nature are accompanied with fees and perquisites, independent of salary, Donald had various bites and nibbles at the public purse.

First, he was provided with a house, bed and bedding.

Second, he was allowed thirty-six peats weekly from the tacksman of petty customs.

Third, he had a bushel of coals out of every cargo of English coals imported into the town.

Fourth, he was allowed a piece of coal, as large as he could carry, out of every cargo of Scotch coals.

Fifth, he had a peck of oatmeal out of every hundred bolls landed at the shore.

Sixth, he had a fish from every creel or basket of fish brought to the market.

Seventh, he had a penny for every sack of oatmeal sold at the market.

Eighth, he had a peck of salt out of every cargo.

Ninth, he was allowed every year a suit of clothes, two shirts, two pairs of stockings, a hat, and two pairs of shoes.

Added to these fixed and regular sources of income, Donald levied blackmail on the lieges in the shape of Christmas boxes, and had besides a sum of five pounds at every execution at which he presided.

Now all these items must have amounted to fifty or sixty pounds per annum, and as there have been just three executions since Donald acceded to the office they must have cost the town nearly four hundred pounds each execution! It is very true, that many public servants are paid more for doing less; but we think the Council will effect a considerable saving, to say nothing of the cessation of a constant nuisance among our fish and meal, by dispensing with a regular executioner, and trusting to the services of a deputy from Edinburgh or Glasgow.'

If tradition is to be believed, the royal burgh of Wigtown got rid of old and infirm executioners by hanging them! William Andrews, in his *Old-Time Punishments*, (1890) wrote: 'The law was that this functionary was himself to be a criminal under sentence of death, but whose doom was to be deferred until the advance of age prevented a continuance of his usefulness, and then he was to be hanged forthwith. If, it was said, the town permitted the executioner to die by the ordinary decay of nature, and not by the process of the cord, it would lose for ever the distinguished honour of possessing a public hangman.'

Andrews retold the amusing anecdote of Wigtown's last executioner, who was allowed to die in peace because of a trick played upon the council by his friends. 'He was taken ill, and it was seriously contemplated to make sure of having a public hangman in the future by seizing the sick man and hanging him.' The anonymous hangman, a shoemaker by trade, was propped up in his sick bed with his tools, to allay the suspicions of the burgh officials.

The last person he executed was Patrick Clanachan, a horse thief, who was hanged on the 'gyppet' at Wigtown between twelve and two in the afternoon on 31 August 1709. The felon was dragged to the gallows on a hurdle, and, as the townsfolk hurried

past him to see the execution, he is said to have quipped: 'Tak' yer time, boys; there'll be no fun till I gang!'

In bygone times a local authority in search of an executioner went after its man with the help of that familiar lure, a newspaper advertisement. In the *Edinburgh Evening Courant* in July 1772 the magistrates at Haddington offered their prospective executioner a salary of £3 a year, a free house, new clothes, and perquisites that included oatmeal, wool and fish.

The following advertisement appeared in the same newspaper on 2 April 1789:

EXECUTIONER WANTED AT PERTH

The magistrates of Perth hereby give notice that the Office of Executioner for the said burgh is at present vacant, and any person willing to accept of that office will have all suitable encouragement and protection from the magistrates. The salary given is seven shilling per week, and the commodious dwelling-house free of rent, and other emoluments annexed to the office; and any one inclining to accept and enter into contract for the said employment may apply to the said magistrates.

Around the same time Elgin Town Council was unable to fill the position of hangman despite having advertised in the local press. The post had its attractions: it was a sinecure and there had not been an execution in the cathedral city within living memory; among the perks were a free house and two acres of land.

A notice, headed 'EXECUTIONER', in the *Glasgow Courier* on 16 April 1803 attracted Scotland's most bizarre hangman. It read:

Wanted, for the City of Glasgow, an Executioner. The bad character of the person who last held the office having brought on it a degree of discredit which it by no means deserves, the Magistrates are determined to accept of none but a sober well-behaved man. The emoluments are considerable. Applications will be received by the Lord Provost, or either of the Town Clerks. Council Chambers, 13th April, 1803.

The new hangman was Archibald McArthur, nicknamed 'Buffy' because of his personal appearance. He was said to be 'about 30 years old, and about 5 feet 2 inches in height, stout and rotund in body, with short bandy-legs, and a big bullet-shaped head, with a florid, bloated countenance, and thick lips, but was a good-natured inoffensive creature'.

'Buffy' waited two years before carrying out his first execution. In the year of his appointment he assisted the Edinburgh hangman, John High, who was hired by the Glasgow magistrates to dispatch thief William Cunningham at Glasgow Cross. Cunningham appeared in his own clothes and refused to wear the traditional white nightcap to cover his features, producing instead from his pocket a coloured woollen one that he handed to 'Jock Heich.'

On 5 June 1805 'Buffy' performed his first execution – a double event. He hanged the Shipbank forgers David Scott and Hugh Adamson with such *sang-froid* that he upset some spectators. A horrified magistrate, Bailie Paton, broke down and 'wept like a child' on the scaffold as 'Buffy stood on one leg, with the other across it at right angles, leaning his head on a hand, with an elbow on the steeple, and looking up at his job dangling aloft.' 'Buffy' hanged an assortment of murderers and robbers. In 1807 he executed Irishman Adam Cox, who brutally murdered his two-year-old only son by drowning him in a clay hole in Calton, 'leaving its feet sticking up out of the water'.

Buffy was hangman for about ten years, during which time he refused to wear his official uniform, either because of his strange figure or the risks of his job. During his period in office, life dealt him some harsh blows. His wife was 'an inveterate tippler', and their only son, a hunchback, died in Glasgow Infirmary. 'Buffy', who liked a good gossip, told neighbours that he was certain of his son's death for the 'doctor had showed him the boy's heart on a plate'.

The town council provided the family with a small, single-gabled cottage in South Montrose Street. It was built hard against the walls of the Ramshorn Kirk and the guardhouse. But because of random attacks by mobs 'Buffy' moved to an almshouse in Glasgow's Kirk or Upper High Street, where he resided until contracting a fatal illness. He died in the infirmary at the age of forty. After his death a twelve-stanza poem, declaring 'Archy is dead', was printed and sold.

Buffy's successor was the legendary Thomas Young – 'Tam' or 'Tammas' to the public. He was the last Glasgow hangman to hold an official post. Tam, a native of the county of Berwick, served with the Berwickshire Regiment of Volunteers before moving to the Calton district of Glasgow, where he worked as a labourer. In 1814 he was unemployed and applied for the post of official executioner. The magistrates were impressed with his character

references, headed by one from the colonel of his old regiment, and he was appointed on 10 December 1814.

He signed an indenture binding him 'to perform the office of public executioner when called upon during the whole period of his natural life – also to inflict corporal punishment – and to work as a labourer about the jail.' He also promised to 'live quietly, soberly and regularly' and on no account to absent himself from his duty. In return the magistrates bound themselves to pay him an annual salary of £52, with an additional guinea for each hanging, and to provide him with a pair of new shoes twice a year, and a free house within the prison precincts, and supplies of coal and candles. Both parties agreed to pay a £50 penalty if either party reneged on the contract.

Tam was public executioner for twenty-three years, during which time he executed seventy criminals – fifty-six of them in Glasgow. The others 'got their business done', according to Tam's quaint turn of phrase, in Greenock, Paisley, Ayr, Stirling, and possibly Dumfries.

It was claimed Tam charged exorbitant fees when performing out-of-town executions and insisted on VIP treatment at all times. He was always driven to and from the scaffold in a carriage with a companion. He dined lavishly, it was also claimed, drinking wine and brandy, instead of cheap booze, and entertained his friends liberally. Tam would ascend the scaffold wearing the official uniform of his office – a blue coat with yellow buttons and scarlet collar – previously worn by 'Buffy' McArthur's notorious predecessor, Jock Sutherland.

Although Tam's tall and lank figure was a familiar sight near Glasgow Jail – executions by this time had been switched from the Cross to outside the new prison – he rarely ventured farther than eastward to Nelson's Monument on the Green. (The South Prison gallows faced the Green, hence the Glasgow insult: 'You'll die facing the Monument!')

After being assaulted in a city pub, Tam kept dogs for his protection – his favourite was a Newfoundland dog called 'Hero' which he boasted 'could safely match against any six ordinary men'. Tam, his family and two dogs lived in quarters within the jail. He was described as a quiet, inoffensive man who in later life enjoyed his dram. His obituary in the *Glasgow Herald* noted: 'When enjoying a glass he got animated over the appalling theme, and seemed to take a strange delight in minutely describing the means by which any wretch coming under his hands might be most

promptly disposed of.'

During the last two years of his life Tam's strength gradually sank under the weight of his years. In 1835 he was too ill to hang murderer George Campbell, and the Edinburgh 'finisher of the law' was hired. For eight months he lay seriously ill at home and when he died on 9 November 1837 he left his widow and three children destitute. His obituary ended with these words: 'Now that Glasgow is without an executioner we are certain that we only express the public wish in hoping that no appointment of such a functionary will again be made.'

By this time, however, Glasgow already had the man to fill Tam Young's shoes. They had retained the services of an out-of-work baker, John Murdoch, who had acted as the regular hangman's deputy. Although Murdoch was never appointed Glasgow's official executioner, he was to become Britain's oldest hangman. His 'stalwart form and grim visage (partially concealed by an old high-neck waterproof)' were a familiar sight for forty years on scaffolds throughout Scotland and the north of England.

In the early days Murdoch set up house in Glasgow but as he became known he decided for safety's sake to move out of the city, living for a spell in the towns of Paisley and Kilmarnock and outlying villages, including the future steel town of Motherwell. He was spotted working as a pastry baker's assistant at a 'fashionable Clyde watering place'.

'The tidings of a murder case at a Glasgow Circuit always drew him forth,' wrote his obituarist.

As soon as the Judges sat down, he reported his presence to the authorities, and then waited patiently in the hope that the man would be hanged. After sentence was pronounced he felt all right.

That the mind of the Magistrates might be kept perfectly easy as to no accident taking place at the eleventh hour – for in this case, according to the old notion, the youngest Bailie must do the work – Old Murdoch always lodged himself in prison a week or ten days before the event, where he had bed and board at the public expense, and thus he was certain to be forthcoming when needed on the morning of the execution. But most fortunately Glasgow alone did not afford employment enough to support a man of this trade, when 'paid by the piece', and, accordingly, he laid himself out as a peripatetic finisher of the law in general; and we suppose he referred to the Magistrates of Glasgow for his character and qualifications.

Murdoch, like his predecessor Tam Young, travelled far and wide to hang people. Apart from Glasgow, he carried out executions in Edinburgh, Stirling, Jedburgh, Inverness, Aberdeen, Ayr, Perth, Dundee, Newcastle and Carlisle.

Towards the end of his career Murdoch was so crippled by rheumatism that he could only walk with the aid of a stick. In October 1849 the *Kelso Chronicle*, reporting the execution at Jedburgh of Irish navvy Thomas Wilson, convicted of murder at a riot at St Boswell fair, commented: 'The hangman tottered up to the scaffold with the assistance of a stick, pulled the rope out of his coat pocket, fastened it to the beam, and then adjusted it round the prisoner's neck.' The newspaper further horrified its readers by describing how Wilson's body, on being cut down, 'fell like the carcase of a sheep' into the arms of waiting attendants below the scaffold.

'Since he last officiated here it is said he has officiated at 30 similar occasions,' added the newspaper. 'He is an old man, and we would think he should be giving up such kind of work now. It is not altogether improbable that he may have another visit here soon again, as it appears that the execution of Brady's sentence is only suspended until the Home Secretary has made enquiries into the case.' (John Brady, Wilson's co-accused, eventually had his sentence commuted to transportation for life).

Murdoch, whose last official business in the town had been the hanging of murderer Thomas Roger in 1831, was paid £20 for executing Wilson.

When Murdoch performed his last execution in Glasgow on 24 October 1851 he was in his 84th year, more than three times the age of the condemned man. Archibald Hare had disembowelled an innocent Blantyre man by 'using Jack' – Victorian slang for a knife. (Contrary to popular belief Hare was not the nephew of William Hare, of Burke and Hare infamy).

On the day of execution Murdoch hobbled behind convicted murderer Hare and mounted the steps to the gallows with the aid of a staff. But once Murdoch stepped on the platform he performed his duties with 'nerves of steel'. Hare's small and light frame spun like a top at the end of the rope and the hangman could only hasten his demise by clinging to the struggling man's legs. Because of the bungled execution the magistrates could no longer trust the old man and hired the London hangman William Calcraft for future work. The authorities did not wash their hands of old Murdoch, electing to pay him a monthly dole–payment that was

Hanging – Anglo-Saxon
style

entered into the Town Chamberlain's accounts as 'criminal expenditure'.

John Murdoch died in Bothwell, Lanarkshire, on Saturday 15 March 1856. The octogenarian had lived quietly in retirement with only a few locals knowing his true vocation. In the twilight of Murdoch's career it was calculated that each execution held in Glasgow cost the Common-Good Fund between £30 and £40, even though the crime and criminal sometimes had no earthly connection with the city. As far back as 1773 an effort by Glasgow magistrates to rid themselves of the unwanted financial burden of hanging culprits convicted of 'out-of-town' crimes was given short shrift by the Courts of Justiciary.

During Murdoch's time an amusing story went the rounds that while a predecessor was off sick the Edinburgh hangman was hired to carry out an execution in Glasgow. The account presented to the Glasgow magistrates included an item for a few shillings for 'a padlock and hasp'. The substitute hangman explained that 'he had the misfortune to be cursed with a drunken wife', and that when called into the provinces on 'professional business' he secured his wife inside their home until his return. He emphasized that he always left her with a supply of provisions, but no hard liquor.

We do not know whether or not Murdoch wore the official uniform of the Glasgow hangman, but in 1843, when he executed octogenarian Allan Mair, the last man to be hanged in Stirling, his choice of dress was decidedly bizarre, for he was 'singularly attired

in a light jacket and trousers, seamed with red and black, and a huge crape mask'. No wonder Mair shrank from this terrible figure. Unlike their European brethren, Scottish hangmen were not in the habit of playing the dandy by adopting top hats, breeches and silk stockings or multi-coloured garb.

Masks were worn on rare occasions to protect the identity of the executioner. The hangman who dispatched burglar John McGraddy in Stirling on market day, 26 May 1826, sported a long black robe and a black mask. McGraddy, a 22-year-old Irishman, cast a cool eye over the weird figure before dying bravely.

The identity of the masked man who hanged another Irishman – Mark Devlin in Dundee – was the source of intense speculation and controversy in the city for many years afterwards. It still remains a secret. Devlin, a native of County Tyrone, had moved to Scotland five years before to work as a handloom weaver. After two years in Glasgow he travelled to Dundee, where he married a Glasgow girl and lived in the Hilltown district of Dundee. But his elder brother John became his 'evil genius', leading him down a criminal path, which eventually led to his raping a fourteen-year-old girl and, as a result, to the gallows.

The execution took place in High Street, in front of the Town House, on Saturday 30 May 1835. The casement was removed from the easternmost window of the Guild Hall and the scaffold erected high above the pavement, so that the criminal stepped on to the platform from inside the hall. The fatal beam projected from the upper part of the window space, while the rails of the platform were draped with black cloth to hide Devlin's death struggles from the public gaze.

The method of hanging was both peculiar and primitive. The gallows rope was threaded over a pulley to a windlass inside the room. A handle fixed to the cylinder allowed the executioner to lengthen or shorten the rope to order.

For two hours before the execution – scheduled for 2 p.m. – the streets around the Town House began to fill with spectators. Devlin, dressed in black with weepers (crape armbands), showed great composure in his final moments. He shook hands with the sheriff and magistrates before being accompanied by two priests on the short walk to the scaffold. The masked hangman pulled the white hood over Devlin's head but the condemned man requested it be raised so that he might address the crowd. He acknowledged his crime and expressed hope of divine forgiveness, saying: 'This is a disgraceful death in the eyes of the public – but I hope the Lord

will have mercy on me.' The crowd did not disperse until his corpse was cut down forty minutes later.

Rumours spread about the identity of the mystery hangman. It was said the professional executioner had failed to appear and that a last-minute volunteer took his place. Certainly, there was no question of him being the junior bailie.

Six days after the execution the *Dundee Advertiser* reported:

> As may naturally be supposed, curiosity is busy in ferreting out the individual who officiated as executioner on the occasion. The sentence required to be carried into effect, and some of our species must have been the instrument.
>
> An impression, however, having gone abroad to the prejudice of a townsman, we consider it fair to give insertion to the following which clearly proves that James Livingstone was not the individual.

Livingstone was a well-known character around the towns and villages of Angus, where he made a living by touring fairs with hobby-horses, merry-go-rounds and other sideshows. In the days following the execution a rumour circulated that he was the mystery hangman of Dundee. Livingstone could prove he was in Forfar on the fateful day and appealed for help from the local civic authorities. Therefore, after the account of Devlin's execution, the following letter appeared:

Dundee, June 4, 1835

> Sir, You and the public are well aware that the individual who acted as hangman at the execution of Mark Devlin did so in disguise. Some malicious enemy of mine has circulated a report that I was the individual, and I have been openly assailed most opprobriously with the false accusation.
>
> On the day of the execution I was in Forfar market during the whole day, attending to my hobby-horses; for the proof of this, I appeal to the respectable Provost of the borough, Mr Meffan, who granted me permission to exhibit; and to Mr John Stewart, Town-officer who has the sole charge of pointing out the stands on market days; as also to the public of Forfar in general. Perhaps I have not any right to call upon the magistrates of Dundee for the name of the individual; but I publicly call upon the presiding Magistrate to exonerate me. I am a poor man with a family, and cannot afford to lose character in such a manner.
>
> Trusting you will give this a corner in your columns, I remain, Sir, your most obedient servant. James Livingstone.

Printed below Livingstone's letter was one from the Forfar authorities which confirmed the showman's innocence.

> We, the Magistrates of Forfar, do hereby certify that James Livingstone, from Dundee, was in the Market-place here, from ten o'clock forenoon till eight o'clock evening, of Saturday, the 30th of May last – Witness our hands at Forfar, the fourth day of June, one thousand eight hundred and thirty-five years. Pat. Meffan, Provost. John Lawson, Bailie. John Boath, Junr. Bailie.'

Livingstone's plea to the Dundee magistrates fell on deaf ears. Years later the respected Dundee historian Mr A.H. Millar wrote:

> It was, nevertheless, known to some of the Town Councillors that a Dundonian had performed the hangman's duties, though the secret was religiously kept. A very worthy and highly esteemed Bailie, recently deceased, who was a mere boy at the time of Devlin's execution, but who came to learn the secret afterwards, refused to disclose the name of the amateur executioner, even after that person was dead. And thus the mystery of the masked hangman of Dundee remains unsolved.

2

'Tongue, ye lied!'

For centuries the customs and distinctive lifestyle of the fisherfolk of Footdee at the mouth of the River Dee cut off the community from neighbouring Aberdeen. The people of 'Fittie', now a peninsular city suburb, believed in the evil eye, while the menfolk shunned the subject of salmon, pigs or ministers while at sea. In the early days of steam the close-knit villagers, feeling their livelihood threatened by new-fangled trawlers at Torry, just across the water, stoned the ships as they left port.

Four hundred years ago Fittie fisherfolk were equally suspicious of strangers. In the summer of 1600 a rash of vandalism sprang up in Fittie. The target was a small fleet of visiting fishing boats that sheltered in its tiny harbour at Pockraw, now Pocra Quay, where oil rig supply boats berth. Shipmasters complained to Aberdeen Town Council that their vessels were being cast adrift, causing them 'gryt hurt and henderance'. Craft were damaged through mooring ropes being deliberately cut by villagers, whose motives can only be speculated.

The town council acted with great severity and warned that any man or woman convicted of these offences would be tied to a stake within the flood mark for three hours, while the water swirled around the malefactor. Afterwards the half-drowned criminal was to be scourged through the streets and banished forever from Footdee and Aberdeen.

Life was cruel – and justice swift, painful and bloody. In the previous century, as old court records and archives show, Scotland was in the grip of a virtual crimewave. It was left to local landowners to administer their own brand of punishment to offenders whose crimes ranged from hamesucken (assaulting a

person in his home) to murder. Humiliation, mutilation or execution were the order of the day.

The Reformation in the mid sixteenth century saw the rise of the all-powerful Kirk. Through its general assembly and kirk sessions, and aided by local magistrates (themselves kirk elders), it unleashed a bizarre range of humiliating punishments on parishioners who broke its strict moral code.

The jougs was a common instrument of punishment in Scotland from the sixteenth century onwards. It consisted of a hinged iron collar and a padlock to secure the neck of the wrongdoer. The jougs was usually attached by a chain to the wall of the parish church or the gallows or whipping-post. At Stirling the jougs was a curious contraption – an iron collar, 9 inches in diameter, attached to a 3-foot-long extension with handcuffs. The jougs at Ceres hang at the front door of the old weigh house, now Fife Folk Museum, over which is carved, 'God Bless the Just.' Jougs can still be seen on the walls of churches at Reay, Caithness and Garvald in Lothian.

In 1574 the kirk session in St Andrews ordered a bareheaded and barefooted David Leys to appear before them on a charge of assaulting his father. Leys was forced to sit on the repentance stool with the weapons used in the attack, a hammer and stone, in either hand and wearing a paper crown bearing the message: 'Behold the onnaturall Son, punished for putting hand on his father, and

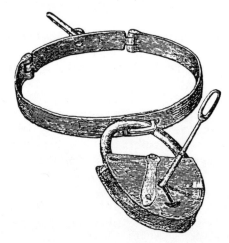

Drunks, slanderers and other offenders against the Kirk
morality were locked in the jougs

dishonouring God in him.'

Parents insisted on obedience and civility from their offspring. In 1598 the presbytery in Glasgow considered the conduct of a youth who had passed his father 'without lifting his bonnet'. In Wigtown in 1694 a servant who abused her mistress was ordered to stand in the jougs for an hour. A Rothesay woman who refused to heed warnings about the evils of drink was told by the kirk session that 'if hereafter she should be found drunk, she would be put in the jouggs and have her dittay [charge] written on her face'.

The records of the kirk session at Dumfries contain some curious examples of punishment by the jougs:

In 1637 slanderer Thomas Meek was put in the jougs at the Tron, and then forced to go on his bare knees to beg forgiveness from Agnes Fleming, the target of his abuse.

Bessie Black, found guilty for the third time of straying from the path of virtue, was ordered to stand at the cross in the jougs on six successive Sundays.

A husband and wife, found guilty of slander, were ordered to stand at the kirk stile with their hands in their mouths.

To neglect church services was an offence. In 1651 John Pearson was publicly rebuked by the kirk session of Galston, Ayrshire, and warned that if he missed going to the kirk on two successive Sabbaths he would be put in the breggan (jougs). At Lesmahagow, Lanarkshire, a shepherd who had shorn his flock on the parish fastday prompted the kirk session to fix jougs to the church door to deal with future wrongdoers and debtors.

In April 1595 Aberdeen Town Council ordered the Dean of Guild to arrange for a pair of jougs to be fixed to the gibbet at a cost of £1 – for punishing 'commoun flyteris and slanderous persones'.

Kirk sessions set a strict dress code for congregations. The wives of Aberdeen burgesses were expected to wear decent cloaks, but never plaids, and to hear sermons in full view of the preacher. Only harlots were allowed to wear plaids covering their head at church or market. Maids who dressed in ruffs or red hoods risked having the offending items ripped off and trampled in the gutter.

There were other forms of humiliation. In May 1759 three Aberdeen women, Janet Shinnie, Margaret Barrack and Mary Duncan were convicted of receiving goods stolen from a local merchant. They were tied to a stake at the market cross by the public hangman, with a noose about their necks and a paper denoting their crimes pinned to their breasts. Aberdeen's first

printer, Edward Raban, the 'Laird of Letters', who in the seventeenth century had a workshop near the cross, was contracted by the town council to print papers which were 'prined on the bristis' of culprits pilloried at the scaffold. Their ordeal at the cross lasted twenty-four hours, and ended with being banished from the burgh in a cart. To add to their ignominy they were bareheaded, and dogged by the hangman, the town drummer and a jeering crowd.

Alexander Stuart, a cattle thief, was taken from Banff tolbooth on 15 July 1748 and forced to stand at the market cross with a placard bearing the message in large letters: 'An Infamous Outhounder of Thieves.' He was then banished from the town with the grim warning that if he returned he would be publicly flogged by the hangman – receiving six lashes at each of the following places: the market cross, kirk stile, the foot of the Water Path, the Grey Stone, the head and at the foot of the Back Path. In Keith the whipping-stations were at the front of the Town House and at three places in the main square.

Rogues were drummed out of Banff, and ritually kicked on to the ferry boat which plied across the River Deveron. Felons were pilloried and made to bear notices such as 'An Infamous and Notorious Thief' or 'A Receptor of Stolen Goods'.

In March 1792 a servant at the Mill of Boyndlie stood bound and bareheaded at Banff Cross; there he bore the label: 'Alexander Scott, an Infamous Swindler and Cheat.' He was drawn through the streets in a cart while the town drummer beat the 'Rogue's March'. His ordeal continued in nearby Portsoy before he was banished from Banffshire.

Debtors (or dyvours) were physically punished and further humiliated by wearing the 'dyvours habit' – a coat of half yellow and half brown, and stockings, cape or hood in the same colours. Before he was released from custody John Crichton wore the habit when led from Banff tolbooth to stand for an hour at the local cross on market day. The practice was abolished during the seven-year reign of William IV (1830–7).

At the end of the last century elderly persons in Sanquhar, Dumfries-shire, remembered seeing a petty thief – 'a fine-looking young woman' – drummed out of town in 1830. She was brought from the jail with a rope tied around her neck and a notice pinned to her back: 'This is a Thief.' A jailer led her the entire length of the main street and back, with the town drummer hounding her every step.

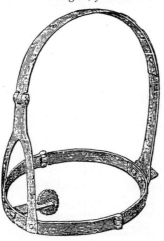

The branks, or scold's bridle, was a punishment reserved
mainly for nagging wives, gossips and scandalmongers

During the Aberdeen witch panics of the sixteenth and
seventeenth centuries no one was safe from malicious gossip, no
matter what their place in society. Marjorie Mearns begged
forgiveness in church for slandering an Aberdeen widow by calling
her a witch. Her punishment: to grovel on her knees before the
widow and congregation and utter the words: 'Tongue, ye lied!
Tongue, ye lied!'

In Stirling in July 1545 Agnes Henderson, found guilty of heaping
insults on Annabel Graham, was ordered to don a hairshirt, walk to
church carrying a wax candle and beg forgiveness by repeating,
'Tong, you leid.' In the same town two years later Jane Bell, who
had falsely accused Janet Sharp of bearing David Sibbald's bastard
child, was forced to walk through the streets wearing a hairshirt and
crying out to all and sundry: 'Tongue, ye lied on her!'

First used in Scotland in the sixteenth century, the branks, or
scold's bridle, was an instrument reserved for the punishment of
women offenders – nagging wives, gossips, scandalmongers,
suspected witches and fornicators. In 1560, for example,
Edinburgh Town Council ruled that all blasphemers be 'brankit'.
The instrument consisted of an iron framework that enclosed the
head in a close-fitting cage. There were holes for the eyes and an
iron gag, sharpened or spiked, to prevent speech – a loose tongue
could cause terrible injuries. The hapless woman was led by a
chain attached to the bridle.

The punishment was still in use in the eighteenth century. In Old Aberdeen in 1701 Marjorie Garioch slandered weaver James Fraser and his wife by calling him a 'landlowper' and 'beggar fellow', and accusing her of escaping banishment seven years previously. Garioch was fined and 'brankit'.

There was an embarrassing outburst by a woman member of the congregation at St Andrews Parish Church as Archbishop Sharp preached during the divine service in the 1660s. The woman claimed that when the archbishop was a college student in the university town they had conducted an illicit affair. The woman was arrested and dragged before the kirk session, whose members sentenced her 'to appear for a succession of Sundays on the repentance stool, wearing the brank'.

But occasionally men were 'brankit', too, usually for sexual offences. The Canongate kirk session in Edinburgh convicted David Pearson of fornication, and he was placed in the branks for four hours, while his lover, Isobel Mountray, was banished from the parish. In 1591 an Aberdeen man, Patrick Pratt, was locked in the branks at the market cross for committing the 'horrible and heinous crime' of incest. He was also forced to stand barefooted and barelegged in a hairshirt at the kirk door, followed by a spell at the 'pillar' (stool).

There were two types of chairs – the pillar or high stool of repentance, an elevated piece of furniture that stood near the pulpit, and the less conspicuous laigh-stool for those whose offences were less serious in the eyes of the kirk. Transgressors occupying the former seat could hardly escape the contemptuous gaze of the congregation and the fiery rebuke of the preacher.

Persons guilty of adultery were made to wear a garment of sackcloth and take their seat on the repentance stool, known as the 'cutty stool'. But at one stage in Scotland's history persons who broke the seventh commandment were put to death. Adultery was made a capital crime in 1563. John Guthrie of Kirkliston, a 'notair' adulterer (he had fathered an illegitimate child) was hanged in 1617, and there were other cases where adulterers ended their days on the gallows.

The punishment was later restricted to a fine for first offenders, failure to pay resulting in a short jail sentence on bread or water, followed by two hours in the pillory. A second offence resulted in a stiffer fine and a shaven head for the offender. A heavy fine, ducking and banishment awaited anyone foolish enough to commit a third offence.

In the Scottish Borders in 1663 a minister, Rev. Paul Methven, was found guilty of adultery. The General Assembly conferred with the Lords of the Council and their judgement was that he be 'permitted to prostrate himself on the floor of the Assembly, and with weeping and howling to entreat for pardon'. His sentence: 'That in Edinburgh as the capital, in Dundee as his native town, and in Jedburgh, the scene of his administration, he should stand in sackcloth at the church door, also on the repentance stool, and for two Sundays in each place.'

Sexual immorality was a major offence in the eyes of the Kirk. In St Andrews alone there were 1,000 known cases processed by the local kirk session between the years 1560 and 1600. In Aberdeen various such offences against the kirk saw fifty persons banished from the town in one day, while seventy-four were bound over for good behaviour. Glasgow harlots were pulled through the town in a cart, and adulterers were ducked in the River Clyde from a pulley suspended from a bridge.

Foul language in public fetched a fine of 12 pence in Aberdeen; the penniless were placed in the cuckstool or 'goffis' (pillory) and forced to wear a paper crown advertising their crime. Habitual swearing and bad language at the table resulted in similar punishment, while a third conviction for the same offence meant instant banishment.

The cuckstool, which was first mentioned in the Domesday Book as punishment reserved for brewers of bad ale, was a degrading method of chastisement in Aberdeen from 1405, when it was ruled: 'Whosoever shall abuse the town bailies, or any of the king's officers, shall kiss the cuckstool for the first offence and be fouled with eggs, dung, mud and suchlike for the second offence, and for the third offence they shall be banished from the town for a year and a day.' Banishment was recorded in case the culprit returned to the burgh before the time limit had expired.

In England the cucking stool was originally a commode. In Leicester in 1467 the mayor ordered nagging women to be seated in the cuckstool before their own doors and then carried to the four gates of the town. But in Scotland the term cuckstool was later applied to the stocks or even the pillory, two different implements of punishment, but with the same purpose. According to an old rhyme:

The tane, less like a knave than fool,
Unbidden clam the high cockstool

And put his head and baith his hands
Throw holes where the illdoer stands.

In Dundee the 'cuck-stole' was placed at the market cross. In the
mid sixteenth century a quarrelsome neighbour, Bessie Spence,
was admonished with this stern warning: 'that if she be found
flyting (abusing) with ony neighbour, man or wife, and specially
agains Jonet Arthe, she shall be put on the cuck-stole and sit there
for twenty-four hours'. But the punishment was not reserved only
for women in Dundee, for the old burgh records show that: 'Sande
Hay, for troublance (petty assault) made upon Andro Watson, is
discernit for his demertis to be put in the cuck-stole, there to
remain until four hours efter noon.'

The pillory and stocks, punishments more associated with
Merrie England, were a familiar sight in Scottish market places. In
some towns the pillory, whipping post and stocks were combined.
The Stirling stocks were seldom without an occupant, but despite
having been in extensive use, they are still well preserved. The
stocks consist of two wooden beams, each 12 inches broad by 6
inches thick, and 6 feet 6 inches in length, with hinges at one end
to lift the upper beam, and hasps and staples at the other for
padlocks to trap the culprit's feet. The stocks have a bench and an
aperture for an odd foot, there being seven holes in all, which
meant four culprits could be detained, one by a single foot! The
Stirling stocks and jougs originally stood at the Tron but were
moved to Broad Street in 1703.

In sixteenth-century Dundee Jock Galloway, found guilty of
assaulting Pat Baxter, was ordered to donate a candle to St Mary's
Church altar and beg forgiveness, failing which he was to 'lie the

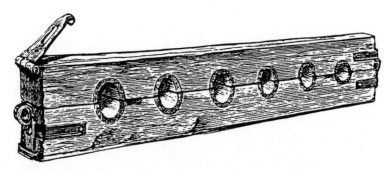

The stocks from the Canongate Tolbooth, Edinburgh

nicht in the stocks and ask Patte's forgiveness the morn at the Mercat Cross'. Another Dundonian, Nichol Anderson, was 'discernit to lie twenty-four hours in the stocks for stroubling [sic] of this gude town and wounding ane stranger, because he has nocht to pay the leech (surgeon)'.

In Peebles in 1633 John Brown, convicted of stealing corn, was jailed, fined and placed in the stocks at the market cross for twelve hours, with the corn stacked beside him. In the same town in 1559 two husbands took the place of their bickering spouses in the pillory until the women promised not to give the burgesses any more trouble. The stocks provided entertainment elsewhere in the Borders when a Kelso woman was convicted of theft. The event – which took place not in medieval times but in 1834 – attracted huge crowds.

The Courtbook of the Barony of Leys at Crathes, Kincard-ineshire, deals with the case of one James Paterson who unlawfully retrieved his horse which had been impounded by a court officer in May 1623. Paterson was placed in the Banchory stocks for twenty-four hours, ordered to pay the laird, Sir Thomas Burnett of Leys, the sum of forty pounds, and had his goods and gear confiscated. As well as in Stirling, stocks in Stonehaven Tolbooth and at Crieff, which has a set made of iron, continue to fascinate visitors.

The ducking stool, another beloved spectator sport, became so confused with the cuckstool, that their names were frequently mixed'up. The victim, however, was never in doubt. The ducking stool consisted of a long timber beam, evenly balanced on a pivot, with a small chair at one end. The culprit was strapped in the chair while the operator, usually the burgh hangman, took up his position at the other end. He would then dip the wretched victim in and out of the 'thief's pottie' at will.

In Aberdeen 'ducking at the cran [crane]' was reserved for fornicators, blasphemers and petty criminals. Women deemed immoral by the kirk were the chief sufferers. The crane was used for loading and unloading heavy goods from ships in port, and was stored in a harbour shed. The victim sat astride a ram's horn at one end of the cran, which was situated at the Quayhead, the site where accused witches were ducked.

In November 1602 Janet Shearer, who had been exiled from Aberdeen for harlotry, made the mistake of returning. She was imprisoned in the kirk vault and ordered to be ducked at the cran, and thereafter banished. However, on payment of ten merks [sic],

she was spared the punishment.

An Aberdeen woman was to be ducked – and then whipped, according to the *Aberdeen Observer* of 4 October 1833: 'On 1st July 1638 a frail female was sentenced by the Kirk Session to be cartit from the mercat croce to the Kay-heid, thair to be dowked at the cran, shall remain till Whitsunday nixt [from July 1638 to May 1639!] and to be quhipped everie Monday during that space'. The punishment was unusually brutal, whatever her crime.

Ducking went back many centuries for at Kincardine O'Neil in 1388, Isobel Duff, Baroness O'Neil, ordered a ducking stool to be sited at the burn to punish women scolds 'wha deal in fibs, an' tittle-tattle'. In Dundee unchaste conduct brought a spell in both the pillory and the ducking stool. According to the old court records, men and women were 'for the first fault to be admonishit by the preachers to forbear in time coming. But gif he and she be again apprehendit in the same fault, they sall stand three hours in the gyves, and be thrice doukit in the sea, and gif that punishment serves nocht for amendment, they sall be banishit for ever.'

The life of pregnant women was not to be endangered, however. Instead, 'the woman, of what estate so ever she be, sall be brocht to the Mercat Croce openly, and there her hair sall be cuttit of, and the same nailit upon the cuck-stool, and she make her public repentance.' Not only human hair was exhibited. After 16th century 'tulzies' (street fights) confiscated weapons, such as 'whingers', a hanging dagger or small sword, were fixed to the Dundee cuckstool.

Branding and mutilation, such as boring holes in tongues, cutting off ears or nailing ears to the tron (weighing-machine) or cuckstool, were regarded as minor forms of punishment. In Banff in 1695 the hangman was paid six shillings for 'setting up the cock stoole' and nailing a condemned man to the seat by his ear. A youth, Patrick Falconer, described by Old Aberdeen magistrates in 1699 as a habitual thief, was punished by having his ear nailed to a stake, burned on the cheek with a hot iron and then exiled. Stone-throwing vagabonds who smashed the windows of the kirk in Old Aberdeen were tied to the market cross for twenty-four hours and then branded. Parents and employers of local children and servants convicted of the same offence were fined six shillings and eightpence. Three women found guilty of the 'fylthie cryme of fornication' were left with an unpleasant choice: to be banished from the burgh, or face the branding iron, which could be an iron bar or a red-hot key.

On 2 August 1700 two thieves were carted from Stonehaven Tolbooth for punishment at nearby Dunnottar. John Duncan, of Auchenblae, had been found guilty of stealing cattle, and would hang. John Reid, who had stolen linen at Den of Morphie, was branded on the right shoulder-blade before setting out for the gallows. The culprits were roped together. Reid was forced to watch Duncan be hanged and then help to bury his body at the Gallowhill. As a final indignity John Fraser, the court dempster and hangman, kicked him on the backside, a symbolic gesture signifying exile from Kincardineshire.

Criminals branded in Stonehaven underwent the ordeal at a blacksmith's shop opposite the courthouse. After one wretch had both ears pierced with a hot iron he roared out: 'I would be right now if I had pendices! [earrings]'

The Inveraray Jail records of 1705 show that twenty-year-old Anne Harris, hanged as a 'notorious shoplifter', was so frequently burnt on the hand that there was no room for the executioner to stigmatize her. A grim tableau at Inveraray shows John McConachie McCaig being burned on the cheek with the letter T – the mark of a thief. He was convicted in 1672 of stealing clothing and money from Sir Rone McLeod and robbing a chapman in Appin. His punishment included being scourged from one end of the town to the other.

A Cullen woman, Isabel Paterson, volunteered to go into exile after being caught stealing corn from a farmer in 1636. If she returned she was 'content to be taken and brunt [sic] with ane key upon the cheeke', and then banished. Another woman thief, Maddy Bathelem, was also burned on the cheek when she returned to Stirling from exile without permission. She was threatened with the gallows if she showed her face again. But consider the fate of Elspeth Rule, who was burned on the cheek at Dumfries in 1701. It was said the torturer applied the white-hot iron with such vigour that witnesses recalled years later how smoke poured from the poor woman's mouth.

Branding was not a particularly effective answer to crime or moral lapses. The punishment proved counterproductive, for the tell-tale brand marks made it difficult for the victim to find honest employment.

The searing agony of the lash was inflicted on criminals, no matter what their sex or age. Flogging was inflicted with a 'cat o' nine tails', birch rod, or forked strap. The cat was a lethal wooden-handled instrument with nine whipcord lashes. Old

records tell how the common hangman wielded the scourge with relish. On being asked the secret of his whipping arm, the Edinburgh 'finisher of the law', Jock Dalgleish, replied nonchalantly: 'Oh, I lay on the lash according to my conscience!'

Old Aberdeen, in common with other Scottish towns, employed its own 'scourger', who also carried out executions. It was created a free burgh of barony by James IV in 1498, and did not merge with the city of Aberdeen until 1891. Archibald Bishop landed the job as hangman and scourger in May 1636, at a weekly wage of 8 shillings. One of his tasks was to round up beggars and vagabonds and evict them from the town. If they defied the burghers Bishop put them in the stocks or jougs, and they could face branding. Townsfolk who harboured vagabonds were fined. In the event of a strong beggar refusing to be flogged Bishop had the authority to deputize two persons to help subdue the culprit. Refusal to help, or any attempt to free the beggar, could lead to the wrongdoer losing three week's wages, a spell in the tolbooth or a fine.

For theft of a shirt in Old Aberdeen in April 1608 Isobel Jamieson, of Fordoun, Kincardine, was tied to the market cross and 'tirrit' – stripped – from her waist up and flogged. The punishment continued as she was marched through the streets and banished from the bishopric, 'never to return under the pain of death'.

On 22 September 1652 the Old Aberdeen hangman James Anderson scourged a notorious thief, Margaret Strachan. The punishment was administered on the stretch of high road between the kirk and the Spitalhills, the burgh boundary, where the woman was warned that if she ever set foot in the town again she would be drowned 'without doome or law'.

In 1640 Margaret Warrack was detained in the Aberdeen Correction House until she confessed the 'sin of fornication' and to loosen her tongue the kirk session ordered her to be whipped at the stake.

In the eighteenth century whipping was carried out at three places in Aberdeen: the Bow Brig, which spanned the Denburn on the main road to the south; the head of St John's Wynd and at the tolbooth stairhead.

In 1772 barber's apprentice Adam Frain appeared before the sheriff charged with breaking into advocate John Durno's house and stealing books and banknotes. He was flogged by the 'hangie', then jailed and banished from Aberdeenshire for life. He was warned if he ever returned to the county he would be

'apprehended, incarcerated, whipt and again banished'. Adam Frain was a mere thirteen years old. Surprisingly, John Davidson, a miller, escaped with only a flogging after stabbing his wife at Gordon's Mills at Tillydrone, Aberdeen. Thomas Scotchie, a drummer with a puppet show, received identical punishment for attempting to rape Barbara Wilson on the road to Slains Kirk, north of Aberdeen. Yet James Aberdein, convicted of cutting down a tree in a local estate, was jailed for four months and flogged through the streets of Aberdeen on the last Friday of four successive months.

The old burgh records of Stirling itemize the cost of public floggings by the staffman. In 1683 the common hangman received £1 4s for 'whipeing' a man and two women through the town. The additional cost of the rope for binding them and the tawse for inflicting the punishment came to 6s 8d. In September 1698 three purse cutters were pilloried at the Tron before being scourged. The total cost amounted to £3, which included the fees of the hangman and his escort.

In Banff in 1629 a thief, Isobel Mitchell, was 'ordanit to be presentlie strippet naikit and scurgit out of this burgh and perpetuallie banischit'. When Duncan Macdonald took up his duties as executioner at Banff in 1693 his first act was to flog his predecessor, Allister, and Donald Ross, for a fee of twelve shillings. Their offences are not recorded.

Military flogging was particularly brutal. Joshua Smith, a private whose regiment was garrisoned in Aberdeen in 1752, was sentenced to 800 lashes for theft.

Six persons – four soldiers and two civilians – were indicted at the Circuit Court of Justiciary in Aberdeen for stealing meal from a ship berthed at Banff. Three of the accused were acquitted, but Alexander Robb, a resident of Banff, and Walter Annesley and John Blair, both of the Sixth Regiment of Foot, were found guilty and sentenced to be publicly flogged and banished to the plantations for life. On Friday 13 June 1766 the men were taken from Aberdeen Tolbooth under military guard to be flogged by the hangman. The hangman had no sooner begun the punishment when an enraged mob attacked him and the guard with clubs and a hail of stones. The military escort was badly beaten and unable to prevent the mob from helping the prisoners to escape. The magistrates offered a reward of twenty guineas leading to the arrest of one or more of the escapees, and an additional ten guineas for the arrest of the ringleaders of the riot. But the rescued and their rescuers vanished into thin air.

In 1700 Edinburgh magistrates ordered the flogging of several lawbreakers following an anti-English riot. But the culprits had the mob on their side. On the pillory they were presented with wine and flowers and even the hangman entered into the spirit of things by never once allowing his whip to touch their backs. The furious magistrates sentenced their hangman to be scourged in his turn. They hired the Haddington executioner but he took one look at the vengeful mob and fled down a nearby alley. The tables were turned on the magistrates, who, it was said, would have had to hire a third scourger to punish the Haddington man whose courage had deserted him. The matter was dropped.

A curious incident occurred at Dundee in 1552 when accomplices Wattie Firsell and Duncan Robertson were found guilty of robbing 'ane puir woman within silence of the nicht'. The court ruled 'that Duncan sall scurge Wattie round about within the bounds of this burgh, as use is, and gif he fails in the extreme punishment of Wattie, then Climas (the hangman) sall scurge them baith in his maist extreme manner he can. And thereafter Wattie to be had to the Cross, and, by open proclamation, banishit this burgh for seven years'. There is no record of Robertson shirking his duty.

At the beginning of the last century the theft of yarn in the 'jute city' of Dundee was heavily punished, probably because the administrators of the law were themselves merchants and factory owners. Embezzlement and handling of stolen yarn were punished with a £20 fine, and culprits who failed to pay were flogged at the market cross. In July 1805 it was reported that thirteen women and five men were in custody awaiting a public whipping.

In 1822, a few years before the grim spectacle was abolished in Scotland, there was a rash of floggings. In February that year the Sabbath was shattered in Glasgow when a rampaging mob ransacked the home of oil and colour merchant George Provand in West Clyde Street, in the mistaken belief that it was a den of resurrectionists – those loathsome body-snatchers who stole fresh corpses for medical research. The riot was triggered by inquisitive, and highly imaginative, passers-by who peered into the basement of the gloomy mansion. This was reputed to be haunted by a previous owner, Robert Dreghorn, who, because of his notoriety, was dubbed 'Bob Dragon'. Staring into the murky recesses, the gathering crowd conjured up a floor streaming with blood and the severed heads of two missing chimney-sweeps. Every pane of glass in Bob Dragon's old house was smashed, before the mob battered

down the front door. Its elderly owner scrambled out of their clutches by a back window and fled down the Stockwell. The mansion was ransacked of its gold and silver, while furniture, blankets and bedding were dumped in the Clyde. The uproar raged for hours before the Riot Act was read, and the cavalry and infantry were summoned from their barracks.

A check revealed that the blood on the basement floor of the wrecked house was red paint and the human heads turned out to be two pots of black paint. The Lord Provost and magistrates offered a reward of 200 guineas leading to the arrest and conviction within one month of the 'actors in this wicked and unprovoked outrage'. Arrests were made but only five people stood trial at the High Court in April. They were found guilty and each was punished with transportation for fourteen years.

John Campbell, a shoemaker, formerly a policeman, was singled out as the ringleader. Instead of standing up for law and order he had incited the mob. As an additional punishment he was ordered to be scourged through the Glasgow streets by Tam Young, the public hangman. At noon on 8 May 1822 Campbell was brought out of the jail by the north door and tied to the tail of the cart. A strong detachment of the 4th Dragoons acted as escort. At the south side of the jail the culprit's back was bared by the hangman, who inflicted the first twenty lashes with the 'cat'. The punishment was repeated at the foot of the Stockwell and at the head of the Stockwell. The last twenty strokes, making eighty in all, were inflicted at a crowded Glasgow Cross.

In September there was another public flogging in Glasgow: Edward Hand, convicted of assault in Greenock, received a total of eighty strokes at four whipping stations. A minor dispute arose between Tam Young and the magistrates over duties connected with the flogging: who would carry a spare whip? This was settled by suspending the substitute 'cat' in a bag from the cart tail.

On the evening of 5 May 1822 a young girl was sexually assaulted by two men on the road between Dundee and Glamis. John Miller and William Storrier were arrested and appeared before Lord Hermand and Lord Succoth at the High Court in Perth in September. The defence claimed there had not been enough daylight for Margaret Miller, who was fourteen, to identify her attackers. But the octogenarian Lord Succoth produced an almanac to prove that on the evening in question there was a full moon – vital evidence that surprised the prosecution and demolished the defence. The culprits were found guilty of serious

assault and sentenced to be publicly flogged, and afterwards transported for fourteen years.

The streets in the centre of Dundee were overflowing when noon struck on the clock of the Town House on Friday 4 October. A cart rolled up to the square and the prisoners were fetched from the upper cells of the jail, hats slouched over their pale faces. Their backs were stripped bare and a cord was tied round their waists and fastened to the tail of the cart. In the square alone there was an estimated crowd of 10,000; other spectators crammed neighbouring streets. Even so there was no demonstration and the people obediently parted as the cart moved slowly towards the Seagate. The first halt was made at the corner of the Trades Hall, where the hangman gave each prisoner 'three stripes' with the cat o' nine tails. The route of the melancholy procession went along Seagate to St Andrew's Street, Cowgate, Murraygate and back to High Street. The cart trundled westwards, by the Overgate, down Tay Street, returning by the Nethergate to the Town House. The prisoners, their flesh cut and bleeding, were led back to their cells, with the jeers and hooting of the crowd ringing in their ears. The men were each whipped three times at thirteen halts, conforming with the scriptural number of 'forty stripes less one'.

A public flogging was staged in Dundee on 14 May 1824 when a robber named Webster was paraded through the streets at the cart tail. After an assault trial at Perth Circuit Court three years earlier, Webster had been jailed for a year and banished for five years with the threat of a public flogging if he returned to Scotland prematurely. That is exactly what happened. In May 1824 Webster was recognized in Dundee after he had assaulted a number of people in the east end of the city, and duly arrested. The local hangman did not administer justice on this occasion. Instead it was left to the Edinburgh hangman, who, on the previous Saturday had been summoned to Arbroath, where a vast crowd had turned up to see farm servant Robert Sim flogged for attempting to murder his sweetheart.

The following year, 1825, John Kean, a Glasgow cotton spinner, appeared before Justice-Clerk Boyle at the Glasgow Circuit Court on a charge of attempted murder. Kean was found guilty of shooting a fellow workmate in the street. Years later defending counsel Lord Cockburn recounted how the wounded man, John Graham, pale, feeble, paralysed by the pistol ball that had shattered his spine and dying, was carried into court on a stretcher to give evidence. 'My client would have been hanged if the law had

allowed it, but unfortunately, the statute which makes shooting, though not fatally, capital, had not then been extended to Scotland. This miscreant had the merit of getting it done.' And this said by the man who defended Kean!

Kean was sent into exile for life, but not before he was flogged on 11 May 1825 on a temporary scaffold erected in front of the jail. He was tied to a cross-shaped framework and given eighty lashes by Tam Young, wielding the 'cat'. It was rumoured that Kean's trade-union associates had collected £100 to bribe the hangman to resist severity, but there was no disturbance, only loud cheers from spectators when blood trickled down over the prisoner's bare back. Kean's supporters did, however, avenge their friend's pain and humiliation. Soon after the flogging they lured Tam Young to the Humane Society House in the city 'to partake of a glass of ginger beer', and 'violently assaulted' him. It was the only serious attack Young suffered in his career as finisher of the law. This was the age of bitter feuds between trade unionists and employers, with strikes, riots, shootings and acid attacks in Glasgow streets. This violent period reached a climax with the Glasgow cotton-spinners' trial in 1837, when five accused of murder were cleared but given seven years' transportation for other offences.

The last sentence of corporal punishment imposed by the High Court of Justiciary took place on 14 March 1831 when James McGowan, before being exiled for seven years for assault, was flogged through the town of Haddington. But the streets of Scotland offered other forms of rough justice.

'Riding the stang' was an ancient custom carried out in many parts of Britain, although in the south of England it went by the name of 'Skimmington Riding'. The victims were almost always men, accused of beating their wives, or of being unfaithful. The guilty party would mount a timber beam that was then carried shoulder-high through the community. A noisy procession of men, women, children, banging and beating kettles, pots and pans and blowing whistles, horns and trumpets, pursued their victim. Frequent stops were made so that a spokesman could loudly proclaim the culprit's offence and then deliver slanderous rhymes to him.

In Huntly, Aberdeenshire, in January 1734, John Fraser complained to John Gordon, bailie for the Duke of Gordon, that his neighbours were threatening him with 'riding the stang'. Investigations revealed that Fraser's wife, Anne Johnston, had been ill-treated by her husband. Neighbours told how they were

A fanciful view of 'riding the stang'. It was far more
humiliating with sometimes tragic results

forced to rise from their beds and rescue Anne from her husband's
'barbarous hands'. Ann and ten other women petitioned the duke
to grant them a 'toleration of the stang'. 'If his lordship could
suggest any more prudent method, we would be glad to hear of it
for preventing more fatal consequences.'

Fraser claimed he was a good husband and would in future be
civil to his wife. He was given twenty-four hours to keep his word,
but when the next day dawned he was seized by four men and
forced to ride the stang, a wind-blown tree, through Huntly.
Fraser later complained bitterly to the laird and his tormentors
were fined £20 and told to pay him £12 in compensation.

The court book of Banff records two cases of 'riding the stang'.
On 26 January 1747 Alexander Clark, journeyman shoemaker,
and several others, were fined £3 for causing Walter Elles,
wheelwright, and James Cooper, blacksmith, to 'ride the stang'.
They carried their hapless victims through the whole burgh,
thereby hurting and bruising them 'contrair to all law and against
the rules of a well-governed burgh'. The second incident that took
place at Banff went far beyond the bounds of horse-play, for the

victim was a pregnant woman. On 26 July 1740 Nicol Copland, a baker's apprentice, and four accomplices, all working for local shoemakers, dragged Ann Milne, a saddler's wife, from her home. In a violent scene they forced her to mount a fallen tree, then carried her aloft through the burgh. The culprits were each fined £6 for causing a 'tumultuous and riotous assembly' and for violently attacking Mrs Milne. The court also ordered them to be held in the tolbooth until a midwife could report on the victim's condition.

A case of 'riding the stang' ended tragically in March 1736, when the *Caledonian Mercury* reported that a wife-beater, blacksmith George Porteous, of Edmonstone, was so 'affronted' by his treatment at the hands of his neighbours that he hanged himself.

A military version of 'riding the stang' was the 'Timmer (timber) Mare', a punishment introduced into Scottish garrison towns. Prints of bygone Edinburgh show the wooden horse outside the guardhouse of the City Guard. The effigy had four legs, a head and tail and stood six feet from the ground. Its back had a sharp ridge so that an infantryman (the punishment was usually reserved for foot soldiers) would suffer an agonizing induction to equestrianism. To add to the pain and chafing the victim's hands were tied behind his back and muskets strapped to his feet. This was by no means the only variation on the theme. In Cromwellian times drunkards were forced to ride the horse – sometimes referred to as the 'German mare' because it was imported from that country –

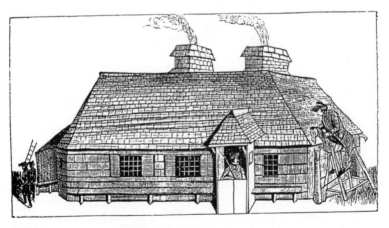

A culprit rides the 'Timmer Mare' outside Edinburgh's City Guardhouse

with a drinking cup balanced on their heads.

The curious punishment was brought to Aberdeen by General Munro's covenanting troops when they garrisoned the town in May 1640 during the Scottish Civil War. It was placed at the front door of a *corps de garde* in the Castlegate. In 1656 a Roundhead captain punished one of his soldiers for the sin of incontinence by ordering him to 'ryde the meare'.

But the punishment was not only imposed on the military. Aberdeen lawyer John Spalding, who has left an eye-witness account of 'The Troubles', recounts how a tactless remark by a 72-year-old citizen resulted in a painful riding lesson. 'Daylie deboshing, drinking, night-walking, combating and sweiring' by the occupying troops did not help public relations, and on being told that one of Munro's men had been accidentally drowned the foolish septuagenarian wished 'that all the rest should go the same gate [road]'. He was jailed and then made to ride the 'timmer mare', or, in the words of the chronicler, 'syne rode the mare to his great hurt and pain. Thus none durst do nor speak any thing against them! Uncouth to see such discipline in Aberdeen, and painful for the trespasser to suffer!'

Before the occupation by the Covenanters ended in February 1642, a fierce gale destroyed the guardhouse. One hopes it blew the timber mare into the harbour.

3

Turn of the Screw

On the night of 21 February 1437 a small band of assassins slipped into the royal lodging of James I, King of Scotland, in Blackfriars Monastery at Perth. The conspirators, led by Sir Robert Graham, a bitter enemy of the king, gained access because the locks on the doors had been tampered with beforehand and the guards stood down. Legend would tell how 'Kate Barlass' – Lady Catherine Douglas – was hurt when she tried to bar the door of the royal chamber by thrusting her arms through the sockets.

Kate was not in fact in the chamber. But Queen Joan was wounded as she tried to prevent the murderers from attacking her unarmed husband. The king was cornered in a sewer below the room and hacked to death. As he kissed the blood-stained corpse, the papal representative, the Bishop of Urbino, declared that 'The Poet King' had died a martyr.

Queen Joan, the granddaughter of John of Gaunt, had been courted by James during his eighteen years of captivity in English hands. She was a spirited and vengeful lady for she helped to plan the fiendish punishment of her husband's enemies, headed by Walter Stewart, Earl of Atholl, the king's uncle, who for long had had his eyes on the crown of Scotland, and whose grandson, Sir Robert Stewart, the king's domestic chamberlain, had betrayed his master at Blackfriars.

Queen Joan, the king's beloved 'milk-white dove', wreaked revenge on her husband's murderers in a most barbarous manner, and was said to have gone beyond the 'bounds of humanity'. The method of torture was described as 'perhaps the most appalling that is recorded in our country's history'.

Because Atholl was reckoned to be the chief conspirator his

punishment was inflicted over three days in Edinburgh. On the first day he was led to a cart bearing a bizarre contraption – a tall engine shaped like a monstrous stork. Atholl was stripped and hoisted feet-first into the air by ropes running through pulleys. Suddenly he was given 'ane swack': the ropes were released so that his body hurtled towards the ground, but were pulled up short, resulting in dislocation of his limbs. He was then dragged to a pillory where he was crowned with a red-hot iron diadem bearing the mocking inscription, 'The King of Traitors'.

On the second day of his torture he was bound to a hurdle and drawn at a horse's tail through the streets of the capital, lined with jeering, taunting crowds, for the population was stunned and angered by the death of its popular king.

On the third day Atholl was stretched on a plank in full view of the mob and disembowelled alive, and his organs and private parts were thrown into a fire. His heart was torn out and burned. His head was cut off and brandished by the executioner before it was set on a spike in the highest part of the city. Finally his body was divided into four quarters, which were later exhibited in Scotland's main towns.

The next to be butchered was Sir Robert Stewart, but because of his youth his accusers decided 'they would not put him to so much pain ... therefore he was *only* hanged and quartered'. (*My italics.*)

The villain of the piece, Sir Robert Graham, suffered horribly. His right hand, no doubt the one which brandished the murder weapon, was nailed to a portable gallows, set up on a horse-drawn cart. Executioners pierced his thighs, arms and other parts of his body with white-hot spikes, but were careful not to strike a fatal spot. Then his body was dismembered.

The sadistic ingenuity of the assassins' torturers reflected a brutal age, but the centuries to come showed mercy to be a rare commodity. Indeed, one cannot help but be shocked by the depravity of men as they sought new methods of inflicting excruciating torment and pain on their fellow humans.

His enemies damned him to hell and dubbed him 'Bloody Tam' and the 'Muscovy Brute' – appropriate sobriquets for the man who introduced the thumbikins to Scotland. In legend General Sir Tam Dalyell was in league with the Devil, and was said to play cards with Auld Nick at his West Lothian seat, the House of the Binns. But 'Bloody Tam' took no chances, for the round towers of his mansion were built to prevent the Devil from blowing them away. Superstitious folk believed Tam was bullet-proof, that his

spittle could burn a hole in the ground, that he roasted his enemies and that cold water turned to steam if poured into his riding boots. The lore that grew from the exploits of the general was fuelled by Sir Walter Scott, who, in *Redgauntlet*, had Tam roistering in hell with Auld Nick.

In truth Dalyell was an able Royalist general and a thorn in the flesh of the Covenanters during the seventeenth-century Scottish Civil Wars. The fierce old Cavalier refused to cut his snow-white beard after the death of Charles I. He escaped to Russia from the Tower of London in 1652, and carried on his military career on behalf of the Czar Alexis. Over a ten-year-period he led Russian armies against the Poles, Tartars and Turks. On the restoration of the monarchy Charles II came to the throne and General Dalyell went back to Scotland, bringing with him the thumbikins.

The actual 'thumbi-kins' used to torture Protestant minister, William Carstares

The Scottish thumbikins, or thumbscrew, was a device that induced terror in both accused persons and reluctant witnesses, for it was used in dungeon and courtroom as a legitimate means of eliciting evidence.

Only a handful of specimens survive. The thumbikins resembles a macabre nutcracker. The instrument consists of a bar of iron, three or four inches long, from which rises three vertical rods, the

centre one having a screw thread. An upper bar was forced downwards on the victim's thumbs or fingers by a nut working on the vertical screw. The thumbikins was used by several Scottish authorities. One specimen was found in the thatched roof of a house in Forres, Morayshire, which tumbled down early last century. A lengthy iron chain was fixed to a pair used in Montrose so that the sufferer could be easily led by his tormentor. Three pairs of thumbikins were exhibited at the Glasgow Exhibition in 1888.

The most ornate example came to light at the end of the last century, when the Crawfords were moving from their mansion of Cartsburn at Crawfordsdyke to Ratho, near Edinburgh. The padlock that fixes the hasp, preventing the slackening of pressure, is in the form of a serpent, while the key for tightening the nut represents an ornate cross. The Spanish Armada was said to have carried a large number of thumbscrews for the purpose of converting heretics, and it is possible that the Crawford thumbscrew, which is not of Scottish origin, might have been such an example. Certainly the Baron Court Books of Crawfordsburn make no reference to the thumbikins.

One of the first victims of the thumbikins was William Spence, a servant of the Earl of Argyle, who was tortured in July 1684 when he refused to disclose the secrets of coded letters, which had fallen into the hands of the Royalists. Spence suffered terrible agony but stubbornly refused to give details of the supposed 'English phanatique plot', aimed at overthrowing King Charles II.

Even the offer of a pardon failed to loosen his tongue, so he was handed over to 'Bloody Tam', who forced Spence to wear a hairshirt and kept him awake for five nights until he was out of his mind with lack of sleep. To add to the horror he was tormented with a 'pricker' – a long iron needle – favoured by witch hunters, before being thumbscrewed until his hands were crushed, bruised and bleeding.

Incredibly Spence remained silent, but he was weakening. On 7 August 1684 the threat of renewed torture induced a change of mind and he 'being frightened, desired tyme, and would declare what he knew'. Two weeks later, when no doubt his frightful injuries had healed enough to allow him to grasp a pen, he deciphered the secret letters 'to avoid any farder torture'.

Soon it was the turn of a Protestant minister, William Carstares, to suffer the torture in his cell at Edinburgh Castle. Carstares was suspected of being implicated in the Rye House Plot, a conspiracy

to assassinate King Charles II and his brother James in an ambush near a place of the same name in Hertfordshire. The Privy Council of Scotland was so determined to establish the names of the plotters that a special act was raised in favour of Carstares being tortured.

A set of new thumbikins was specially made for the interrogation. In their design they resemble a thumbscrew of Italian workmanship. The powerful key with a cross handle for turning the nut makes the device look like the product of modern engineering – in contrast to most specimens in the Museum of Antiquities in Edinburgh. After suffering the torment for ninety minutes it is little wonder that Carstares 'confessed ther hes bein a current plot in Scotland thesse ten years past'. But not before the Dukes of Hamilton and Queensberry had stalked from the torture chamber because of the revolting spectacle and the victim's shrieks of agony.

Carstares confessed his part in the defeated plot, but he said nothing of the future plans of the Prince of Orange, the future William III. He escaped with his life and was imprisoned for a year in Edinburgh Castle, during which time the boredom of prison life was relieved by the young son of Sir Alexander Erskine of Cambo, the constable of the fortress, who brought the inmate fruit, provisions and writing materials. Carstares never forgot this kindness and in later years the king bestowed the office of Lord Lyon on the young heir of Cambo. On his release from prison Carstares went to Holland to become chaplain to the Prince of Orange.

Carstares eventually became principal of the University of Edinburgh and confidential adviser to the king on Scottish affairs. After William of Orange was crowned, the instrument once used to torture his new adviser was presented to Carstares by the Privy Council. An anecdote handed down by descendants claims the device was demonstrated to King William by Carstares.

'I have heard, Principal,' said the king, 'that you were tortured with something they call "thumbikins"; pray what sort of instrument of torture is it?'

Replied Carstares: 'I will show it you the next time I have the honour to wait upon your Majesty.'

In time Carstares kept his promise. 'I must try it,' the king told him. 'I must put in my thumbs here. Now, Principal, turn the screw. Oh, not so gently – another turn, another. Stop, stop! No more! Another turn, I am afraid, would make me confess

anything.' The potential pain of the experience was not lost on the monarch.

The thumbscrew was inherited in Victorian times by Alexander Dunlop, Consul-General of London, a direct descendant of Principal Carstares. By a quirk of history Queen Victoria heard of the device while on holiday at Balmoral Castle. Her informant, Professor Storie, one of the deans of the Chapel Royal, told her it was in Dunlop's possession. She expressed an interest in inspecting the thumbscrew. Her wish was granted, but it is not recorded whether Her Majesty experimented with the thumbikins in the same way as her royal predecessor.

The last time the thumbscrew was used in Scotland as a judicial torture occurred in the case of the unfortunately named Henry Neville Payne, an English Catholic suspected of being entangled in a 'horrid plott' to overthrow king and government and place James VII on the throne. On being threatened with high treason in England Payne fled north of the border. Torture was banned in England and it has been suggested that Payne was deliberately frightened into quitting England for Scotland, where torture might reveal all. At the time the Solicitor-General for Scotland wrote from London to Lord Melville claiming Payne knew enough secrets to 'hang a thousand', but that he would only part with them under torture. 'Pray you,' he urged, 'put him in such hands as will have no pity on him; for in the opinion of all men, he is a desperately cowardly fellow.' Payne would make his torturers eat their words.

On 6 August 1690 Payne and three accomplices were subjected to torture in Edinburgh Castle, on suspicion of 'a treasonable and hellish plot'. He kept his mouth shut. On 10 December, under instructions signed by King William, who knew first hand the agony of the thumbikins, he was again tortured. Yet once again his tormentors failed to break his will, but 'in a boasting manner bade them do with his body what they pleased'. Lord Crawford left a stark, blood-chilling account of the torture scene:

Yesterday, in the afternoon, Nevill Payne (after near an hour's discourse I had with him in name of the Council, and in their presence, though at several times, by turning him out, and then calling him in again) was questioned upon some things that were not of the deepest concern, and had but gentle torture given him, being resolved to repeat it this day; – which, accordingly, about six this evening, we inflicted on both thumbs and one of his legs, with all the

severity that was consistent with humanity, even unto that pitch that we could not preserve life and have gone farther – but without the least success; for his answers to our whole interrogatories, that were of any import, were negatives. Yet he was so manly and resolute under his suffering, that such of the Council as were not acquainted with all the evidences, were brangled, and began to give him charity that he might be innocent. It was surprising to me and others that flesh and blood could, without fainting, and in contradiction to the grounds we had insinuate of our knowledge of his accession in matters, endure the heavy penance he was in for two hours; nor can I suggest any other reason than this, that by his religion and its dictates, he did conceive he was acting a thing not only generous towards his friends, but likewise so meritorious, that he would save his soul and be canonised among their saints. My stomach is truly so far out of tune by being a witness to an act so far cross to my natural temper, that I am fitter for rest than anything else. Nor could any less than the dangers from such conspirators to the person of our incomparable King, and the safety of his government, prevail over me to have, in the Council's name, been the prompter of the executioner to increase the torture to so high a pitch.

I leave it to other hands to acquaint your lordship how several of our number were shy to consent to the torture, and left the board, when by a vote they were overruled in this. I shall not deny them any charity than this was an effect of the gentleness of their nature; though some others of a more jealous temper than I am, put only another construction on it.

A close relative of the thumbscrew was the pilniewinkies, also known as the pilliewinkis, pilliwinkes, pyrowkes, pyrewinkes, pilnewinks and pennywinkis – all names to raise a smile unless you were the victim.

The pilniewinkies, first mentioned in late fourteenth-century court records (also exhibited at the 1888 Glasgow Exhibition), was

The funny-sounding pilniewinkies was no laughing matter

specially designed to crush all the fingers of one hand, or one or two fingers of each hand. It consisted of two plates of iron, hinged at the back, and held open by a strong spring. Attached to the lower plate was a strong iron bar which bent up over the hinge, and divided into two arms, which stretched towards the extremities of the upper plate. Each was provided with a screw. The front edges of the plate were turned over so as to touch each other, but were sharp enough if sufficient pressure be applied to cut the flesh. The plates were curiously shaped. The front edge was concave, and from horn to horn was about six inches; of the other two sides, one was convex, the other concave.

The victim's fingers were placed between the plates, which were then forced together by the screws, causing cutting or severe bruising of the flesh and, ultimately, crushing of the bones.

In 1590 the pilniewinkies failed to break the spirit of Geillis Duncan, a 'young and comely' maidservant who was suspected of sorcery. Because she failed to answer questions put by her employer, David Seaton, deputy bailiff in Tranent, 'her maister, to the intent that he might the better trie and finde out the truth of the same, did with the help of others torment her with the torture of the Pilliwinkes upon her fingers, which is a grievous torture, and binding or wrinching her head with a cord or roape, which is a most cruell torment also, yet she would not confess anie thing'. But after a season in the tolbooth the wretched girl was forced to denounce the infamous Dr Fian and the North Berwick coven of witches.

As late as 1745 a less sophisticated version of the pilniewinkies was used. The tooth of a harrow was removed, and the victim's finger pushed into the gap, and the tooth driven in against the finger.

But the Scottish torture chamber exhibited other grisly instruments to chill the blood and drive hapless victims mad with agony. These were the boots, cashielaws and the torkas. Sometimes the unholy trinity was inflicted on a single person.

In the case of suspected perjury at the Court of Session in Edinburgh on 29 June 1579 the king's advocate produced a royal warrant for examining 'Johne Soutter, notar, dwelland in Dundee, and Robert Carmyle, Vicar of Ruthwenis, witness in the action of improbatioun of ane reversioun of the lands of Wallace-Craigy; and for the mair certane tryall of the verities in the said matter to put them in the buttis, genis, or ony other tormentis, and thairby to urge them to declair the treuth.'

The buttis – boots, booties or bootikens – was, along with the

thumbikins, a favourite instrument of Royalist torturers.

There were several versions. A visitor to Scotland in 1679 gave this description: 'Four pieces of narrow board nailed together, of a competent length for the leg, not unlike the short cases we use to guard young trees from the rabbits, which they wedge so tightly on all sides that, not being able to bear the pain, they promise confession to get out of it.' Repeated mallet blows drove the wooden wedges home between inner and outer boards, in which the leg was boxed.

William Spence, who was tormented with the thumbikins by 'Bloody Tam' Dalyell, was 'extremely bootit' on the orders of Charles II. The king also ordered that Gordon of Earlston be tortured in the boots but when he was brought to the Council Chamber 'thro fear and distraction roared out like a bull and cryed and struck about him, so that the hangman and his man durst scarce lay hands on him'.

The torture of North Berwick warlock Dr Fian, denounced by Seaton's maid, Geillis Duncan, makes vile reading. Fian, alias John Cunningham, a schoolmaster from Saltpans in the Lothians, and his fellow witches were accused of raising a storm which threatened to engulf the ship carrying King James VI and his new bride, Anne, Princess of Denmark, home to Scotland. The king personally examined the accused and was furious when Fian managed to escape between bouts of giving his testimony and demonstrating his magical powers. On his recapture the king commanded the unfortunate Fian 'to have a most straunge torment'.

A contemporary account of the torture proves His Majesty's wishes were carried out with gusto: 'His nailes upon all his fingers were riven and pulled off with an instrument called in the Scottish a Turkas, which in England we call a payre of pincers, and under every nayle there was thrust in two needels over even up to the heads.' Despite the fiendish torture the doctor 'woulde not confesse anie things'. But the king insisted the torment continue and so Fian was 'convaied againe to the torment of the bootes, wherein he continued a long time, and did abide so many blows in them that his legges were crusht and beaten together as small as might bee; and the bones and flesh so bruised that the bloud and marrow spouted forth in great abundance, whereby they were made unserviceable for ever.'

Poor Fian refused to break and 'utterly denied all that which he before avouched; and would say nothing thereunto but this, that what hee had done and sayde before was only done and sayde for

fear of paynes which he had endured'.

On the last day of January 1591, Fian, helplessly crippled and unable to walk, was carted to the stake on the Castle Hill of Edinburgh, and there strangled and consumed by flames.

The cashielaws (whose variants included the caschielawis and caspilawis), was said to be derived from the old French, *casse-loix*. It was a horrifying version of the boots. The leg was placed in an iron frame that had a screw attachment. During interrogation the iron-bound leg was inserted in a portable furnace heated to increase the agony. An inventory at Finlarig Castle, Perthshire, in 1603 lists not one, but four 'glaslawis' with chains and shackles attached.

In 1596 John, Master of Orkney, was put on trial for attempting to murder his brother, the Earl of Orkney, first by witchcraft and then by poison. The crimes were said to have taken place two years earlier and the charges of sorcery hinged on evidence given by a supposed witch Alison Balfour, who was executed on 16 December 1594. But not before she and members of her family were tortured by the cashielaws, boots and thumbikins.

The defence proved that Alison had been forced to make a false confession after she suffered the ordeal of the cashielaws for two days, when she was 'sindrie tymes taken out of them deid [faint], and out of all remembrance either of guid or evil'. At the same time her husband, aged ninety-one, was placed in the stocks and had iron bars, weighing fifty stones, piled on his bare legs. The couple's son was stuck in the boots and given fifty-seven 'strokes', while their daughter suffered by the pilniewinkies. All this took place in front of Alison Balfour so that they, 'being sae tormented beside her, might move her to make any confession for their relief'.

A second accused, Thomas Papley, was also brutally tortured until he confessed involvement in the poison plot. He was kept in the cashielaws for eleven days and eleven nights, during which time he was twice daily 'driven' in the boots. He was stripped naked and scourged with ropes, so that there was hardly an inch of whole flesh or skin left on his body.

Both accused revoked their confessions, and Balfour was said to have continually protested her innocence when she was led to her death on the Heading Hill at Kirkwall. On 24 June 1596 the case against the Master of Orkney collapsed, but the verdict came too late for Alison Balfour and her associates.

Judicial torture was not formerly abolished in Scotland until 1708, almost a quarter of a century after the death of 'Bloody Tam' Dalyell.

4

Heads and Bloody Tales

The grim, gallows-shaped frame, ten feet high and charged with a cruel blade of iron and steel, should belong in a chamber of horrors. Instead it occupies centre stage in the Medieval Room in Edinburgh's Museum of Antiquities. For 150 years 'the Maiden', a forerunner of the French guillotine, tasted human blood on the streets of Old Edinburgh.

Before the death machine made its debut in the second half of the sixteenth century Scottish criminals were decapitated by a heading sword – not unlike the specimens exhibited in the Tower of London. Scottish executioners had long favoured this weapon, although an axe was used in St Andrews and by the lairds of Glenorchy in Perthshire.

Edinburgh archives for 1552 record that it cost ten shillings to sharpen the 'commone Sweird' after an execution. The weapon was still in use nine years later when Wood, the minister of Cousland, was beheaded by the public executioner, Andrew Finnie, after he was caught in bed with a man. Finnie, who also performed hangings, scourgings and other tortures, was probably kept in a state of inebriation, for the perks of his bloody work included free ale.

In 1563 Treasurer Robert Glen was instructed by the town council to offer William McCartney the sum of £5 for his two-handed sword to be used as 'ane heiding Sword, because the auld Sword is failzet [broken]'. In the same year two men were condemned to be beheaded 'with ane' sword', perhaps the newly purchased weapon.

An old German print shows a decapitation from 1591 in progress. The victim is kneeling, his shirt unbuttoned, his hands

65

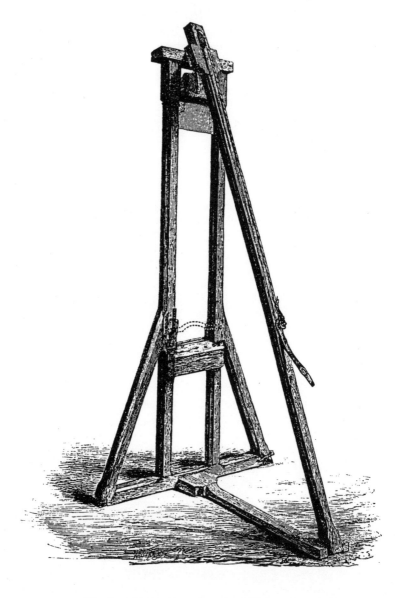

The Scottish Maiden, the beheading machine which
pre-dated the French guillotine

bound, and his face turned away from the headsman, on this occasion Master Franz Schmidt, the Nuremberg executioner, who has a firm, two-handed grip of the hilt. A thief, Hans Froschel, who was executed in 1591, chose beheading rather than hanging. But beheading by sword or axe proved bloody and horrific when left to an inexperienced headsman, so the provost, bailies and councillors of Edinburgh decided it was time for a change. They had their eyes on a novel method of execution, and some time between the feasts of St Michael 1564 and 1565 the Maiden was built. The work was carried out by local tradesmen. Mungo Hunter supplied the iron, Andro Gottersoun put the finishing touches to the blade in his smithy while the woodwork was completed in the workshop of Patrick Shanks.

The Maiden is made of oak and at first glance resembles an artist's easel. It consists of a single 5-foot-long horizontal beam into which are fixed two upright posts 10 feet in height, each 4 inches broad and 3½ inches thick, with bevelled corners. The upright posts are braced on either side, and the tops are fixed into a cross rail 2 feet in length. The block is a traverse bar, more than 3 feet from the bottom, 8 inches wide and 4½ in thickness. Copper-lined grooves on the inner faces of the uprights were kept greased or soaped to ensure the smooth descent of the axe, which consists of a plate of iron faced with steel. Measuring 13 inches long by 10½ inches broad, the axe was sharpened at its edge and weighted at the top with a 75-pound block of lead.

After the condemned person positioned his throat on the block an iron bar was lowered on to the back of the neck, so that he was unable to withdraw his head. When the lockman was given the fatal signal he pressed a lever to release the axe, which delivered a chopping blow – less efficient than the clean cut of the French guillotine's triangular-shaped blade. After the Maiden had dispatched its victim the severed head was caught in a buckram sack and exhibited in a public place. The floor of the scaffold would resemble a slaughterhouse and the pools of blood had to be soaked up. In 1583 'twa poks of bran' were spread around the machine after an execution.

The beheading machine was not a Scottish invention, having been in use many years before in other parts of Europe. Early sixteenth-century pictures by German and Italian artists portrayed similar machines. One example can be seen in a woodcut, published in Wittenberg in 1539, by the eminent German artist Lucas Cranach.

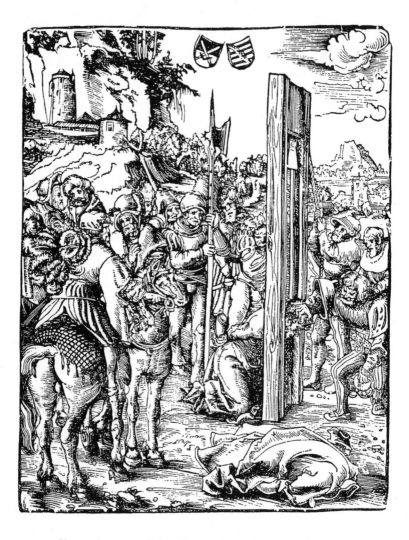

Sixteenth-century beheading machine as portrayed by the
German artist Lucas Cranach in 1539

The Italians dubbed their machine *Mannaia*, 'the great knife', which featured a hatchet loaded with a 100-pound weight.

In 1844, four years after Charles Dickens was a disgusted eyewitness at the Newgate hanging of François Courvoisier, who murdered his master Lord William Russell, the author attended a beheading in Rome and described it as 'an ugly, filthy, careless, sickening spectacle', as lottery speculators silently counted the gouts of blood that spouted from the stunted corpse. If Italians picked lottery numbers on the strength of blood spurting from the neck of a decapitated criminal, it is probable people who attended public executions in this country gambled on how often a body twitched at the end of a rope!

Decapitating engines were used in France before the guillotine. Marshal de Montmorency was beheaded by one at Toulouse in 1632. Holinshed's *Chronicles of Ireland* carries a woodcut of a beheading machine and notes: 'In the Yeere 1307, the first of April, Murcod Ballagh was beheaded near to Merton by Sir David Caunton, Knight.' Muriad Ballaigh was an Irish rebel.

Sixteenth-century Scots would only have had to travel as far as England to see a primitive guillotine in action. The Halifax gibbet – which inspired a Yorkshire beggar's prayer, 'From Hull, Hell and Halifax, Good Lord deliver us' – was, according to the 'Water Poet', English pamphleteer and Thames waterman, John Taylor (1580–1653), a machine that sent 'thieves all headless into heaven and hell'.

In Tudor times Halifax was famed for its cloth manufacturing industry, and any person caught stealing goods worth 13 pence-halfpenny or more within the bounds of the manor of Wakefield was shown scant mercy by the burghers. The gibbet stood on Gibbet Hill until it was dismantled after the last execution in April 1650 (a replica can still be seen in the town). Forty-nine persons of both sexes were executed in the sixteenth century, the first occasion probably taking place in March 1541.

The executions, which took place on market days, had a bizarre touch. Since no official executioner was present to undertake the task, spectators were encouraged to pull, touch or reach out for the rope which released the axe. In cases where the criminal had stolen a farmyard animal the beast in question was tethered to the end of the operating rope. When the animal was led away a pin was drawn back, releasing the axe. This is borne out by a curious print of an execution showing a horse being driven off by a man with a whip.

A touch of mystery encircles the origins of the Scottish Maiden. James Douglas, Earl of Morton, is credited with having brought a 'patterne' (sketch or model) of the Halifax Gibbet to Scotland after seeing it in operation during his travels. The future Regent was in England three times – in 1547, when he was carried off as a prisoner; in 1560, when he went on a mission to the Elizabethan court; and in 1566, when, following the murder of David Riccio, the favourite of Mary, Queen of Scots, he spent a year lurking around Newcastle and Alnwick. It is unlikely he obtained plans of the Halifax Gibbet during his first stay in England and by his third visit the Maiden had already dealt with its first victim. If Morton really did obtain a 'patterne' it must have occurred during his visit in 1560. But why was it not produced in 1563 when the 'auld heiding sword' of Edinburgh was beyond repair? But the Morton connection cannot be discounted. Archibald Douglas of Kilspindie, a kinsman of Morton, was Provost of Edinburgh around the time the Maiden was mooted, and it is possible Morton described the machine to him.

The two machines are not alike, however. In Halifax the condemned lay full length and face downwards on top of the platform, while the Maiden's victims knelt. The Halifax Gibbet, according to a woodcut in 1650, was five feet higher than the Maiden. It was also a permanent fixture, erected on a stone platform with steps, whereas the Maiden was portable: executions would take place at the Cross of Edinburgh, the Castle Hill, Grassmarket, Girth Cross, and, on occasions, the machine was hired by neighbouring towns, such as Leith. In 1591 it cost 30 shillings to transport the Maiden to Leith 'and hame again'.

Who or what inspired the name of the contraption, which through the ages was also known as the Madin, the Maydin and the Widow? The Edinburgh city treasurer's accounts in 1608 actually referred to the machine as 'her'. The true meaning seems lost in history. Dr Charles Rogers, writing in 1884, suggested the appellation came from the Gaelic, 'Mod-dun' originally signifying the place where justice was administered. Other theories abound. It was said to have been given the name because of the time gap in 'blooding' the contraption, or else it referred to its 'unfleshed and maiden axe'.

Was there a link between the Scottish Maiden and the Iron Maiden of Nuremberg? The machines served the same purpose, but there the similarity ends. The Iron Maiden, also known as the Virgin Mary, resembled an Egyptian mummy case, except that the interior was lined with eight-inch-long spikes.

The Iron Maiden was probably the most infamous of Europe's

spiked torture implements, but doubts have been cast on its hideous reputation. Perhaps there was a religious significance behind the naming of the Maiden in Scotland, for an effigy called the Maiden was introduced into festive processions in pre-Reformation Scotland. Perhaps it was a macabre joke – a back-handed compliment to Mary, Queen of Scots. Or there might be a simpler explanation – that the machine was regarded as female by its makers, the craftsmen, in the same affectionate way that mariners regard ships.

Mary Stuart became unwittingly enmeshed in the affairs of the Maiden after her 'most special servant', David Riccio, was savagely murdered in Holyrood Palace, Edinburgh, on the evening of Saturday 9 March 1566. The pregnant Queen was dining in her private apartments with Riccio, her Italian secretary and musician, and others when the assassins struck with great ferocity. As night fell the Earl of Morton, Lord Lindsay and their fellow plotters slipped into the palace courtyard and barred the gates. The Queen's husband, Henry Lord Darnley, led the assassins to her chambers and watched another conspirator, Lord Ruthven, and his gang drag the screaming Riccio to his doom. His body was hacked to pieces and then stripped of its belongings. Mary fled to Dunbar with Darnley, but would return within days to avenge Riccio's murder and prevent a Protestant plot to seize her throne.

Two of the murderers were Ruthven's retainers: Tom Scott, under-sheriff of Perth, and Henry Yair, who slew a Dominican priest, Father Adam Black, during the raid. Justice swiftly caught up with both men. On 3 April 1566 Scott became the first person to 'blood' the Maiden's steel.

The following expenses were noted by the City Treasurer:

Item: To the pynouris for the bering of dailles and pouncheoins fra the Blackfreiers to the Croce with the gibbett and Madin to mak ane scaffald, and awayiting thairon the day quehn Thome Scot was justefeitt: 7 shillings

The 'pynouris', like their brethren in Aberdeen and Perth, were labourers or porters hired to transport the Maiden and a gibbet, as well as planks and tools, to and from Blackfriars to the market cross in High Street. Blacksmith Andrew Gottersoun, who made the axe, was paid to sharpen its blade and carpenters were responsible for erecting and dismantling the scaffold. Thus:

Item:	To ane wrycht for making of the	
	Scaffald and dountaking thairof agane,	8 shillings
	For nailes thairto,	2 sh. 8 pence
	For tymmar to hald the gibbett	
	fast,	3 shillings
	To Andro Gottersoun, smyth, for	
	grynding of the Madin,	5 shillings

So Tom Scott, who had also been charged with the serious crime of 'warding the Queen within Holyrood', met his fate. He may have been hanged from the gibbet and taken down while still alive and beheaded. Afterwards his body was quartered with an axe and exhibited. On 10 August 1566 Yair was also hanged, beheaded and dismembered. But the Queen spared the lives of two lesser players, Mowbray and Harlaw.

Early historians believed Morton was his own executioner. An eighteenth-century Scottish proverb ran: 'He that invented the Maiden, first hanselled it.' The legend that Morton was first to die under the Maiden's blade was perhaps enhanced by a popular English tale, 'The Pinder of Wakefield', published in London in 1632, which told of a friar: 'very ingenious, he invented an Engin, which by the pulling out of a pin, would fall and so cut off the neck, this device kept them in awe a great while till at last this Fryer had committed a notorious fact, and for the same was the first that hanselled the new Engin his owne invention'.

Morton, a tough and unpopular Regent since 1572, was eventually executed for his involvement in the murders of Riccio and Darnley, who perished in the blasted ruins of Kirk o' Field in Edinburgh in February 1567. It came about when a favourite of King James VI openly accused the Regent of having been concerned in the murder of the boy king's father. Morton was not given a fair trial. He had enemies on the jury and his servants were tortured to give damning evidence. It was therefore no surprise when he was found guilty of having been 'airt and pairt' in Darnley's murder. The former Regent was sentenced to hang, but it was only by the caprice of the king that Morton fell under the stroke of the Maiden on 2 June 1581, the day of his trial. His death did not trouble the king's conscience, for a few days later as His Majesty left Dalkeith Kirk he was preceded by two pipers.

The Maiden that looms over visitors to Edinburgh's Museum of Antiquities is not the original structure. In the centuries following Tom Scott's execution the machine was kept in regular repair, with

old parts being replaced. In 1660 a new axe was provided and Alexander Davidson was ordered to maintain the Maiden 'all the dayis of his life', which suggests he was the executioner. In the last century the curator of the museum gave part of the original wooden stay at the back of the machine to a Major Wemyss, but it was returned 'very much decayed' in 1926, by a Mrs Lyon of North Berwick. High-born Scots who were 'justefeitt' included Sir John Gordon of Haddo, a Civil War cavalier who was imprisoned in a corner of St Giles Cathedral known as Haddo's Hole, and the Earl of Argyle, who, on placing his neck on the block in 1685, said it was 'a sweet Maiden, whose embrace would waft his soul into heaven', although sources claimed his last words referred to the death machine as the 'sweetest maiden he had ever kissed'. The family was clearly fated, for the Earl's father, the Marquis of Argyle, had been beheaded by the Maiden a quarter of a century earlier on the orders of a vengeful Charles II.

On 21 May 1613, five years after Lord John Maxwell of Caerlaverock slew the Laird of Johnstone in a long-standing feud, he was tricked into returning to Scotland. There he was seized and promptly beheaded at the Cross of Edinburgh, 'suffering his eyes to be covered with ane hankerchief' before the axe fell.

A terrible scandal rocked seventeenth-century Edinburgh society when the elderly Lord Forrester was murdered by his mistress. When word reached Christian Hamilton, the fiery-tempered wife of a wealthy city merchant, that her paramour had slandered her she hurried to his seat at Corstorphine Castle to confront him. They met in the garden where she stabbed him with his own sword. She hid in a garret but was discovered when one of her slippers dropped through a crack in the floor. Condemned to death, she managed to escape from the Edinburgh Tolbooth disguised in men's clothes only to be recaptured the next day. She wore mourning dress on the scaffold and showed great courage as she removed her long veil and bared her neck for the headsman.

Another Edinburgh *femme fatale* beheaded by the Maiden was the young and beautiful Jean Livingstone of Dunipace, who was implicated in the murder of her wealthy husband, the Laird of Warriston, on 1 July 1600. Love turned sour because of the laird's alleged ill-treatment of his wife, who later confessed 'deadly rancour, hatred and malice' towards him. Lady Jean induced Robert Weir, her father's former servant, to commit the crime, and it is likely the young groom was fatally attracted to her. On the night of the murder Weir was smuggled into the Warriston home

and hidden in a cellar. At midnight Lady Jean led him to her chamber where the laird was asleep. Weir attacked the laird with his bare hands, and, after giving him a severe beating, strangled him. Weir fled, despite Lady Jean's pleas to take her with him. She was taken 'red-hand' – arrested at the scene of the crime – along with her servants, including her nurse Janet Murdo, who had brought Weir to the house. At the subsequent trial Murdo claimed her mistress had wanted the laird murdered and had waited in the hall while her husband struggled for his life in the bedroom.

Because of her high rank, and the powerful influence of her father and friends, the judges decided she should be decapitated by the Maiden, rather than strangled and burned at the stake. They also agreed to a request by the family that the execution be as private as possible, probably to avoid further disgrace rather than to protect the feelings of Lady Jean. With indecent haste, the lady's father urged magistrates to hold the execution at nine-thirty on the evening of Friday 4 July. But they set the time for around sunrise on the Saturday.

The scaffold was erected at the foot of the Canongate, near Girth Cross, the ancient boundary of the Abbey Sanctuary at Holyrood. It was said that Lady Jean, who was only twenty-one, behaved as cheerfully 'as if she had been going to her wedding, and not her death'. She proclaimed her guilt in plotting her husband's 'cruel murder', but added that she had not laid a hand on him herself. She repeated her confession at the four corners of the scaffold. Her conduct appeared heroic. When the moment came to blindfold her she coolly handed a fastening pin to a friend. She then offered her neck to the axe, laying it 'sweetly and graciously' on the block. 'When her head was now made fast to the Maiden, the executioner came behind her, and pulled out her feet, that her neck might be stretched out longer, and so made more meet for the stroke of the axe.'

But the bloody ritual lingered on agonizingly. When the lockman pulled the lever the axehead dropped only a few inches. A friend held her hand as she repeated her devotions in a loud, clear voice: 'Into thy hands, Lord, I commend my soul'; but her prayers were cut short by the axe. Lady Jean's father was reported to be indifferent to her fate and even failed to visit her in the death cell.

At 4 a.m.on 5 July 1600, the same hour as Lady Jean's execution, her erstwhile nurse, Janet Murdo, and another woman servant, were strangled at the stake and burned on Castle Hill. It

was hoped that early risers would flock instead to the burning and so lessen the disgrace of the House of Dunipace.

When justice caught up with Weir four years later, the young groom's punishment was equally cruel and brutal. He confessed to Warriston's murder and was sentenced to be broken on the row (wheel) at the Cross of Edinburgh on 16 June 1604. Robert Birrel records in his diary: 'Robert Weir broken on ane-cart wheel, with ane coulter of ane pleuch, in the hand of the hangman, for murdering the Laird of Warriston.' The barbaric punishment, which was unknown in England but common on the Continent, had been inflicted on a previous occasion in Scotland. John Dickson, who murdered his father, John senior, of Ballchister, was executed at the market cross of Edinburgh on 30 April 1591.

In Germany the criminal was bound to a cartwheel and his limbs smashed to a pulp with a sharp-edged iron bar. Forty was the regulation number of strokes, with the fatal blow being delivered above the heart or on the nape of the neck.

Miscreants convicted of murder, theft, treason, forgery or incest were killed by the 'merciless Maiden'. Records do not always give the names of the criminals or their crimes. In Edinburgh in 1680 the 'butcher's bill' itemizes a charge for 'heiding four men and five men'.

At St Leonard's Hill, where witches once cast spells and duellists settled grievances, Robert Auchmutie, a barber surgeon, slew James Wauchope, a gentleman, in a duel in 1600. Auchmutie was arrested and thrown in Edinburgh Tolbooth. His elaborate escape plan failed and his fate was secured by the Maiden. John Brand, a son of the manse and a student of philosophy, also killed his opponent in a duel at the same place, and was beheaded in 1615.

In 1601 James Wood and others broke into his father's house at Bonnington, Forfarshire, and stole some legal papers belonging to Lady Usan. Wood was beheaded at the Edinburgh Cross at six in the morning, 'ever looking for pardon to the last gasp' – which might have come if he had not been a staunch Catholic who had attended a secret mass and harboured a priest.

In January 1605 Laurence Mann, a boy of sixteen, killed professional gambler James Young, in a quarrel over a game of dice, in St Giles Cathedral. Despite his tender years Mann was executed on the Castle Hill.

According to the 'Newgate Calendar' the last person to be beheaded by the Scottish Maiden was a gentleman, John

Hamilton, who was related to the Dukes of Hamilton. Young Hamilton dashed his parents' hopes of his becoming a lawyer by dropping out of his studies in Glasgow. He seemed destined for a military career, but abandoned the idea in favour of a life of drinking and gambling with feckless friends. After several days and nights of debauchery Hamilton quarrelled with the landlord of a tavern and ran him through with his sword. During the brawl the landlord's blind daughter managed to tear off part of the killer's coat. Hamilton also left behind the murder weapon. These blatant clues eventually brought Hamilton to justice. After the murder he fled to Holland where he stayed for two years, only returning to Scotland when his parents died. At the trial his plea of being drunk at the time of the crime, and appeals for clemency, failed to save his skin: John Hamilton, Esquire, was beheaded on 30 June 1716.

After the last execution the Edinburgh Maiden was stored out of sight in the vaults of Parliament House, but, after an unsuccessful application in 1781, Edinburgh Town Council relented and donated the machine to the Museum of Antiquities in January 1797.

In his brief history of the Maiden the keeper of the museum William McCulloch (1815–1869) states his belief that the Edinburgh machine was the only one of its kind in Scotland. He was mistaken. A primitive guillotine, also known as the Maiden, was introduced in Aberdeen near the end of the sixteenth century and it is almost certain the design was based on the Edinburgh Maiden. It was perhaps no coincidence that James VI, a frequent visitor to the city by the grey North Sea, was in the burgh around the time of a double execution.

A loyal servant of 'Jamie the Saxth', George Keith, Fifth Earl Marischal, supporter of the reformed kirk and founder of Aberdeen's Marischal College, might have influenced the introduction of the Maiden to Aberdeen. After all the machine was stored for safekeeping in the walled passage of his home in the Castlegate.

There is mention of the Maiden in the Aberdeen treasurer's accounts for 1594/95 when George Annand was hired to transport the machine to the Heading Hill and back again to the Earl Marischal's house. He was also paid for carrying out repairs and maintenance, which included sharpening the blade of the axe and soaping the suspension rope.

The particular item reads: 'For ane garrone [a spike] to the madin, mending of her by George Annand, wright, scharping the

aix, for saip to the tow, kareing of hir to the hill, and hame agane, to my Lord Merschells cloiss – 25 shillings.' (Note that the machine is referred to as female – more than a decade before a similar reference to its gender in the Edinburgh records.)

Aberdeen, in common with other Scottish towns, favoured the 'heiding sword' until it adopted the Maiden. More than twenty years before the machine was carted out of the Earl Marischal's close John Ewen, burgess, was convicted of coining in 1574 and was half hanged then 'heidit' with a sword.

There was an old tradition that Mary, Queen of Scots, was present at Sir John Gordon's execution by the Maiden in Aberdeen after the Battle of Corrichie in 1562. The combatants were on one side the supporters of the Queen, and on the other Sir John's father, the proud and powerful Earl of Huntly, whose army was routed after an hour-long slaughter that turned the Corrichie Burn red with blood. The defeated Huntly surrendered but as he was led away the 'Cock o' the North' suffered heart failure and dropped 'starke dedde' from his horse. His corpulent body did not escape justice. It was embalmed by an Aberdeen surgeon with 'vinegar, aqua vitae, powders, odours and other necessities', dressed in sackcloth and shipped to Edinburgh. It was stood upright in its coffin during the Privy Council hearing and declared guilty of treason. The Huntly lands were seized. Legend has it that before the battle Lady Huntly's soothsayers had foretold that by nightfall the Earl of Huntly would be in Aberdeen and she therefore spurred on her husband to face the Queen's army believing no harm would befall him.

A distraught Queen was compelled to watch Sir John's execution, which was clumsily performed with a sword. She was led from the nightmarish scene as the young Gordon was executed 'by a butcherlie fellow, that strooke his head off with many blowes'. Hanging as an ultimate punishment was reserved for the lower orders. While Sir John was honourably butchered five of his men were hanged.

The Maiden was last used in Aberdeen in 1615 when Francis Hay was beheaded for the murder of Adam Gordon, brother of the Laird of Gight.

The wooden frame of the Aberdeen Maiden no longer exists but the crude chopping axe can be seen in the city's Tolbooth Museum, which opened in April 1995.

Dark legends are associated with seventeenth-century Finlarig Castle, near the head of Loch Tay, in Perthshire. Sir Duncan

Campbell of Glenorchy – 'Black Duncan of the Cowl' – was supposed to have beheaded gentry in a 'heading pit' while commoners were hanged on a nearby oak. A local woman told me how as a child she played around the ruined castle and its square-shaped pit, complete with chains and a block. A modern guidebook claims the Maiden was used at Finlarig. But one historian doubted the pit's function was so macabre, claiming it was an ancient water-storage tank. A hollow, said to be the sunken cavity in which a victim placed his neck, was actually the overflow!

An inventory of the Laird of Glenorchy's possessions at Balloch Castle, near Aberfeldy, in 1605 does however list 'i heading axe' and 'ane tua handit sword gilt with gold'. Balloch was pulled down and replaced by Taymouth Castle in 1801 and when its contents were sold in 1922 items included a silver-bladed execution axe made in Brescia, Italy, and a German executioner's sword, probably the same weapons itemized above.

When heads rolled in Scotland they were exhibited on the highest public place to terrify onlookers and deter them from crime. Tolbooth pinnacles and ports (gates) throughout the country were garnished with the heads and limbs of criminals executed by the axe or rope. Before heads and quarters were spiked they were specially treated to withstand the rigours of the weather, the ravages of hungry birds and decomposition. The method involved parboiling the body parts in baysalt and cuminseed.

In November 1551 Thomas Littlejohn who robbed and murdered a Frenchman carrying hundreds of pounds to pay the garrison at Leuchars in Fife, was sentenced 'to be hangit and his head chopt off' and exhibited on one of the gates in Cupar.

In 1538 the Master of Forbes was found guilty of treason. He was accused of plotting to assassinate James V and of being the ring-leader of a mutiny of Scottish forces at Jedburgh. He was hanged on Castle Hill, Edinburgh, and while still alive was beheaded and quartered, and his limbs exposed on the city gates.

In 1541 James Hamilton, bastard son of the Earl of Arran, had murder on his mind when he was caught breaking into the king's chamber. He was beheaded at the capital's market cross.

A border rogue, Adam Scott of Tuschelaw, who was known as 'the King of the Thieves', lost his head in Edinburgh in May 1529, and had it exhibited on the tolbooth.

In Dundee George Caball, whose crime was smuggling fake pennies from Flanders, was led to the gallows, hanged, then

beheaded. His head was spiked on the east gable of the tolbooth and his quarters were suspended in chains from the main gates.

An early form of industrial sabotage was ruthlessly punished in 1615. Having packed air vents with straw, coalminer John Henry set fire to the mine at Little Fawside in Lothian because he bore a grudge against his new employer.

He was hanged at the market cross in Edinburgh and his head stuck on a pole on a hill at the colliery.

On 8 July 1662 Sir Archibald Johnston of Warriston was hanged for treason and had his head cut off and stuck on the Netherbow Port.

Official executioners usually had the grim task of treating and exhibiting mangled heads and limbs, and were rewarded accordingly. The Edinburgh City Treasurer's Accounts carry the following macabre entries:

For ane barrell to salt the quarteris with salt thereto,	12 sh. 8d
Payit the maissoun for making the hoillis to the preikis (iron stakes) upon the heid of the Tolbuith,	£4. 9s 4d
Payit to the lokman for the executing and putting up of the heidis and quarteris and towis (rope) thairto,	£1 1s 4d

In 1636 a famed freebooter Gilderoy – real name Patrick McGregor – and nine of his band were captured after terrorizing the Highlands for three years. They were eventually hanged at Edinburgh Cross. Because of their notoriety Gilderoy and his lieutenant John Forbes were hanged on a higher gibbet than their comrades. Their heads and right hands were struck off and exhibited on city gates throughout Scotland.

Famous soldiers and politicians who were spiked after execution included Sir William Wallace, whose limbs were scattered throughout the land: his was also the first head to be exposed on London Bridge.

The same fate awaited the Royalist military leader James Graham, Fifth Earl and First Marquis of Montrose, after being half-hanged on a lofty gibbet in Edinburgh in May 1650. His head was stuck on the tolbooth, while the rest of his dismembered body was dispersed – to Stirling, Perth and Aberdeen. His arm remained a curious relic on a pinnacle of Aberdeen Tolbooth for

many years before being returned to his family after the Restoration in a coffin draped with crimson velvet.

Richard Rumbold, a Hertfordshire gentleman who held a colonel's commission in the Earl of Argyle's army, suffered greatly on the scaffold after his master had 'kissed the Sweet Maiden' in 1685. His fate was to be hanged, drawn and quartered, but after he was cut down half dead his heart was torn from his chest, then exhibited 'dripping and reeking' on the point of a plug-bayonet while the executioner announced: 'Behold the heart of Richard Rumbold, a bloody English traitor and murderer!' His head was exposed on the West Port before being sent to London, and his quarters sent to the main Scottish centres.

There is a curious story concerning the head of Reverend James Guthrie – 'Guthrie the Puritan' – who was executed days after the Marquis of Argyle was beheaded by the Edinburgh Maiden for supposed treason in 1661. Some time after the head was fixed to the Netherbow Port, the King's Commissioner, General Middleton, who had been excommunicated by Guthrie, passed through the gate in his coach. Blood from the head dripped on to the roof of the vehicle, staining the leather. Doctors were consulted but could give no explanation as to why the stains could not be removed. The roof was replaced.

The Earl of Morton's head gave no such trouble during the eighteen months it remained on its pike, after its owner was executed by the Maiden in 1581. Because the king's new councillors felt Morton had been harshly dealt with in life the former Regent's head was wrapped in fine cloth and carried by a sobbing Laird of Carmichael to rejoin the rest of his body in its grave.

The axe, although not popular in Scotland as a method of executing criminals, was wielded in the town of St Andrews, where it can be seen in the Museum at Kinburn House. The burgh treasurer's accounts give precise details of the cost of an execution in 1622. Six shillings were paid to John Cromme for sharpening the axe to 'heed the man that slew Johnne Jak', and various payments were made to the headsman and others for providing the dead man's coffin and materials for erecting the scaffold.

The last person to be officially sentenced to execution by the axe in Britain was a Scotsman. Simon, Lord Lovat, had his head cut off at Tower Hill in London on 9 April 1747 for his role in the Forty-Five Uprising. It was said his jailer gave him lessons on how to position his neck on the block, which had been specially made for the corpulent octogenarian.

But Lord Lovat was not the last man to be *beheaded* by the axe in the British Isles. That unwanted distinction belonged to another Scot – and it took place as recently as the last century.

But first, in December 1793, a cockpit in Edinburgh's Grassmarket was raided and a number of republican sympathizers arrested. A wine merchant, Robert Watt, and David Downie, a goldsmith, continued to play a dangerous game and became part of a nationwide plot to overthrow the government. In Dundee a mob led by another Downie, a local shoemaker, danced around a bonfire and the 'tree of liberty' in High Street. The mob broke up and the tree was thrown in the 'thief's hole'.

In Edinburgh there was a more tragic turn of events when a political society calling itself the Friends of the People planned an attack on the castle and the arrest of judges and magistrates. Two blacksmiths were employed to make four thousand pikes, but the plot was uncovered and the ring-leaders jailed. Watt and Downie were implicated and found guilty of treason and sentenced to be hanged, drawn and quartered – in reality the victim was first 'drawn' to the scaffold in a hurdle, hanged on a gibbet, then, after half an hour, taken down and quartered – butchered alive.

When Downie's punishment was commuted to transportation, he was said to have sunk to his knees in his cell and sobbed: 'Glory be to God!, and thanks to the king! Thanks to him for his goodness! I will pray for him as long as I live!'

There was no respite for Watt, however, and on 15 October 1794 his hurdle, black-painted and pulled by a snow-white horse, was escorted by a phalanx of magistrates, the city guard and town officers, carrying halberds, from the castle to the tolbooth. The sheriff and his deputies were dressed in black, wore white gloves and carried rods. Two hundred men of the Argyle Fencible Highlanders stepping out to the strains of the 'Dead March' added to the solemnity of the occasion. Amid the pomp and pageantry Watt approached the scaffold wrapped in an old greatcoat and red nightcap. On mounting the platform, he exchanged his garb for a white coat and round hat.

Watt hung on the gibbet for the regulation thirty minutes. After he was cut down and laid on a table, the executioner separated the head from the body with two strokes of his axe. He brandished the head aloft, proclaiming the age-old cry: 'This is the head of a traitor!' The quartering had been waived by order of the king. The spectators seemed totally unprepared for the sight of the axe. The event, according to a contemporary report, 'produced a shock

instantaneous as electricity; and when it [the axe] was uplifted such a general shriek or shout of horror burst forth as made the executioner delay his blow, while numbers rushed off in all directions to avoid the sight.'

The bizarre and sickening ritual of beheading a corpse did not end with the execution of Robert Watt. It happened on three more occasions in Scotland during the turbulent summer of 1820, when Britain was in the grip of strikes, riots and general unrest, brought about by unemployment, food shortages and the unpopular Corn Laws. The trouble spread to the radical handloom weavers in the west of Scotland. A new revolutionary government was formed in April and there was a call for a general strike. Disorder was threatened and in Glasgow troops were called out to guard strategic buildings and bridges. Four rioters were shot when the Port Glasgow Volunteers were attacked after escorting prisoners to Greenock Jail.

Forty radicals, led by Andrew Hardie, took to the road armed with guns and pikes. The plan was to join with comrades at Cathkin Braes in Glasgow. At Castlegary the group divided, with John Baird taking command of the second force. Their goal was the famous Carron Ironworks, the artillery and munitions factory at Falkirk. But the rag-tag army was intercepted by a detachment of 10th Hussars and Stirlingshire Yeomanry at Bonnybridge, and put to flight.

Another prominent reformer, James Wilson, who was sixty years old, set out with supporters for Cathkin Braes from the Lanarkshire village of Strathaven. They were poorly armed – Wilson waved a rusty old sword – but they marched under a banner bearing the motto: 'Scotland Free or Scotland a Desert'. But the group of weavers disbanded at Kilbride when it became obvious that Glasgow was quiet and the insurrection had failed.

Baird, Hardie and twenty of their accomplices were arrested and taken to Stirling, the county town closest to Bonnybridge, where they eventually faced charges of high treason at a Special Commission Court. Baird and Hardie were found guilty after trial, contrary to their claims of innocence, while the others changed their plea to guilty. Lord President Hope pronounced the ring-leaders' doom: 'The sentence of the law is that you and each of you be taken to the place of execution, there to be hanged by the neck until you are dead, and afterwards your head severed from your body and your body divided into four quarters, to be disposed of as His Majesty may direct. And may God in His

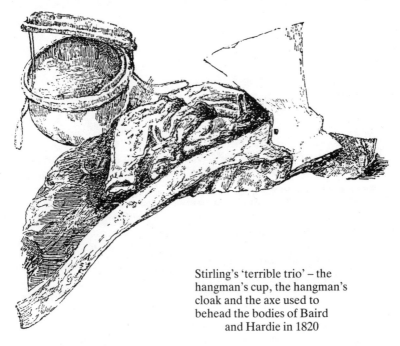

Stirling's 'terrible trio' – the
hangman's cup, the hangman's
cloak and the axe used to
behead the bodies of Baird
and Hardie in 1820

infinite goodness have mercy on your souls.' Eventually twenty men were spared – they were banished to the colonies – but there was no mercy for Baird and Hardie. They kept a date with the executioner on Friday 8 September 1820.

In Glasgow nine days earlier Wilson, described by the trial judge as 'a miserable and sinful creature', was executed in front of the Justiciary Court, at the foot of the Saltmarket. There was a strong military presence as a crowd of some twenty thousand watched the condemned man arrive at the scaffold, facing the green, in a hurdle drawn by a pony. He had a mysterious travelling companion, the sinister figure of the headsman, hooded and clutching an axe. Wilson wore an open-fronted shirt over his white moleskin prison garb and a pair of white gloves.

On the scaffold Wilson spoke to the hangman Tam Young. 'Did you ever see such a crowd?' he asked, viewing the sea of faces. 'Oh, aye,' replied Tam laconically.

There was a brief diversion as a large section of the crowd stampeded into the Molendinar Burn, fearing the dragoons were preparing to charge.

When the drop fell it was noted that Wilson's body 'convulsed with agitated jerks' and his ears began to bleed. His head was separated from his corpse with one blow of the axe. The cry of 'Behold the head of a traitor!' was greeted with hisses and shouts of 'Shame!' and 'Murder!' from angry and shocked spectators. Some of the soldiers fainted.

It had been arranged in advance that Wilson's body would be spared the final, barbaric act of quartering.

The old weaver's mutilated body was hustled into a pauper's grave in the burial ground of Glasgow Cathedral, but that night his daughter and niece exhumed the body and took it back to Strathaven. It was secretly buried in the parish graveyard, not far from his monument, which stands on the site of his birthplace in Castle Street. In Strathaven today local folk refer to 'Purlie' Wilson, a nickname he earned after having invented a special stocking frame in which the 'purl' stitch could be worked. A blood-speckled signal handerkchief exhibited at the town's John Hastie Museum is believed to be the actual one Wilson dropped at his execution, where handbills distributed by his supporters read: 'May the ghost of the murdered Wilson haunt the pillows of his relentless jurors – Murder! Murder! Murder!'

Sympathy lay also with Baird and Hardie when they were carted from Stirling Castle to the scaffold in Broad Street, directly in front of the tolbooth. A scaffolder, Robert Burns, was paid £5 to clear the path from the castle to Broad Street so that the pony-drawn hurdle would not be impeded by years of accumulated dirt and rubble. The 'hurley' had been specially modified to seat three passengers – the condemned pair and the headsman, dressed in the same attire he wore at Wilson's execution, although one account said he also wore a 'boy's hairy cap'. It also described the figure with the axe as 'a little man, apparently 18 years of age, rather delicately made and well-looking'.

On the scaffold Hardie addressed the spectators: 'My suffering countrymen! I remain under the firm conviction that I die a martyr in the cause of truth and justice, and in the hope that you will soon succeed in the cause which I took up arms to defend!' His speech was interrupted by the Sheriff of Stirling, Ranald MacDonald, who had elicited a promise that no political speeches would be made by the prisoners.

A brief scuffle at the edge of the crowd was instantly quelled by the military. Tam Young, the Glasgow hangman, stepped forward and adjusted the ropes and white stocking caps, while Baird and

Hardie prayed. The two friends clasped hands as the drop fell at eleven minutes past three. They died with barely a struggle. Baird's bible fell from his clenched left fist and was scooped from the cobbles by friends. It was noticed that some of the soldiers guarding the scaffold shed tears.

The crowd of two thousand, surprisingly meagre considering it was market day, melted away before the drop – 'fled towards the cross streets and closes,' according to a journalist.

As the bodies hung from the nooses the sheriff's officers clung to the legs while the executioner cut each body down. The headsman then strode on to the scaffold carrying his axe upon his shoulder. The bodies were placed on their coffins face down over a chopping block. Catcalls, hissing and horrified cries of 'Murder! Murder!' rang out as the headsman took three nervous blows to remove Hardie's head, and two of Baird's. He then lifted each head with his bloody hands and proclaimed: 'This is the head of a traitor!'

The heads were tossed into the black coffins, but, at least the bodies were spared the indignity of being quartered.

Baird and Hardie were buried behind a northern buttress of Holy Rude Church at the 'tap o' the toon', but in recent times were exhumed and reburied in Glasgow as martyrs.

The anonymous headsman was said to be a Glasgow medical student or surgeon named Thomas Moore, who years later was traced to Londonderry. Moore hurriedly quit Stirling but he abandoned his bizarre accoutrements: the all-in-one black and bloodstained cloak and hood, torn in places by the blade of the axe, and the axe itself – both of which in time joined the stocks, mantraps, shackles and William Burke's tanned skin in the town's Smith Art Gallery and Museum.

5

Devil's Brew

Scotland's great witch-hunts are grim episodes in the country's history, when the reek of tar barrels, coal, peat and fir-torches darkened the sky from the Borders to the Highlands.

The suffering of the poor wretches who perished in the name of superstition, ignorance and financial greed beggars belief. Records show that persecution took place during three periods covering the sixteenth and seventeenth centuries, with an estimated 4,500 convicted witches having been executed between 1590 and 1680, although the total might easily have been double.

The name of King James VI of Scotland and I of England has long been associated with the Scottish witch hunts. He had a deep-rooted fear of witchcraft and his bestselling tract of 1597, *Daemonologie*, coupled with an outbreak of pestilence, stirred up the persecutions in North-east Scotland, culminating in trials and executions in Aberdeen. The king and his advisers fervently believed in the biblical text: 'Thou shalt not suffer a witch to live.'

But it was in the reign of his mother, Mary, Queen of Scots, that witchcraft became legally punishable in Scotland. An act passed by the Protestant parliament on 4 June 1563 ruled:

> That nae person take upon hand to use ony manner of witchcrafts, sorcery, or necromancy, nor give themselves furth to have ony sic craft or knowledge thereof, there-through abusing the people ... nae person seek ony help, response or consolation at ony sic users or abusers of witchcrafts ... under the pain of death.

For centuries the belief in witches and warlocks had been widespread in Scotland, particularly in the remote regions. The witch cult had its roots in pagan times, when people worshipped

the gods of nature. Neither the saints nor the Reformation managed to stamp out the ancient ways, and although the Kirk remained the cornerstone of life in sixteenth-century Scotland the peasants still sought solace in the spirits of the forests, rivers and holy wells.

The witch cult survived early Christianity and its converts became feared, yet important, members of everyday life. There were rich pickings to be had for the unscrupulous witch, although payments were mostly made in kind. Witches could 'work weel as well as woe'. They would cure a sick child, heal cattle or ensure a good harvest on land and at sea. At Newburgh, Aberdeenshire, the fishers gave Helen Fraser a large piece of salmon as a bribe to ensure good fishing. It worked, for they caught a dozen fish at the first 'schote' (haul). Some witches traded in winds – to guide fishermen safely home to port or to winnow corn after harvest.

Written charms carried by a sick patient could cure toothache. At Elgin, Isobel Thomson, alias Preinak, was paid 6s 8d for treating Nicoll Watson's hands. Her remedy for curing a sick bairn was a mixture of honey, vinegar and butter. Aberdeen witch Bessie Thom, on learning a husband and wife were on bad terms, asked the wife, Isobel Irving: 'What will you give me if I rid you of your husband? Twenty merks?' Bessie finally settled for 40 shillings and a hunk of beef. When Isobel Strachan's request for meal for the miller at Caskieben, Aberdeenshire, was refused Scudder, her alias, caused both of the mill-wheels to break down.

The Kirk zealously hounded any person suspected of being a witch or believing in supernatural powers. Women were denounced from the pulpit and neighbours urged to give evidence against the accused, giving rise to a wry comment that 'Scotch witchcraft was but the result of Scotch Puritanism.' When the witch-hunts were at their peak, between 1590 and 1597, King James hit upon the idea of appointing, for a fee, Royal Commissions to deal with the problem without too much formality. In a single day fourteen commissions were granted. In addition a band of heartless and greedy men, called 'witch-prickers', 'jobbers' or 'brodders' – in 1670 they were also referred to as 'provers' – toured the country sniffing out suspected witches.

Suspected witches were shown little or no mercy, especially, as in the case of two Forres witches, 'Satan hardened them to deny' the charges against them. The accused person was dragged before the local kirk and evidence taken from parishioners. It was important to get a confession, whether the accused co-operated or

not. The first stage was to imprison the suspect in solitary confinement. Skilled inquisitors would rob the victim of sleep and search for the traditional 'witch mark', also known as the 'Devil's Mark' or 'Devil's Nip'.

The victim was stripped, shaved and then inspected from head to toe. Heaven help the poor suspect with a wart, mole or similar skin blemish. The pricker would pierce the offending spot with a long brass pin, sometimes specified as a 'lang preen of three inches' or 'a preen the length of one's finger'. If the victim felt no pain or the wound did not bleed, the test was ruled positive.

In January 1591 Agnes Sampson, the 'elder witche' of the North Berwick coven, showed amazing fortitude when grilled by King James VI and his nobles at Holyrood House. 'She stood stiffely in the deniall of all that was layde to her charge,' and the impatient monarch ordered her back to the tolbooth, 'there to receive such torture as hath beene lately provided for witches'.

Her hair was cropped and her head 'thrawen with a rope, beeing a paine most grievous, which she continued almost an hower, during which time she would not confess anything untill the Divel's marke was found upon her privates, then she immediately confessed whatsoever was demanded of her, justifying those persons aforesaid to be notorious witches'.

In Banffshire Andrew Mann, warlock of a coven, recanted the black arts and set to the task of finding the devil's mark on a former convert, Janet Leask, who had a talent for making wax effigies of intended victims. The test took place in the house of William Bain in Portsoy. Andrew affirmed that Janet had been a witch for thirty years and had the tell-tale mark under her left breast. It was visible with the naked eye.

A landowner from the North-east, the Laird of Esslemont, acted as a witch-pricker when Marjory Mutch stood trial. In the charge against her it was said that on being confronted by William May in a house in Portsoy he declared her a manifest witch 'in token whereof he showed her mark under her left lug in her crag, and a pin being inserted therein by the Laird of Esslemont, she could not feel the same'.

The common prickers were kept busy. When Tranent's John Kincaid was summoned by the authorities at Dalkeith to test a suspected witch, Janet Preston, he 'found two marks upon her, which he called the Devil's marks'. Janet felt no pain during the test, and when the three-inch pin was plunged into her flesh, no blood issued forth, and she pointed to the wrong spot. A pin

withdrawn from the body of another suspect, Janet Cock, left the spot bloodless as if the instrument had been thrust into 'whytt peaper'. James Scobie was hired to test an alleged witch from Musselburgh, who, 'being tryed in the shoulders, where there were several spots, some read, some blewish, after a needle was driven in with great force almost to the ege, she felt it not'.

In 1662 a freelance pricker called Paterson went to the kirk of Wardlaw at Kirkhill, near Inverness, to test fourteen women and one man, all members of the Clan MacLean. The sadistic Paterson was found to be a woman in disguise.

Not surprisingly the activities of Kincaid and other freelance prickers, such as David Cowan, who examined a respectable widow at Prestonpans, proved highly dubious, and many ended up behind bars for their pains. Sir Walter Scott believed the pricker tricked his victim and witnesses by using 'a pin, the point, or lower part of which was, on being pressed down, sheathed in the upper, which was hollow for that purpose, and that which appeared to enter the body did not pierce it at all'. (This contains an echo of the trick daggers used by actors in mock fights.) In 1678 the Scottish Privy Council took pity on a poor woman who had been harshly treated by a country magistrate and a pricker, and branded the pricker 'a common cheat'.

After pricking, the accused was forced to make a confession, which involved further ill-treatment, ranging from 'waking' – depriving the prisoner of rest – to starvation and scourging. In 1668 an English traveller enthused at the 'waking ordeal', describing it as 'the choicest means they use in Scotland for discoverie of witches'.

In 1618 Ayrshire witch Margaret Barclay was subject to so-called 'gentle torture' by her judges in order to force a confession. She was blamed for the loss of a ship carrying her brother-in-law and the Provost of Irvine. What started as a family feud became in others' eyes a sinister plot by local witches. Her fate was sealed when a piece of rowan and coloured thread (ironically, used in a spell to thwart witches) was found on her. She said it was to make a cow express milk. Lord Eglington ordered Barclay to be placed in the stocks and bars of iron to be piled on her bare legs.

The trapped woman's screams rang round the chamber and it was not long before she poured out a confession. She was subsequently strangled and burned at the stake. Before her execution she pleaded mercy for Isobel Crawford, whom she had

falsely implicated. But Crawford was also subjected to the 'gentle torture', which she endured 'admirably, without any kind of din or exclamation, suffer about thirty stone of iron to be laid on her legs, never shrinking thereat in any sort, but remaining as it were, steady'. But her courage finally broke. The agony proved unbearable when the bars were shifted to another part of her shins. 'Tak aff, tak aff!' she cried to her torturers.

In 1652 two Highland women told the Court of Session in Edinburgh of the cruel methods used to make them confess. They were hung up by their thumbs and whipped; lighted candles were placed in their mouths, under the soles of their feet, and between their toes. Four of their number had died of ill-treatment. Other women were stripped naked and forced to wear hair-shirts soaked in vinegar to 'fetch off' the skin.

If savage torture behind locked doors did not gain a confession there was another method by which a witch might be tested – the ancient ordeal of water. Before 'swimming' a witch she was stripped naked and bound in the shape of the holy cross – her right thumb tied to the left big toe, and the left thumb tied to the right big toe. Occasionally a blanket held at each corner was placed below the 'swimmer', probably to prevent the accused from drowning. To sink meant the woman was innocent (but she was frequently left to drown) and if she remained afloat she kept a date with the executioner. However, in Babylonian times if a witch was drowned while being tested the verdict was guilty. In North-east Scotland in the 17th century the Kirk frowned on the 'swimming of names', a method to unmask a thief. The names of suspects were written on slips of paper and dropped into water. If a name sank that person was the guilty party.

The practice of ducking witches had the whole-hearted approval of King James VI, who wrote favourably of 'the fleeting in the water'. 'It appears,' he said, 'that God hath appointed that the water shall refuse to receive them in her bosom that have shaken off them the sacred water of Baptism, and wilfully refused to benefit thereof.'

Scotland has many reminders of hell-pots, as they were called. A pool in the River Carron, near Dunnottar Church, Stonehaven, is known as the 'Witches' Pool'. 'Gaun's Pot' in the Isla is the spot where Keith witches were tested. 'Gaun's Stone' on the south bank of the river was the place from where they were tossed into the water. There is a traditional tale that a criminal, who was nailed by the ear to the gallows tree at Keith, was so anxious to see

a witch drown in the pot he tore away his head and raced to the scene.

In bygone Aberdeen witches and criminals were drowned in 'The Pottie', a deep pool in the harbour, where a sea-girt rock was named the 'Witch Hillock', an unhallowed place that was traditionally never covered by the tide. In Edinburgh the North Loch, drained in the last century, was where they tested witches and drowned criminals. At Stitchill in the Borders in 1661 barony court records showed that water-filled pits for soaking flax were full of drowned criminals.

In the ancient city of Elgin witches were swallowed by the waters of a deep, dark and reed-fringed pool east of the ruined cathedral, burned by the Wolf of Badenoch in 1390. The 'Order Pot' – the name is thought to be a corruption of 'Ordeal' – was used to test witches up to 1560. Earlier this century a headstone was erected to mark the grim spot, which in bygone days gave rise to a quaint prophecy linking the Pot, the River Lossie and Elgin Cathedral:

> The Order Pot and the Lossie gray
> Shall sweep the Chan'ry Kirk away

Hell-pot. Old print of 'The Order Pot' where Elgin witches were drowned

An old account describes the ordeal of a suspected witch, Marjory Bisset, as she was dragged through the dirt to the Elgin Order Pot, crying: 'Pity! Pity!' She presented a pathetic figure, with her grey hair hanging loose and the jeers of the crowd ringing in her ears.

Master Wiseman, a clerk, who had given evidence at her trial, spoke up for Bisset, describing her as 'peaceable and unoffendying'. She was a respectable widow, he said, who was not guilty of gossiping or spreading slander. He challenged the assembly: 'What else have you to say against her?' His remarks

angered the listeners, among whom were members of the clergy. Wiseman pressed for a reply. A friar repeated what had been alleged at Bisset's trial, that she had said her prayers backwards. Others reminded Wiseman that Bisset was responsible for infecting cattle.

Her pleas of innocence in court were cut short when a leper from the nearby hospice pushed his way forward with a dramatic accusation. Holding up his 'wythered' hand and arm he claimed that his deformity was due to an ointment administered by Bisset to cure swelling. As the mob clamoured for action Bisset screamed that God had forsaken her and that she had meant only good and not evil. Her claim that the ointment had been a gift from her husband, who had brought it home from abroad, was ignored. The mob yelled 'To trial! To trial!', as they dragged her to the pot and threw her in.

As the water engulfed her a great roar went up from the spectators, but when she rose again, there was silence. But when the doomed Marjorie Bisset 'went doune with ane bublinge noise' the final shout arose: 'To Satan's kingdom she hath gone!' (The Elgin ritual would appear to have been a different interpretation of the water ordeal, in that when Bisset sank the crowd gleefully believed her guilty.)

Suspected witches were sometimes lynched. At the beginning of the eighteenth century, when more enlightened authorities were reluctant to prosecute suspected witches, the small port of Pittenweem in the East Neuk of Fife was in the grip of witch hysteria. Beattie Laing, a tailor's wife, was placed in the stocks and then jailed after accusations that she had bewitched a young blacksmith, Patrick Morton. But soon she was freed by liberal-minded law lords and quit her native town.

Janet Cornfoot was not so lucky. A fisherman claimed that while asleep in bed he was tormented by Janet and two other witches, led by the Devil himself. Janet confessed under torture but later pleaded innocence. Her case attracted sympathy from persons of rank and education, and a local minister arranged her escape from the tolbooth. But Janet was recognized by a clergyman in a neighbouring parish and he ordered her back to Pittenweem in the custody of two men.

On 30 January 1705 Janet arrived home and was set upon by a raging mob, at whose hands she suffered a terrible, brutal ordeal lasting three hours. The wretched woman was trussed up and severely beaten, before being dragged by the heels to the shore. A

local bailie appeared on the scene and the crowd retreated. But when no attempt was made to rescue the injured woman the mob resumed its horrible work. Janet was tied to a rope stretching between a berthed vessel and the shore, and as they swung her to and fro they hurled stones at her. Eventually, tired of this bloodthirsty sport, they released the rope so that she landed heavily on the beach. More blows rained down on her. She was then covered with a heavy door, heaped with heavy stones. Finally a man drove his horse-drawn sledge over her mutilated corpse.

Thomas Brown, who also had the finger of suspicion pointed at him by Morton, died in prison 'after a great deal of hunger and hardship'. Both he and Janet Cornfoot were denied Christian burials. Morton was later exposed as a fraud – but Janet's killers were never brought to justice.

After the witch-prickers and cruel torturers had finished their grim work a catalogue of weird and bizarre confessions spilled from the convicted witches. North Berwick witch Agnes Sampson, hell-bent on destroying the king's homeward-bound ship from Denmark, tossed witch cats into the sea, then sailed forth with her confederates 'in ane boit lyke ane chimnay' (an uncanny precursor of a steamship), with the Devil acting as pilot. The witches slipped onboard a ship, *The Grace of God*, and, after drinking the crew's good wine and ale, departed, leaving the Devil to raise an 'evill wind', which capsized the ship.

Forfar and Paisley witches horrified courts with tales of cannibalism. Helen Guthrie described how she and her Forfar sisters dug up the body of an unbaptized bairn and used its feet, hands and flesh from the head and buttocks to bake a pie. The Devil himself gave the Balgarran coven a piece of unchristened child's liver to eat. In both cases it was a bid to prevent the witches from confessing their secrets, if caught. Gibbeted criminals proved a rich source of 'hackit flesh' for witches to work their magic. A gibbet at Aberdeen Links was visited by witches at midnight. Janet Wishart forced workman John Taylor's wife to accompany her to the scene and made the terrified woman hold the foot of a hanged criminal steady while she cut off 'pairt of all his members'.

Witches assumed the shape of hares to milk cattle, caused pestilence, shot elf-darts at humans and beasts, they committed murder – Janet Wishart bewitched two scholars into drowning themselves at Aberdeen beach – and they drove people mad. At Kintore in rural Aberdeenshire Thomas Small was tied hand and foot by neighbours after witches made him insane.

In an attempt to destroy an enemy the infamous Isobel Gowdie and her accomplices of the Auldearn coven concocted a charm consisting of entrails of toads, nail-parings, the liver of a hare and assorted rags. Magistrates and ministers were spellbound by the devilish antics. Witches, they heard, were carried aloft to their hellish meetings by sieves, straw horses or even broomsticks anointed with magic ointment. Colin Massie, the warlock of Glendye, rode to witch gatherings on a huge black boar. Other witches favoured cats, cockerels and bourtrie bushes to transport them there.

The witch meetings were wild. The warlock, representing the Devil, would assemble with twelve disciples – in all thirteen, the so-called 'Devil's dozen'. Sometimes 'Auld Nick' himself turned up. There was no shortage of new recruits to take the unholy oath or kiss the Devil's buttocks. Sexual intercourse played an important part at meetings, as did other, more bizarre, practices: Agnes Sampson told her inquisitors how the Devil, in the likeness of a man, had commanded at North Berwick kirk that 'they should kiss his erse, in a sign of duty to him; which being put over the pulpit bare, every one did as he had enjoyned them'. Isobel Gowdie claimed in her confession that the Devil would appear at these assemblies in various forms, such as a calf, bull, roe deer or huge black dog.

Dancing and feasting were other highlights of meetings. The Aberdeen coven jigged to music at the market cross and Fish Cross in the Castlegate, and while riding trees early on Rood Day at St Katherine's Hill, now present-day Adelphi. The Aberdeen witches were accused of shape-shifting and celebrating their orgies as hares and cats. They danced to a Jew's harp, the instrument demonstrated to a delighted King James VI at the trial of the North Berwick witches.

A piper played for the witches at Forfar and Tranent. The two favourite tunes of the master at the latter venue were 'Kilt thy coat, Maggie, and come the way with me' and 'Hulie the bed fa' '.

A Deeside witch, Beatrice Robbie, who attended meetings at Craiglash Hill, near Torphins, with her mother and sister, was indicted 'as a notorious witch, in coming, under the conduct of the Devil thy master, with certain others, thy devilish adherents, to Craigleauche, and their dancing altogether about a great stone, a long space, and the Devil your master, playing before you'.

Witches suffered a terrible death. They were either 'virreit' (strangled) and burned at the stake or burned 'quick', that is,

alive. Typically the witch would be tied to a stake, which was then piled high with huge quantities of timber, peat, coal, and assorted barrels of oil and tar. At the Regality of Broughton, Edinburgh, in 1608 there were ghastly scenes as a number of witches perished at the stake. The Earl of Mar told the Privy Council how the wretched women were 'burnit quick'. But some, despite horrific burns, managed to break free only to be seized and thrown back into the hungry flames.

At the Aberdeen witch trials in 1597, the following sentence was pronounced by Hutcheon, the doomster, on four Deeside witches: 'You will be taken out betwixt the hills at afternoon, bound to a stake, and virreit until you be deid, and thereafter burnt to ashes.' Burnings in Aberdeen drew a large proportion of the burgh's population of 7,500. On the appointed day the condemned were bound and then dragged at the back of a cart through the streets to the stake, which was located between Castle Hill and Heading Hill. In all, twenty-three women and one man, the son of a witch, were executed in the burgh during the witch panic of 1596/97.

The burning of Margaret Clerk or Bain, a Lumphanan witch schooled in the black arts by her sister (herself executed in Edinburgh), attracted a big crowd when she died in Aberdeen on 25 March 1597. Wooden barriers were erected to keep control, but because of the crush two spars were smashed. Thomas Dickson's halberd axe was also broken during an Aberdeen witch burning, and he received £1 10s in compensation.

The expense of executing Scottish witches was carefully noted and some records still exist. Here, for example, are the accounts relating to Margaret Bain's execution:

For sixteen loads of peats:	£1 15s
For four loads of fir:	16s
For one oil barrel:	10s
For one tar barrel:	6s 8d
For two iron barrels:	6s 8d
For three fathom of rope:	3s
For a stake, carrying and dressing it:	13s 4d
For carrying the peats, coals, and barrels to the hill:	8s
For carrying of four spars to withstand the press of people (two spars broken)	8s 8d
For John Justice for his fee:	6s 8d

Rewards were high for public officials in charge of organizing the burnings. In 1597 a grateful Aberdeen Town Council awarded the Dean of Guild the sum of £47 3s 4d for his 'extraordinary pains' in executing a great number of witches and hanging four pirates at Footdee. The money came from the burgh's Guild Wine Fund. Even John Justice enjoyed rich pickings. After executing Janet Douglas and Agnes Smellie for a combined fee of 13s 4d the executioner was paid an additional 6s 8d for burying two thieves at the foot of the gallows. The expense of lodging and feeding the Aberdeen witches in the tolbooth during the same period came to £177 17s 4d.

However, during a witch panic in Renfrewshire in 1698, the prisoners fared less well. The sheriff complained to the Privy Council that because of lack of burgh funds the suspected witches were facing starvation, and witnesses to the alleged crimes were leaving the district because of the long delays in convening the trial. When he threatened to send the prisoners to Edinburgh Tolbooth, the Privy Council ordered the treasury to pay a groat a day for the upkeep of each prisoner. (After death witches' worldly goods were confiscated by the crown. At Lauder, in 1649, part of the costs of an execution was deducted from the victim's estate.)

The high and mighty did not escape suspicion. Lady Fowlis and her stepson had the good fortune of being cleared of witchcraft in 1588, but Jane Douglas Lady Glammis, who along with close members of her family was accused in 1537 of attempted regicide by means of sorcery, was burned alive. So too was Major Thomas Weir, the 'Wizard of the West Bow', and a former captain of Edinburgh City Guard, and his spinster sister, in 1670.

Inhumane treatment and fear of execution drove many witches to suicide. At least two Aberdeen witches died in captivity. The archives show that Helen Mackenzie, also known as Suppock, died in prison. Isobel Monteith cheated John Justice by hanging herself in jail. But she did not rest in peace. Her persecutors dragged her corpse through the burgh in a cart and buried it at the gallow's foot.

John Reid, one of the seven Paisley witches wrongly condemned by 'Bargarran's Daughter', Christian Shaw, a Renfrewshire laird's 10-year-old daughter whose supposed bewitchment led to the tragedy, was found dead in the local tolbooth on 21 May 1697. He was sitting upon a stool, his neck tied with his own neckcloth to a small stick thrust into a cleft above the chimney lintel. It was said that the devil had murdered him. His fellow prisoners, four

women and two men, were executed on the Gallow Green. They were first hanged but soon after their bodies were cut down and burned. A barrel of tar was added to the conflagration to consume the bodies more quickly.

There is an old story in the Berwickshire town of Greenlaw that as a witch was being dragged to the stake at the Gibbet Lea, a field south-east of the town, her pleas to be allowed to drink from a stream were met with a taunt from the crowd: 'Don't let her drink: the drier she is she'll burn the better!'

The last witch to be executed in Scotland was Janet Horne, a mad old woman living in the parish of Loth in Sutherland. Janet, who came from Crathie, near Balmoral, faced several charges, one alleging she had transformed her daughter into a horse so that she could ride to a sabbat. But first the daughter was shod by the Devil. The fact that the daughter had a deformed hand convinced her persecutors that the mother had been unable to break the spell on her return from the witch meeting. Her daughter was acquitted, but Janet was sentenced to death by Captain David Ross, the sheriff-depute. Tradition has it that as Janet was brought to the execution site she warmed her hands at a blazing tar barrel and pronounced it a 'bonnie fire'. A stone inscribed 1722, the year of the execution, marks the spot.

On 24 June 1736 the Witchcraft Act was repealed in Scotland, but the fear of witches lingered on. Two years later a man was hanged in Sutherland for murdering a suspected witch with a spade. And there were a number of incidents in which women believed to be witches were 'scored abune the breath' to weaken their power – this was done by scratching a cross on the victim's forehead with a silver pin.

The stake and drowning pot were used to dispatch not only witches, but other malefactors too. 'Unnatural offences' meant almost certain death by burning or drowning. In September 1570 John Swan and John Litster, blacksmith and servant to Robert Hannay, were burned on the Castle Hill, Edinburgh, after being found guilty of the 'wyild, filthie, execrabill, detestabill and unnaturall' crime of sodomy.

In September 1605 John Jack, alias Scott, a servant in Roslin near Edinburgh, was strangled and burned at the stake on the Castle Hill, after being convicted of the 'abominable and monstrous act of sodomy' with a mare. The horse shared the same fate and Jack's possessions were confiscated by the Crown. Seventy years later Duncan McCaw was caught in the act with a

white mare, and both he and the animal were killed and burned at Inveraray.

Drowning was normally reserved for women criminals, as it was deemed to be more respectable. It was common in the days of Regality and Barony Courts, which had the feudal right of 'pit and gallows', the pit referring to a dungeon, rather than a drowning pool. In 1530 Katherine Heriot was drowned in Quarry Holes at the Greyfriars Port in Edinburgh. Her crimes: Theft and being the carrier of a disease from Leith.

Edinburgh's North Loch was the site for judicial drowning. Sentence was passed by the bailies of Edinburgh or by the baron-bailie of the Regality of Broughton, a thatched village with its own tolbooth, courthouse and stocks, which has long been swallowed by modern Edinburgh. In the last century human bones were frequently unearthed when the bed of the drained loch was excavated.

In January 1599 Grissel Matthew, servant to Aberdeen burgess James Seaton, confessed without 'tortour nor yrnes', to stealing a strongbox from her master's house in Broadgate, Aberdeen. She was tried in Edinburgh, and, after conviction, drowned in the North Loch, and her meagre estate confiscated. William Calder, a porter who helped to carry the chest containing private papers from the house, was flogged through the capital's streets, and then exiled.

Elsewhere in Scotland Janet Anderson was drowned in April 1533 for being 'airt and pairt' in burning a cattle byre, along with its occupants, owned by the Laird of Rosyth. In 1611 a Lanark man, James Watson, was drowned for stealing a lamb.

In December 1556 Adam Sinclair and two accomplices broke into the parish kirk of Forres 'under silence of night', and stole a quantity of silver and gold coins and chalices. Henry Elder, one of his associates in crime, was hanged. But Adam, the son of James Sinclair of Ley, was drowned *ex speciali gratia Regine* – at the behest of Mary of Guise, the dowager queen of Scotland, either because of Adam's youth or the result of a direct appeal by a family who did not wish their son to suffer an ignominious death on the gallows.

In 1623 a Peebles weaver, Thomas Paterson, was found guilty of sheep-stealing and drowned in Peebles Water, a tributary of the Tweed. In Deeside females were drowned in a 'pot' at the Burn O'Neil at Kincardine O'Neil.

Two women narrowly escaped judicial drowning at Dundee in

December 1563. Agnes Robertson was convicted of theft and sent away from the burgh for life, while Janet Morris was banished for a year and a day. Both were told they returned 'under the pain of drowning'.

Marchmen who pillaged, burned, kidnapped and committed blackmail in the Borders in the sixteenth century were swiftly dealt with by the law. Judicial executions included drowning and Sir Walter Scott wrote of drowning in 'special pits'.

In 1561 fifty-three 'mosse troupers' – cattle robbers – were arrested, and because of a shortage of trees and rope, eighteen were drowned in the Teviot near the Black Tower of Drumlanrig in Hawick.

In Aberdeen six people – two men convicted of murder and four women convicted of child murder – perished in 'the Pottie', opposite present-day Shore Brae, between 1584 and 1587. Alexander Blyndcele, who slew an inmate of St Thomas's Hospital for the poor and infirm, paid dearly for his crime. He was drowned ten days later on 18 February 1584. His antecedents had for many years been members of a rich and influential family, including Robert Blinseill of Pitmuckston, Provost of Aberdeen in 1482.

In 1586 John Green and three women, one of whom was his wife, were convicted of poisoning a child 'begotten in adultery'. Green was hanged and quartered, and his head spiked on the Justice Port, Aberdeen. The women were publicly drowned. Elspeth Mitchell, the wife of an Aberdeen burgess Patrick Maver, was also found guilty of child murder and was drowned at the Quayhead on 27 March 1587.

6

Groans of the Gallows

The isolated Gallows Tree o' Mar stands sentinel on the south side of the road that twists and turns between Braemar, the village world-famous for its Highland Games, and the Linn of Dee, where a Gothic arched bridge spans the narrow river chasm. The 'dool, dark pine' carries a terrible curse, invoked centuries ago by a heart-broken widow whose doomed son was accused of cattle-rustling by the powerful Clan Farquharson of Inverey. She predicted the tree would 'flourish high and broad' long after the Farquharson clan had departed Deeside. By 1805 the direct male line of the Farquharsons of Invercauld had withered and died.

The hanging tree slid into a sandhole almost eighty years ago and is now supported by wire guy ropes, but it remains a rare example of a primitive gallows in Scotland, harking back to an age when local lairds had absolute power over their tenants. Hangings would be grisly affairs indeed: a rope was thrown over the bough of a living tree, a noose slipped over the head of the culprit, who was then hoisted into the air, kicking and struggling, to die of slow strangulation.

Deeside has another interesting execution relic – the 'Hangin' Stane o' Dess,' believed to be the socket for the gibbet post, which was unearthed during roadworks at Gallows Hillock, on the north side of the A93 between Kincardine o' Neil and Aboyne. The stone now forms part of a wayside bench.

A stone marks the last execution on Gallows Hill at Dornoch, Sutherland, where Donald Mackay was hanged on 26 May 1738 for murdering a witch. Gordon Cross, near Dufftown, Banffshire, was the stone base of the local gibbet.

Old records of the Barony Courts show that tribunals were

conducted with great formality and fairness. At Finlarig Castle in Breadalbane visitors in the last century heard blood-chilling tales of executions ordered by Black Duncan Campbell, but the idea that culprits were chained and then hanged in their hundreds round the tower of his castle was fanciful.

But Black Duncan was involved in mass executions in bygone Scotland. At the turn of the sixteenth century he and his followers were involved in a bloody campaign against Alasdair Roy MacGregor of Glenstrae, Chief of Clan Gregor. Hundreds were slaughtered and great tracts of land and property plundered. On 20 January 1604 MacGregor and seventeen of his men were hanged in Edinburgh. The gallows was cruciform in shape and big enough to accommodate all the prisoners, the laird of Glenstrae having been hanged on the highest point. The gibbet, 'MacGregor's Gallows', entered Scottish folklore.

Long before the measured drop of Victorian hangmen a condemned person would climb a ladder propped against the gallows beam and stand on a rung while the executioner made the necessary adjustments to the noose. He was then pushed off the ladder; sometimes the hangman swung from his legs to speed the criminal's demise. A biblical print of an old Anglo-Saxon hanging shows the culprit without a blindfold, and indeed it was not until the eighteenth century that the doomed criminal's last look at the world was blotted out by a nightcap pulled over his face.

When cattle thief and housebreaker John Hutcheon was carted to the gibbet in Aberdeen on 28 June 1765 he was given time to read a book of devotion before he was 'thrown off'. After hanging for some time his body was cut down and spirited away by anatomists.

Animals dying on the scaffold was a common occurrence on the Continent in medieval times. French judicial records show how swine, cattle and dogs were routinely butchered for killing humans. In Nuremberg it was customary to hang a dog alongside a German Jew. Two such bizarre executions took place in seventeenth-century Aberdeen. In 1688 a leading Catholic, Peter Gibb, angered local Protestants by naming his terriers Calvin and Luther. The magistrates did not see the joke and Peter was summoned before them. The dogs were seized and hanged at the market cross.

The next 'improvement' in the history of hanging was the substitution of a horse and cart for the ladder. The execution of Alexander Morison, a respected Aberdeen cartwright, on 1

Edinburgh Tolbooth, known as the Heart of Midlothian, with railed extension (*left*) where executions took place

November 1776, was a 'horse and cart' affair. Morison, who had murdered his wife with an axe, was conveyed by cart along the road known as Gallowgate to the gibbet at Gallow Hill, a grassy, windy knoll that today overlooks Pittodrie Stadium, the home of Aberdeen Football Club. A huge crowd braved stormy weather to witness Morison arrive at the hill with Robbie Welsh the hangman. The pair never left the cart. Morison stood erect in a jaunty red waistcoat as Welsh tied his feet, then adjusted the rope and nightcap that would hide the man's facial contortions. Finally Welsh drove off the horse, leaving Morison suspended in mid-air.

The new method was not obviously more efficient, for the criminal would die a slow and agonizing death. At least when a felon was 'turned off' a ladder the jump usually broke his neck. So after much experimentation with the position of the noose executioners settled for the 'knot beneath the ear' method to lessen suffering.

Although the rope with the sliding hangman's knot remained in use until the latter part of the last century, the cart was replaced in most parts of Britain by the end of the eighteenth century. The new innovation was 'the drop', a collapsible platform resembling a short-legged table, which, when activated, caused the criminal to fall a short distance. This was soon replaced with a trapdoor that virtually swallowed the hanged person when a bolt was drawn.

A legend persisted that Deacon Brodie, a prototype Jekyll-and-Hyde, was first to suffer the new drop technique that he himself designed. When Aberdeen shopbreaker James Grant was hanged in June 1788 it was reported that he had died on 'the drop invented by the famous Mr Brodie'. Records show that Deacon Brodie was in fact executed for robbery in Edinburgh *four months later*. An accomplished cabinet-maker, he may have roughed out the gallows that stood on the roof of a railed extension at the west end of 'The Heart of Midlothian' – the Edinburgh Tolbooth – but he did not construct it.

From early times the bodies of executed criminals were gibbeted or hung in chains, usually close to the scene of their crimes. Gibbets became landmarks on the edge of a town or city – on a high hill, near crossroads or beside a main road – designed to deter crime. Before the corpse was fitted with an iron frame and hung in chains it was coated with tar to preserve it. An early instance of hanging in chains in Scotland took place in May 1551 when a Scots pirate John Davidson was gibbeted within the floodmark at Leith for 'violent piracy' against a French ship.

In March 1637 a MacGregor was sentenced to be hanged in a 'chenzie on the gallow-tree till his corpse rot', for theft, robbery and murder.

On 24 November 1752 a man and a woman became the first criminals to be hung in chains in Aberdeen. Seaman William Wast, a murderer, was joined on Gallow Hill by Christian Phren, a farm servant, who had murdered her illegitimate child and tried to conceal her crime by burning the body. The wretched woman was forced to travel to the burgh 'with the remains of the half-consumed infant in her apron'. Despite his impending doom, Wast was in good spirits (he was probably roaring drunk) and offered to put the rope around his neck. 'He died hard, as the sea phrase is,' reported the *Aberdeen Journal*. Phren's body was stolen by the surgeons, but Wast's bones, however, hung undisturbed until they were stolen many years later and dumped in the doorway of a Methodist meeting house in the town's Queen Street. Pinned to the breastbone was a label on which was scrawled an amusing couplet:

> I William Wast, at the point of damnation,
> Request the prayers of this congregation.

The close proximity of Queen Street to Marischal College might imply that medical students were responsible. But there is a traditional story that youths in Old Aberdeen would dare each other to visit the grim gibbet at night. A wager was made that one of them would not go to the Gallow Hill with a bowl of hot soup. A volunteer was found and on arrival at the gibbet presented his steaming offering to the hanged man. A hollow voice replied: 'It's too hot!' The lad replied: 'Well blow, ye bugger!', then bolted back to a High Street pub. The ghostly voice, of course, belonged to a companion hiding near the gibbet. A similar story surrounds the gibbeted body of Matthew Cocklain, who murdered an old woman at Derby on Christmas Eve in 1775.

In Edinburgh Nichol Brown, a sadistic rogue with a liking for beating his wife, boasted to his cronies that he would eat the flesh of the gibbeted corpse of Norman Ross, who had been hanged the previous week. One night Brown carried a portion of the dead man's leg back to Leith where he disgusted customers by grilling it. In August 1754 Brown himself was gibbeted for murdering his wife, whose body he had roasted over the kitchen fire. His body was cut down and dumped in a pond. It was positioned on the gibbet, but vanished a second time, never to be found.

The last person to be hung in chains in Aberdeen was the previously mentioned Alexander Morison, who already has a niche in local criminal history by being hanged while on the back of a cart. His body was recovered by friends after burial at the gallow's foot, and his irons were discarded.

The gibbet chains and the burgh stocks were stored for safe-keeping in St Mary's Chapel below the East Church of St Nicholas, but were eventually acquired by a building contractor. About 100 years ago several human skeletons were found when foundations were dug for a powder magazine at Gallow Hill. Quarrymen excavating the hill some years ago also came across a number of thick chains. In fact the chains had not been for binding criminals at all, but were lightning conductors once attached to the old storehouse.

The body of a child murderer was officially mutilated before it was hung in chains in 1717. Robert Irvine, a licentiate of the kirk, carried out the cold-blooded killing of two of his young charges, the sons of a wealthy merchant, James Gordon of Ellon, Aberdeenshire, who had a villa in Edinburgh. Irvine had a grudge against the brothers after they had told their father that their tutor had taken liberties with the family maid. One Sunday afternoon he took the children to play on a green and broom-covered slope where York Place and St Andrew Place now stand and calmly slashed their throats. A gentleman was watching the horrific scene through a telescope from Castle Hill and raised the alarm. Irvine was caught red-handed and chained to the 'lang gade' (a long iron bar secured to the floor of his cell) in Broughton Tolbooth, where he prayed for forgiveness and broke down when shown the children's blood-soaked clothes. He was hanged in chains on a gibbet at Greenside, the ancient Gallowlea below Calton Hill, but first his right hand was cut off with a hatchet near the wrist. In a macabre twist, the murder weapon was driven through the palm of the severed hand that was nailed over his head at the top of the gibbet.

A gibbet with its creaking burden became a useful landmark for travellers during the daytime, but a place to be avoided at the dead of night. One such fearful spot was 'Gillan's Gallows' on the Moor of Stynie, near Fochabers, Morayshire. Alexander Gillan, who was nineteen, and came from the parish of Speymouth, was found guilty at the Circuit Court of Justiciary in Inverness of the rape and murder of a young girl.

Scottish courts were the first in Britain to rule that hanging in

chains could form part of the punishment. From 1752, thanks to 'An Act for Better Preventing the Horrid Crime of Murder', judges had the choice of ordering a murderer's corpse to be exhibited in chains or handed over to the surgeons to be anatomized – a fearful prospect for any potential criminal. Charles Hope, Lord Justice Clerk, in passing sentence on Gillan, said:

> As there is no school of medicine here, where you can be publicly anatomized, and as the enormity of your sins cries for the severist punishment, I have resolved, by virtue of the powers committed to me by the laws of the realm, to make you a lasting and memorable example of the fate which awaits the commission of such crimes ... I have therefore determined that after your execution, you shall be hung, until the fowls of the air pick the flesh off your body, and your bones bleach and whiten in the winds of heaven, thereby to afford a constant warning of the fatal consequences which almost invariably attend the indulgence of the passions.

On the day of the execution, 14 November 1810, Gillan was taken to Stynie Moor by a party of Highland troops of the 78th Regiment (Seaforths), stationed at Fort George, and attended by two ministers, the sheriff-depute, the provost and magistrates of Elgin, several local gentlemen and 'an immense concourse of people, from every quarter and of every age and sex'.

Gillan broke down in tears and proved unable to deliver his prepared statement to the crowd. But he managed to climb the ladder to the scaffold by himself, although, according to the press, there was a delay while the executioner, hired from Inverness, haggled over his 'perquisites of office'. A hangman earned extra money by the sale of his 'perks' – and it was the custom for the executioner to be given the criminal's clothing and all property found on him at the time of the hanging. This had no doubt led to the unseemly dispute at Gillan's execution. After the drop, Gillan's dead body hung for an hour before it was taken down and put in irons. The Elgin correspondent of the *Inverness Journal* described the gibbeting as: 'A shocking example of the dreadful effects of vice, when permitted to usurp the empire of reason; an example which, it is hoped, will strike deep into the minds of the rising generation, and tend to prevent the recurrence of such terrifying spectacles.'

Gillan's corpse vanished, but for years the rattle and eerie whine of the chains gave the place an evil reputation after dark. In 1911 the Duke of Richmond and Gordon ordered his estate workmen to

dismantle the frame and bury it where it stood. Their labour revealed Gillan's bones.

The gallows was a source of fresh bodies for Scottish anatomists before 1505, when the first charter to the surgeons of Edinburgh stipulated 'ane condampnit man' for dissection each year. The lack of sufficient specimens resulted in an increase in grave-robbing and the advent of the golden age of the body-snatcher, a grim profession that was finally eradicated, more or less, with the introduction of the Warburton Anatomy Act in 1832.

In the year Mary Shelley's Gothic novel *Frankenstein* was published terrifying medical experiments took place in Glasgow that could have been ripped from the pages of one of the world's great horror classics. On 4 November 1818 Matthew Clydesdale was hanged for murdering an eighty-year-old fellow miner, Alexander Love. He killed the old man with the victim's own pick-axe at New Monkland, Lanarkshire. He shared the scaffold with a Rutherglen housebreaker, Simon Ross. In passing the death sentence the judges Lord Gillies and Succoth had ruled that Clydesdale's body be publicly dissected by James Jeffray, Professor of Anatomy at Glasgow University.

After the hanging, Clydesdale's coffin was followed by a cheering crowd to the College of Glasgow, where his corpse was attached to a voltaic pile (a primitive electrical battery). The experiments were performed by Dr Andrew Ure, Professor of Natural Philosophy at Anderson's Institution. Jeffray, who assistèd him, would later dissect the body. The purpose of the experiments was to test the nervous system and the lungs. At one stage the corpse's chest heaved and fell. A lifeless leg shot out with such force that a medical student was almost knocked flying. The corpse's face twitched in apparent rage, horror, despair and anguish – and flashed ghastly grins at the horror-struck onlookers. Professor Ure recorded: 'At this period several spectators were forced to leave the apartment from terror or sickness, and one gentleman fainted.'

There was little hope either of a blessed resurrection for George Thom, a 61-year-old Aberdeenshire farmer who, in a fit of greed, attempted to wipe out his wife's family with arsenic in 1821. Thom was a respectable widower with an irreproachable character when he married wealthy spinster Jean Mitchell, who was living with her brothers, James and William, and sisters, Helen and Mary, at their farm at Burnside, in the parish of Keig, near Alford.

Thom plotted to get his hands on the Mitchell's inheritance and

decided to murder them. He called at Burnside on the eve of 'Sacramental Sunday', a holy communion day. Although disturbed early next morning he managed to spike the salt cellar with arsenic powder. After he made his excuses and left Burnside the Mitchells breakfasted on milk and porridge. In the course of church service later that day the brothers became violently ill, as did their sisters at home. William's condition worsened, and, after becoming blind and paralysed, he died the following week. His brother and two sisters never fully recovered. It transpired the Mitchells had suspected their brother-in-law but had decided to remain silent in the hope they would make a complete recovery.

Thom and his wife attended William's funeral, although understandably they were far from welcome. Even the deceased's neighbours grumbled at their presence, which indicated the Mitchells had voiced their suspicions. At the funeral Thom made a point of voicing the old wife's tale, that toads or puddocks (frogs) had poisoned the stream from which the Mitchells drew their water supply. But Helen replied that the porridge had been made with milk, not water.

Both George and Jean Thom were arrested for the murder of William Mitchell, although it was quickly established that Jean was innocent. During his trial in Aberdeen it emerged Thom had bought arsenic from a druggist in Aberdeen, allegedly to destroy rats. He was found guilty on circumstantial evidence and continued to deny his guilt until the day before his execution when he made a full confession and also cleared his wife's name. After he was hanged in the Castlegate on 16 November 1821 Thom's body was escorted by militiamen to nearby Marischal College where two doctors waited to carry out an experiment.

The next edition of the *Aberdeen Journal* gave details of the hour-long experiment under the heading, 'Galvanic Phemonena'.

> The upper part of the spinal cord and the sciatic nerve were immediately laid bare, and a Galvanic Arc was then established, by applying the positive wire to the Spine, and the negative to the Sciatic Nerve, when a general convulsive starting of the body was produced. [When the apparatus was applied elsewhere]. The hand was closed with such violence as to resist the exertions of the assistants to keep it open.

Montrose vintner's wife Margaret Shuttleworth – under sentence of death for murdering her husband – took a morbid interest in the Thoms' trial, insisting that details of his execution,

as well as the 'more horrid account of the galvanic experiments tried upon the body previous to dissection', be read aloud to her. Margaret disapproved of Thom's crime and said she was 'a saint in comparison to him' and protested her innocence to the end.

Although given a stay of execution Margaret was eventually hanged at Montrose on 7 December 1821, and her body shipped secretly by steamer from Dundee to Fife, and then by ferry across the Forth to Newhaven, where it was forwarded to Dr Monro's to be publicly dissected.

The case of Thom the poisoner resurrected an ancient superstition, 'Ordeal by Blood', first mentioned by King James VI in his *Daemonologie*: 'In a secret Murther, if the dead carkasse be at any time thereafter handled by the Murtherer, it will gush out of blood; as if the blood were crying to Heaven for revenge of the Murtherer.' When the Thoms were invited to view William's corpse, George refused. *The Black Kalendar of Aberdeen* noted: 'We do not know whether or not there was any superstitious notion in Helen Mitchell's mind when she bade her sister look on the dead body, but in all probability there was in Thom's when he avoided approaching it, a dread of undergoing an ordeal, of which such extraordinary relations are on record.'

Two hundred years after King James wrote the strange guide to solving a murder, an entire regiment filed past a coffin in Aberdeen's Castlegate to undergo the macabre ritual. In the coffin was the body of 'Skene's recruit', the batman of Captain Skene, but although every soldier was obliged to touch the corpse the murderer went undetected.

In October 1698 Jean Gordon, widow of Revd Fraser, minister at Slains, Aberdeenshire, who had been for some time weak in mind and body, was found dead in bed. His stepson, also a minister, was suspected of hastening her death. As there was no sign of violence, and poison was suspected, the 'Ordeal by Blood' was invoked. Revd Dunbar, minister at nearby Cruden Kirk, prayed to God that he would unmask the murderer. Then the witnesses touched the corpse but there was no sign of blood.

Brodie's Cairn in Aberdour took its name from a farmer who murdered his mother. When her naked corpse was brought to the gate of the churchyard, every person present was called upon to touch the corpse. But the son held back: when forced to approach the body, he confessed to murder.

The last person to be convicted of the ordeal of Bahr-recht, or the Law of the Bier, was Philip Stanfield, who stood trial in

Edinburgh in 1688, for the murder of his father at New Mills, East Lothian, in November 1687. After suspicion fell on Philip, the body of Sir James Stanfield, who had served as a colonel with Cromwell, was exhumed at Morham churchyard in the Lammermuirs. In accordance with Scots custom Philip lifted his father's head – and horrified witnesses saw blood spurting through the shroud from the left side of the neck which Philip touched. 'God's revenge against murder' had been clearly revealed, and brutal justice followed at the Cross of Edinburgh. Philip's tongue was torn out and burned on the scaffold; the right hand raised by him (he had strangled the elderly man) against his father's life was severed and nailed to the East Port of Haddington; and the body was hung in chains at the Gallowlea.

Public executions, depending on the notoriety of the felon, drew the sort of crowds that today flock to pop concerts or cup finals. Men, women and children of all classes and ages attended executions and the grim ritual would live on in the memory. An estimated 12,000 people saw James Burnett hang in Aberdeen in 1849. 'Almost all,' reported the local newspaper, 'without exception, from the lower class of our population.' Despite this jibe Gordon of Craigmyle, a laird, 'a most benevolent and kind-hearted man', had a mania for attending hangings, and would sometimes be allowed on to the scaffold.

Women were no shrinking violets at hangings. At a Glasgow hanging in 1850 there was 'a large sprinkling of old women', with the vast proportion of the 20,000 crowd consisting of 'the lowest class, with knots of hideous women mixed up here and there amongst the mass.' However, 'A few groups of respectable-looking people hung about the outskirts of the mass, but their numbers were scanty.'

In 1853 the *Kelso Chronicle* was 'glad to observe that there were few females present' at an execution at Greenlaw, but noted that only the postmaster and a grocer shut their businesses as a sign of respect during the hanging. But at the 1848 execution of murderer James McWheelan in front of Ayr Jail the huge crowd numbered 'fully as many women and children as men, and embraced many strangers from considerable distances'.

At another hanging in the town in May 1854 a journalist reported that a considerable proportion of the 3,000 spectators 'were decently dressed females, and what was still less seemly many children'. Several men and women fainted when labourer Alexander Cunningham, who had shot his wife dead at her loom,

paid the ultimate penalty. Before he died he asked a clergyman to take an interest in his orphaned children, adding: 'I hope they will not follow my footsteps.'

The last words of condemned persons were avidly read in newspapers. In Aberdeen a local journalist, William Carnie, stood on the scaffold to record the final words of John Booth, the last person to be hanged in the Granite City in 1857. Carnie wrote in his bulky memoirs: 'For the second time the gruesome task of standing beside the hangman fell to me, and there in view of the spectators, I took his dying utterances. They were, mercifully, the "last words" ever spoken publicly from the gallows in our good town.'

Bookseller Lewis Smith left a graphic account of the execution of seventeen-year-old James Ritchie in Aberdeen on 5 June 1818. Ritchie, a handsome youth, was revered as a saint, rather than despised as a criminal about to be hanged for sheep-stealing. An orphan, he stole thirty sheep from Gordon Castle, near Fochabers, the home of Alexander, 4th Duke of Gordon. Whether or not Ritchie had been the 'dupe of more adroit thieves' failed to save his neck.

In his unpublished memoirs Lewis Smith said sheep-stealing had become so common the judges resolved 'to make an example of the first well-authenticated case'. 'Aberdeen went into mourning,' wrote Smith in 1880,

> shutting up places of business and going into the country to escape the exhibition that was to vindicate the majesty of the law, and deter offenders from breaking it in all future time. Although participating in the universal feeling of pity for the criminal my curiosity to see the tragedy was too strong to overcome, and I witnessed the whole scene.

Smith went on:

> The scaffold projected into Castle Street – the appearance upon it of the ruddy-faced innocent looking lad, in his graveclothes, and him yet living – the universal sigh that ran through the crowd when the chaplain began the devotional exercise – the sobs that mingled with the singing of the psalm by the crowd – the kind, large-hearted Professor Kidd, as he stood by him to the last, and the bustling movements of the executioner [John Milne, himself a criminal], the step upon the Drop, the bang when it fell and the cries that would be held no longer, left an impression on my mind that can never be effaced.

Smith's description of the hanging touches on the condemned youth's dress. Deacon Brodie went to meet his maker dressed and powdered as if going to an Edinburgh soirée, but for many years it was the practice to send a doomed person to the gallows in his shroud.

The last man hanged by Aberdeen executioner Robbie Welsh was a brother of Peter Young, the celebrated gypsy robber and jail breaker. John Young murdered his cousin Hugh Graham in a brawl at the Chapel of Garioch, near Inverurie. Young led a posse of horsemen on a thirty-mile chase, which, according to one source, resembled a fox-hunt, with the pursuers reduced to 'lying by the springs, lapping water with their tongues, like dogs'. But Young was arrested, bound hand and foot, and taken to Aberdeen by cart.

As Young was about to be taken to the scaffold on 11 December 1801 his calm demeanour cracked when the hangman approached with his shroud. 'I dinna want to hae that creature Robbie Welsh's hands aboot me,' he protested. A town official agreed to perform the duty instead. It proved too much for a town sergeant who became ill. Young, his nerves calmed by a glass of wine, faltered a second time when he caught sight of his coffin. After he was cut down he was carried in it to the anatomists at Marischal College.

Bizarre history was made in Aberdeen on 22 May 1822 when two murderers refused to wear shrouds at their hanging. Robert Mackintosh of Crathie, Balmoral, and William Gordon, an Aberdeen wife killer, were each dressed in black suits. A week before their execution they had made a fruitless escape attempt from the tolbooth. Mackintosh's aged father made a vain journey to London to try and get remission of that part of Lord Gillies' sentence that ordered his son's body be dissected. Not only did he fail but to add insult to injury Mackintosh's skeleton was exhibited in the university's anatomical museum.

After the Forty-five Uprising was ruthlessly crushed a wave of robberies and other outrages were perpetrated in North-east Scotland as outlawed rebels scattered. The attacks were mainly directed against manses. At the beginning of 1748 James Davidson, who had deserted the British army to support the Jacobites, was arrested after a robbery at Cortachy in Angus. Davidson had committed several other robberies in Angus and the Mearns. At the Circuit Court in Aberdeen he was found guilty of sorning (forcing meat and lodgings without paying), housebreaking and robbery, and sentenced to be executed on 1 July 1748 at

the Ruthrieston crossroads, near the Bridge of Dee. Davidson lifted the gloom of his execution by wearing a tartan vest and breeches, white stockings, tied with blue garters, a clean shirt, white gloves and a white cap tied with blue ribbons. His escort of St George's Dragoons also wore their best dress, with orange cockades to commemorate the Battle of the Boyne. Davidson, a Catholic, was cut down after twenty minutes and hung in chains. 'This certainly looks more like an Irish affair altogether than an execution in Scotland,' commented *The Black Kalendar of Aberdeen*.

When wife murderer Charles Mackay, whom Lord Cockburn described as a beast in his memoirs, stepped on to the drop in Glasgow in May 1843 he was dressed in black with a white necktie and carried a letter addressed to the Lord Provost exhorting married couples to avoid strong drink.

Dr Edward Pritchard, the fiendish poisoner, was dressed in the height of fashion when he walked to his doom in Glasgow's Jail Square on 28 July 1865. He wore the same suit of mourning in which he had been arrested. He donned one white glove and carried the other. A pair of elastic-sided patent leather boots completed his outfit. Pritchard was buried under a flagstone marked 'P' in the South Prison. In 1910 the graveyard was disturbed by workmen laying new pipes and the doctor's skeleton was exhumed, complete with his boots, which became a grim souvenir.

The Assynt Murder gripped the public's imagination when during the trial at Inverness a witness, Kenneth Fraser, dubbed 'the dreamer', claimed he had dreamt where the victim's pack could be found under a cairn of stones near a stream. He had led a policeman to the vicinity where they recovered items belonging to pedlar Murdoch Grant, whose bruised and broken body had been tossed into a Sutherland loch. His strange evidence helped to hang Hugh Macleod, a crofter's son, who was bizarrely dressed for his execution in Inverness on 24 October 1831. He wore a long black cloak, exclusively made for the occasion, and a white nightcap.

The gallows stood at 'Longman's Grave', on the eastern shore of the Moray Firth, more than a mile east of the Highland capital. 'One of the magistrates asked him if he could walk to the place of the execution, for if he was unable to do so there was a cart ready to convey him,' reported the *Inverness Courier*. 'He replied he could walk ten miles if necessary.' After casting a 'wild, astonished look' at the crowd outside the jail he began the long walk, and as

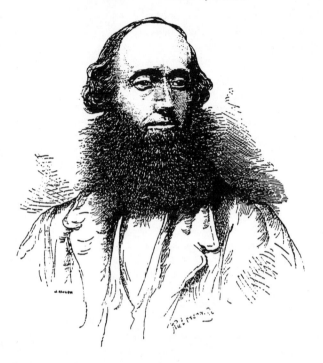

Dr Edward Pritchard, the last man to be publicly hanged in
Glasgow, was dressed in the height of fashion on the scaffold

he walked he read a bible. As he marched to his doom a rope was
looped around Macleod's neck and held behind by the hangman
an action which angered people. However, it was probably done to
prevent any escape bid, even though the weird procession was
strengthened by constables and militiamen.

The weather was wet and windy, which drew the comment from
the felon that the murder had been committed on such a day. On
the drop Macleod spent a quarter of an hour addressing the
8,000-strong crowd in the Gaelic tongue. He confessed to the
crime and cleared 'the dreamer' of any part in the murder.
Macleod's body was taken to Edinburgh for dissection.

The last public hanging at 'Longman's Grave' took place on
Friday 16 October 1835 when wife murderer John Adam was
driven to the scaffold. He had told his jailers that he did not want
to be carted to the gallows and 'hung up like a dog', but the crush
of spectators made it impossible for him to walk there. Adam and

the hangman shared one of the three carriages that forced a passage through the milling crowds. Adam dressed himself in the same garment worn by the Assynt Murderer. Adam's tall and erect figure drew grudging praise from the spectators, but there was scant sympathy after the drop.

Adam was convicted of the foul murder of his new wife, Jane Brechin, whose broken body was found half-buried in a derelict cottage at Mulbuie in the Black Isle. The couple had married a month earlier in the bride's family home at Laurencekirk, Kincardineshire. It transpired Adam, who deserted from the 2nd Dragoon Guards in 1834, had been living under an assumed name with a young woman, and had induced his wife to withdraw her savings and join him in Ross-shire. There he brutally murdered her.

After the execution Adam's body was buried within the precincts of the old jail. A grave was dug beneath a flagstone in the pavement connecting a private entrance to the courthouse and the jury-room, and the corpse buried in an upright position. The *Inverness Courier* complained, 'There is something offensive as well as unwholesome in converting the interior of a prison or Court-room into a charnel house for dead malefactors.'

The Longman, which is now an industrial estate, probably takes its name from the Gaelic *Long-min* meaning 'ship-smooth', a place where boats could beach. More fanciful explanations range from the discovery of a giant human skeleton there in olden times to a grim reference to a hanged man.

In the eighteenth century it was commonplace for the condemned person to go to the gallows in a cart with only the hangman and his own coffin for company. But the macabre custom spilled into the next century. In November 1807, at the last public hanging at Inveraray, Peter McDougall, who had drowned his wife in the River Etive, sat on top of his coffin as he was carted from the local jail to the gallows at the Craggs on the shores of Loch Fyne.

Women wanted to look their best when facing the world for the last time, although their efforts were not always appreciated. Mrs Jaffray created a sensation for the wrong reasons when she was executed in Glasgow on 21 May 1838. Mrs Jaffray, who had murdered two of her lodgers at Carluke with rat poison, wore a shawl in the Rob Roy tartan of red and black checks. Afterwards no self-respecting Lanarkshire female would be seen sporting the vivid tartan. (Black satin gowns were no longer fashionable after Mrs Marie Manning wore one when she and husband Frederick

were hanged for murder at Horsemonger Lane Gaol, London, in 1849.)

Mrs Catherine Humphrey was 'genteely dressed' in black at her execution in Aberdeen's Castlegate on 8 October 1830. Thirty-three years of blighted marriage ended when the vintner's wife poured vitriol into her sleeping husband's gaping mouth. Drink, she told the city fathers, was her downfall, and in a clear, firm voice she implored: 'Gentlemen, you who have it in your power should look to the public houses in the quarter where I lived for many of them are in a bad state and have much need to be looked at.' Her impassioned plea appears to have gone unheeded, for in 1837 Aberdeen, with a population of 60,000, had 870 licensed premises.

On the eve of her execution Mrs Humphrey moaned: 'O, it's a sair thing to wash for the gibbet; but I hope I will be washed in the blood of the Redeemer.' She spent a sleepless night as carpenters built her gallows outside the prison. Mrs Humphrey died struggling. But she made local criminal history by being the last woman to be hanged in Aberdeen, and the last felon to be handed over for dissection in the city.

But there is a harrowing footnote to the tragedy. In May 1784 Jean Craig and Elspet Reid had been found guilty of theft at Aberdeen Circuit Court. Craig was hanged two months later but Reid who had been given a respite because of pregnancy, was not executed until the following January. It transpired that Mrs Humphrey had been present at the execution and, although a child, remembered that after the body was cut down the rope was thrown into the crowd, as was then the custom. The hangman's knot struck her on the breast and before she herself was hanged she described how 'she recoiled with horror and that the circumstances had borne on her mind since she received her sentence'. (Similarly murderer Thomas Rogers, who procured the rope used to hang a criminal called Robertson at Jedburgh Castle in 1822, was himself hanged at the same place nine years later.) (However, in parts of Scotland it was believed the 'hangman's knot' was a lucky charm which could heal certain skin ailments.)

Mrs Hamilton, or Mary Lennox, suffered terribly in the last hours before she was hanged 'facing the monument' on Glasgow Green on 31 January 1850. Mrs Hamilton was guilty of murder and forgery. She had falsified her sister-in-law's signature to draw £20 from her bank account in Strathaven and then poisoned the woman with arsenic.

Dressed in the same black dress she wore at her trial Mrs Hamilton was supported to a chair on the scaffold. Her long black tresses hung down over her pale face and neck from under an incongruous white nightcap. Moments earlier she had been confronted by the hangman, John Murdoch, then eighty-two years old, and walking with the aid of a staff. As he pinioned her wrists she pleaded: 'Don't make it tight to hurt me.' On the drop she again turned to the hangman and whispered: 'Do it with as little pain as you can, sir.' Then she fainted. Alone on the drop, both feet resting on the hatch, the wretched woman swung in a recumbent position at the end of the rope. The chaplain hastily cut short his prayers, and Murdoch ended her agony.

Stirling was the scene of two remarkable executions. They took place at the 'tap o' the toon', in front of the tolbooth in Broad Street. Saturday 8 April 1837 was the date fixed for hanging murderer Alexander Millar, a daring and desperate young man who had twice attempted to escape from the condemned cell.

Millar boasted of his athletic prowess and how he had given law officers the slip while poaching at Dunipace. They had cornered him in a derelict kirk but he fled by sliding down a bell rope and springing through a window, carrying the frame with him. He had swum a river and cleared a nine-feet-high wall to get away from gamekeepers. But his conversation sometimes turned from running, wrestling and jumping exploits. On the eve of his execution he expressed a wish that 'he could just get a peck or twa at the hangman, and he would be happy syne'. On the morning of the execution Millar again expressed a wish to attack the hangman, but when the 'finisher of the law' entered his cell he simply glowered at him.

Millar also told his jailers: 'Only put me to the other side of the Stirling Bridge, with an umbrella in my hand, and put after me twa o' the best mounted dragoons, and I'll show you whaur I will leave them.' But the magistrates were taking no chances. To prevent Millar from leaping off the scaffold a rope was passed through the leather strap which pinioned his arms. The other end of the rope was held by the hangman. Reported the *Stirling Journal*: 'On leaving the cell, he cast another glance at the executioner, and perceiving this rope in his hand, he looked at it with a slight shudder, thinking, no doubt, that it was the rope by which his existence was to be terminated.'

As the melancholy procession passed into the courthouse on the route to the scaffold Millar again inspected the 'leash' and

Murderer Alexander Millar wanted to 'get a peck or twa at
the hangman' before his execution in Stirling in 1837

boasted: 'Ah, if this was a' that was to keep me, I would soon show
where I would be – I could break it as easy as a tailor's thread.'
Seeing the worried expressions on the faces of officials he told
them: 'Ah, you need not mind it. I will make no resistance – no, no
– none. I will die like a lamb.' Even so, on reaching the fatal
platform the hangman instantly looped the noose round Millar's
neck to prevent him from breaking his promise.

Millar, however, was determined that an old crone's prophecy
that he would 'die with his shoes on' – an allusion to his being
hanged – would not come to pass. As prayers were being said
Millar removed his footwear by rubbing one foot against the other
then kicked his shoes over the edge of the platform. He began to
show impatience and restlessness. Despite his pinioned arms he
was able to pull up the nightcap which covered his face. Even after
the hangman adjusted it he again raised it, saying, 'I want to see
them.' After a last look at the large crowd he seemed satisfied and
pulled down the cap. The signal handkerchief was placed in his
hand but he violently tossed it aside.

After the drop fell, a reporter noted 'On account of the cap not
covering his face, his features were distinctly visible to all; but
there was not the least change perceptible, excepting that he
became a little paler – indeed he appeared as if he had merely
fallen asleep.' Millar had kept his word.

During his trial in Edinburgh and leading up to his death, Millar

had strongly denied his guilt. Sixty years later the belief in his innocence was still strong in some quarters and a poem, 'Scatters', which would appear to have been Millar's nickname, was written by James Rae. The poem exonerated Millar and claimed the real murderer had made a deathbed confession.

The hanging at Stirling of Allan Mair, a senile and deranged old man, was a pitiful and extraordinary event. Mair, who was in his early eighties, brutally murdered his common-law wife, Mary Fletcher, at their cottage at Candie End at Muiravonside in May 1843. The cantankerous old bully had frequently beaten the poor woman, who was once heard to say: 'O, Allan, we could live like the king on the throne, although we are poor, if you were good to me.'

Mair finally killed his wife with a heavy stick. Neighbours who tried to enter the couple's home could hear the thump of blows 'like beating a carpet'. The woman died a day or so later, and Mair, who had the audacity to blame a neighbour for the crime, was imprisoned in Stirling Tolbooth.

At his trial at Stirling Circuit Court Mair's agent lodged a special plea of temporary insanity, but the evidence was strongly against the accused and the jury took only twenty minutes to find him guilty.

In the days leading to his execution Mair protested his innocence and poured scorn and hatred on the prosecution witnesses. In the early hours of the morning of his execution, 4 October 1843, he was wakened by hammering. 'O, aye, they're putting up the gibbet,' he said. 'What a horrible thing to be hanged like a dog!' As clocks struck he would make the same comment: 'That's ae hour less I've to live', and slump back into an uneasy sleep.

Mair awoke in a foul mood, ordering the chaplain to 'gang awa wi' his tracts'. As the time of his execution neared he accepted a glass of wine, but refused point-blank to walk to the scaffold. Two men had to support the weeping man into the courthouse, where the provost and magistrates sat. Mair presented an abject figure. He wept bitterly, tears streaming down his cheeks and from between his bony fingers, which he pressed against his face. He refused another glass of wine saying he 'would not go into the presence of God Almighty drunk'.

There followed a dramatic moment when the masked hangman, Glasgow's John Murdoch, entered the room. Murdoch was only a few years younger than the condemned man, who was either

eighty-three or eighty-four. 'O! dinna hurt me,' moaned Mair as his arms were pinioned. 'I'm auld – I'll make nae resistance. An', O! when I gang to the gibbet, dinna keep me lang – just fling me aff at ance!'

Groaning loudly and appealing to God, Mair was led to the drop. A chair was brought so that he could sit while addressing the crowd. Mair harangued them in a voice that reached fever pitch. His bile was again directed at persons connected with his trial. When he drew breath Murdoch stepped towards him and asked if he was finished. 'No sir!', raged Mair, 'I am not done,' striking his fist against his bony knee. The crowd grew restless at the unending tirade.

There was not a hint of regret or repentance in Mair's final words, only vengeance and hate. He was still seated as Murdoch adjusted the hood and placed the fatal handkerchief in his grasp. Muffled curses were heard from behind the hood. Mair refused to budge from the chair and while exclaiming, 'May God be——', the

Exciseman Malcolm Gillespie proudly displayed forty-two
wounds to his jailers before his execution in Aberdeen

bolt was drawn. But Mair did not die without a struggle. The hangman had made a hash of tying Mair's hands and he was able to free one hand as he dangled in mid-air. As his strength drained, Mair managed to lift the free hand to the back of his head and seize the rope. But his grip eased and after a few violent struggles he was no more.

After Mair was cut down artist Nicolas Savoli took a cast of the dead man's head – a practice which followed the execution of many criminals, including the infamous William Burke in 1829.

In 1866 Joe Bell, poacher poet turned murderer, posed for his photograph in the condemned cell at Perth Jail, then ordered prints for family and friends.

Others dictated their memoirs, including young David Haggart, petty thief and murderer, executed in Edinburgh in 1821 for killing his turnkey at Dumfries, and Malcolm Gillespie, a famous exciseman who turned his hand to forgery. Haggart sketched his own portrait in the Iron Room at Calton Jail, while Gillespie proudly showed his jailers the forty-two wounds inflicted on his body by smugglers, before he was hanged for forgery at Aberdeen in 1827.

Allan Mair died in a drizzle, but 'Jumping Jamie' Gordon met his end in an awesome thunderstorm. In November 1820 Gordon murdered a popular pedlar, John Elliot, whose body was found 'stiff and dead' on a moor at Eskdalemuir in Dumfries-shire. Elliot was brutally battered with one of Gordon's iron-shod clogs, which he had abandoned at the murder scene.

Stormclouds gathered over Dumfries on 6 June 1821 as a vast crowd watched Gordon mount the scaffold. The *Dumfries and Galloway Standard* reported:

> The moment he took his place on the treacherous drop, a vivid flash of lightning, followed by a tremendous peal of thunder, gave the scene a character of wild and appalling sublimity. After asking whether any one wished to put a question to him, and no response being made, the convict let fall the fatal signal, and, as another flash of lightning passed hissing through the rain, his soul was ushered into the presence of his Maker.

At his trial, when the judge earnestly exhorted Gordon 'to prepare for eternity and to throw himself on the mercy of the Redeemer', he had muttered through clenched teeth: 'I renounce it! I renounce it!' Perhaps he was given his answer on the scaffold.

Despite such scenes of Gothic horror public hangings failed to

act as a deterrent. The *Glasgow Argus* on 18 January 1838 reported a wave of murderous assaults in the neighbourhood of Paisley after William Perrie was executed there the previous year.

A week after Perrie was hanged

> Agnes Colquhon was murdered, and thrown into the Clyde. The same day, Mr Angus McDonald, of Glasgow, disappeared with property on his person; and from evidence already before the public, is believed to have been murdered, although the body has not yet been found. A few days after, Nov. 11, a gamekeeper, on the estate of Sir W Anstruther, unable to overtake Dickson and another poacher in their flight, wantonly shot them both, for which he has been sentenced to several months' imprisonment. Soon afterwards, Nov. 26th, another man, named Daniel Campbell, was fired at and dangerously wounded between Greenock and Paisley, by two villains, who made their escape. It appears, therefore, that the execution of Perrie, if it has produced any effect, has been a provocative to crime.

A most vivid and touching account of an execution appears in Scottish poet Alexander Smith's collection of essays, *Dreamthorp*, published in 1863. The author was a boy of ten when three Irish labourers, Dennis Doolan, Patrick Redding and James Hickie, were sentenced to death for murdering a ganger while building the Edinburgh and Glasgow Railway at Bishopbriggs. Hickie was reprieved.

Lord Moncrieff ordered that the executions be carried out on 14 May 1841 as near as possible to the scene of the murder at Crosshill, three miles north-east of Glasgow. Smith described how at sunset on the eve of the execution wagons rolled up from the city 'piled high with blocks and beams, and guarded by a dozen dragoons, on whose brazen helmets the sunset danced'. His vivid imagination 'saw the torches burning, and heard the hammers clinking, and witnessed as clearly as if I had been an onlooker, the horrid structure rising, till it stood complete, with a huge cross-beam from which two empty halters hung, in the early morning light.'

A crowd numbering around 75,000 lined the streets or climbed vantage points to watch the procession of dragoons, infantrymen with spiked bayonets, police and bewigged court officials slowly make their way to the scaffold. Smith portrayed the small army, complete with two pieces of cannon, as a 'cold, frightful glitter of steel'. The authorities took no chances as there were rumours of

an attempted rescue by Irish navvies. Doolan and Redding, attended by priests, were conveyed in a separate carriage from that of the hangman.

Smith, now up and about, mingled with the crowd which spilled over the fields on either side of the road leading to the gallows.

> I got a glimpse of the doomed, blanched faces which had haunted me so long, at the turn of the road, where, for the first time, the black cross-beam with its empty halters first became visible to them. Both turned and regarded it with a long, steady look; that done, they again bent their heads attentively to the words of the clergyman.

Smith wrote of the immense confusion at the mound on which the scaffold stood. Then came a poignant moment.

> When the men appeared beneath the beam, each under his proper halter, there was a dead silence, everyone was gazing too intently to whisper to his neighbour even. Just then, out of the grassy space at the foot of the scaffold, in the dead silence audible to all, a lark rose from the side of its nest, and went singing upward in its happy flight ...

The famous Glasgow hangman, John Murdoch, officiated. As he stood at the bottom of the scaffold one of the officials expressed concern for the struggling Doolan. 'It's his ain fau't,' growled Murdoch, 'nocht wad' ser' him, but he wad tak' a jump when the drap gaed doon; but see, sir, hoo kindly Redding's slippin' awa'.'

7

Riotous Assembly

A winter sky in late afternoon, pin-pricked by stars and lit by the glow of the moon, provided an unreal backdrop for Scotland's most grotesque and blood-chilling hanging. The guttering street-lamps of Old Edinburgh added to the appalling scene on the gallows. The judicial execution of Robert Johnston closely resembled a lynching as the struggling felon was strung up for the second time after the angry mob had rescued him from the clutches of the hangman.

Three days after the fiasco the *Scotsman* newspaper said the execution 'equalled in horror any thing ever witnessed in the streets of Paris during the Revolution'. Its correspondent, 'Civis Edinensis', was not guilty of journalistic licence.

Johnston was a 23-year-old petty crook, who, despite a decent upbringing – his parents were city shopkeepers – committed crimes which had landed him in the Police Court dock on minor charges. But in the autumn of 1818 Johnston, along with two associates, robbed candlemaker John Charles near St Patrick's Square in Edinburgh and such offences carried the death penalty. Johnston was betrayed by an informer, and although public opinion favoured a respite the Lord Provost refused to intercede.

Johnston's execution was set between two and four in the afternoon of Wednesday 30 December 1818. It was the first public hanging to take place since the demolition of the 'Heart of Midlothian', and the choice of venue was unpopular with the good citizens of 'Auld Reekie'.

The new scaffold was erected in the Lawnmarket – with the gibbet resting on the wall of the old Cathedral Church of St Giles, where the General Assembly of the Church of Scotland met

annually. The site was the most public place in the capital, but many felt the gable end of Edinburgh's metropolitan kirk was not the most judicious spot for the gallows.

The unfortunate hangman was John Simpson, who two years before was appointed in the place of John High, after 'Jock Heich' was sacked. Johnston's execution turned into a fiasco because of the hangman's failure to check the equipment. The rope was too long and the 'drop' failed to operate. There was no trapdoor for the condemned man to fall through. Instead a 'quadrangular table' with legs only 18 inches high, stood in the centre of the scaffold. Johnston was to stand on the table with the noose around his neck. On his giving the signal the table was meant to collapse, leaving him dangling in the air. At least that was the idea.

Johnston's ordeal began at 2.40 p.m. when he left Libberton's Wynd lock-up, yards from the scaffold. He mounted the steps to the gallows with alacrity, looking boldly around him. He even helped the hangman to adjust the noose. But when he dropped the signal handkerchief, a painful and disgraceful scene ensued. The table was so badly constructed that nearly a minute elapsed before it could be forced down to the level of the scaffold floor. Johnston's fall was far too short and he ended standing on his tip-toes, 'half-standing, half-suspended, and struggling in the most dreadful manner'.

The *Scotsman* report went on:

> It is impossible to find words to express the horror which pervaded the immense crowd assembled round this shocking spectacle, while one or two persons were at work, with axes, beneath the scaffold, in the vain attempt to hew down part of it beneath the feet of the criminal. Meanwhile cries of horror from the populace continued to increase. Still the magistrates and others on the scaffold did nothing effectual; and it is hard to say how long this horrible scene might have lasted had not a person, near the scaffold, who was struck by a policeman, cried out 'Murder!' Those who were not aware of this circumstance, which was known only to a very few, imagined that this cry proceeded from the unhappy Johnston.

The axemen were not trying to free Johnston – they were town carpenters, who, until driven off by the crowd, were attempting to cut a makeshift 'drop'.

The mood of spectators grew ugly. They took up the cry of murder and a hail of paving-stones forced the magistrates, peace officers and clergymen to retreat to the safety of the police office,

which was within the nearby St Giles Cathedral. Only Johnston's hooded figure occupied the fatal platform. The cry rang out: 'Cut him down – he is alive!' A man, 'genteely dressed', sprang on to the platform and hacked at the rope. Johnston collapsed as a ruck of spectators broke through the barriers around the scaffold. The halter and white cap were pulled off Johnston and tossed into the surging crowd.

As Johnston regained consciousness the mob targeted his coffin, smashing it to matchwood and hurling the fragments against the cathedral window. Several policemen were hurt by flying stones, the worst off being a lieutenant who suffered a deep head wound. Hangman Simpson did not escape and was roughly handled. The mob's fury was also directed at the gallows, but they made no impression on its ghastly black bulk. Johnston was carried off down High Street by a swirling mass of people. The police rallied and gave chase.

> The unhappy Johnston, half-alive, stript of part of his clothes, and his shirt turned up, so that the whole of his naked back, and upper part of his body was exhibited, lay extended on the ground, in the middle of the street, in front of the Police Office. At last, after a considerable interval, some of the police officers laying hold of the unhappy man, dragged him trailing along the ground, for about twenty paces, into their den.

A surgeon bled Johnston in both arms, and in the temporal vein in an effort to revive him, and, although he looked as though he'd recovered, he did not utter a word.

During this time Bailie Pattison and the superintendent of police hurried uphill to the castle and enlisted the support of the 88th regiment (Connaught Rangers). The troops forced back the mob and then, with loaded muskets, formed a ring of steel around the police office and scaffold.

At thirteen minutes to four the wretched Johnston, half-naked and his clothes in disarray, was carried by six officers to the gallows. The Lord Provost exhorted the crowd 'to peaceful conduct, lamenting the unfortunate occurrence which had taken place, but observing that the Magistrates had a painful duty imposed upon them, which they were bound, under any circumstances, to fulfil'.

Even as Johnston was positioned on the scaffold his trousers fell down – 'in such a manner that decency would have been shocked, had it even been a spectacle of entertainment, instead of

execution.' The hangman, nervous and reeling from the beating he took at the hands of the mob, again bungled the execution. While he and his assistant were adjusting the condemned man's clothes, Johnston's body was held upright, partly by the vibrating rope around his neck and partly by his feet touching the table. He was then lifted clear of the table as the flustered hangman shortened the rope by looping it several times around the iron hook fixed in the upper beam.

Horror mounted when Johnston was suspended. The hangman had forgotten to cover his face and even as he dangled from the rope Johnston managed to free a hand and twist his fingers around the halter. Angry shouts of 'Murder!' and 'Shame! Shame!' erupted from spectators. Simpson clambered on to a chair and forced Johnston to release his grasp of the noose. But the dying man's face remained uncovered, 'exhibiting a spectacle which no human eye should ever be compelled to behold'. Finally a napkin was thrown over the struggling man's face.

A guard was mounted at the scaffold until the body was cut down. It was almost dark when the disgruntled mob dispersed.

'The butchery,' raged the *Scotsman*,

> for it can be called nothing else, continued until twenty-three minutes past four o'clock, long after the street lamps were lighted for the night, and the moon and stars distinctly visible. How far it was consistent with the sentence of the Justiciary Court to prolong the execution after four o'clock, is a question which the writer cannot answer; but the fact is certain that it was continued until nearly half-an-hour after by the magistrates at the head of a military force.

The *Caledonian Mercury* supported the action of the magistrates.

> It is very erroneously imagined by many that the sentence of execution could not have been carried into effect after four o'clock. The last remarkable execution, in which any disturbance took place in this city, was that of Sergeant-Major John Young, of the 4th foot, convicted of forgery. This unhappy man took it into his head, that if he could protract the execution till after four o'clock he would be free. Accordingly, when the Magistrates came to the prison to demand him, he barricaded the door of his room in such a manner that no entrance could be obtained. The Magistrates, however, were determined to do their duty. They ordered the floor of the

room above to be lifted, so as to admit a man. Six of the most resolute of the city guard dropped down upon Young. The first was knocked down, but the criminal was secured by the others, carried to the Grassmarket, and was executed there at six o'clock at night. This took place on the 19th of December 1748.

Amazingly no one was seriously injured in the riot triggered by Johnston's execution. Shops were closed at the first sign of trouble, although the *Caledonian Mercury* reported that 'many inconsiderate women, with children in their arms, were thrown down and trampled upon'. The improper construction of the scaffold and the bungling efforts of the hangman were the roots of the fiasco. Many Edinburgh citizens wanted future executions to be held at the old site in the Grassmarket or outside the city – at King's Park or at Bruntsfield Links.

John Simpson was instantly dismissed as public hangman. He was later reported to have been appointed hangman at Stirling under the assumed name of John Foster. Simpson had a chequered career at Edinburgh. After exposing a criminal – John Morris or Morrison had committed perjury – on the pillory on 7 March 1817 the spectators decided to vent their fury on the instrument of justice, showering him with verbal abuse, mud, chunks of ice, sticks and stones. The *Edinburgh Evening Courant* reported:

> The unoffending object of their vengeance bore this barbarous treatment with great patience, and maintained his post with astonishing fortitude, till the space, feebly attempted to be kept by the old city guard, was broke in upon.
>
> The poor fellow was then treated with the most wanton cruelty, – knocked down, – trampled on, – kicked, and struck by every hand that could reach him; even the audacious-looking villain, then undergoing the just sentence of the law, for a heinous crime, presumed to kick the persecuted man, when he was driven within his reach by the mob; he was also observed, early in the tumult, to kick at the face of one of the city guard. The executioner was at length delivered from his savage persecutors by four respectable persons, who succeeded in getting him into a stair, the entrance to which they defended at imminent personal danger.
>
> A strong body of police arrived after this stage of the disgraceful scene – but their services were then of no use. It is worthy of remark, that Morris drew little of the attention of the populace, except, indeed, anxiety that was occasionally shown lest he should be hurt instead of the other. The carpenters employed to take down the machine were also ill-treated.

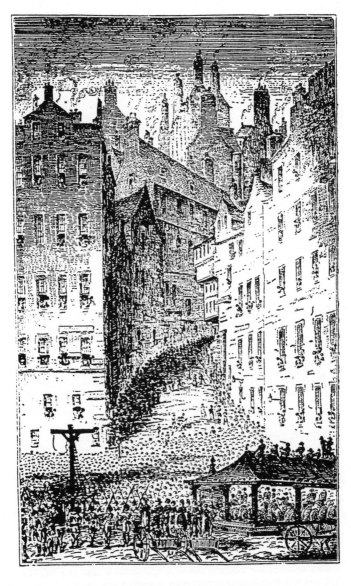

The Grassmarket gallows in Edinburgh

As Simpson recovered from the brutal attack, the police defended their role, announcing they had remained in their office till summoned 'in strict conformity to orders officially communicated to them'.

The law rarely gives up its victim, but in May 1561 the Edinburgh mob 'danged doon the gibbet', smashed it to pieces, and rescued the prisoner from jail. The 'tulzie' was sparked off when a ban was slapped by the magistrates on the old masque of Robin Hood and Little John. The festival had been popular in Scotland in pre-Reformation times although in 1565 Aberdeen craftsmen who attempted to keep the custom were jailed.

The Edinburgh magistrates acted high-handedly by ordering the execution of James Gillan, who was seized as revellers flouted the ban. On the day of the hanging, 21 July 1561, the city's craftsmen stormed through the streets, sheathed in armour and waving spears, axes and guns. Provost Thomas MacCalzean of Clifton Hall and two bailies were arrested and put under guard in a shop. The mob marched to the cross where they reduced the gibbet to splinters with sledgehammers. The prisoner was eventually freed from the tolbooth and carried in triumph through the streets. The riot raged for five hours before peace talks resulted in pardons for Gillan and the craftsmen.

Jock Dalgleish, who was appointed the hangman of Edinburgh in 1722, officiated at two notorious executions in the capital – those of 'Half-Hangit' Maggie Dickson and Andrew Wilson, the Fife smuggler, whose demise sparked the Porteous Riot. This occurrence was the source of Sir Walter Scott's stirring novel *The Heart of Midlothian*, which mentions the hangman.

In 1728 child murderer Maggie Dickson was hanged in the Grassmarket – rose-hued cobblestones mark the place where the 'fatal tree' stood. After her relatives had rescued her apparently lifeless body from medical students they headed for Maggie's home town of Musselburgh, but she regained consciousness because of the jolting of the cart. Maggie was allowed to return home, where she lived for many years and raised more children.

In 1736 Wilson and his gang robbed a tax collector while he slept in a Pittenweem inn. Wilson and accomplice George Robertson were informed upon and were eventually sentenced to death by the court.

Wilson and Robertson were regarded as heroes by the public, particularly after two daring escape bids from the Edinburgh Tolbooth. Finally, three days before they were due to hang,

Robertson got clean away from a crowded tolbooth kirk, which stood within the south-west corner of St Giles Cathedral. The congregation was filing out of the church when Wilson, who was a very strong man, grabbed two soldiers and called out to his companion, 'Run, Geordie, run!'. He then prevented a third guard from going after Robertson by clamping his teeth on to the collar of his coat.

The cruel treatment by Captain John Porteous of the City Guard towards Wilson at his execution in the Grassmarket on 14 April 1736 triggered unrest in the vast crowd. It ended bloodily when Porteous ordered his men to open fire, killing and wounding many people. Porteous was found guilty and condemned to die, but a stay of execution from Queen Caroline arrived in Edinburgh. Five days later, on 7 September 1736, a mob, some disguised and bearing torches and weapons, broke into the tolbooth and frog-marched the wretched Porteous to the Grassmarket where he was lynched on a dyer's pole opposite the gallows socket. The ring-leaders were believed to be friends of Wilson and Robertson but despite extensive inquiries and arrests no one was brought to book.

Hangman Dalgleish's duties were not confined to hanging or flogging. After the Jacobites were defeated at Culloden, the Duke of Cumberland ordered Bonnie Prince Charlie's standard to be ceremoniously burned in Edinburgh. On 4 June 1746 Jock carried the Prince's standard in procession through the streets and burnt it at the cross. The Society of Tron-Men, the chimney sweeps, also consigned to the flames a score of banners captured from the clans.

Dalgleish was tolerated by the Edinburgh public, but never regarded with affection. Church-goers tended to give him a wide berth when he worshipped or took communion in St Giles. Dalgleish died in 1748 and his coffin was escorted to Greyfriars Churchyard by the City Guard and the Society of Tron-Men. The chimney sweeps occupied a room in the old tolbooth but any involvement in executions was frowned upon by their association. After one of their kin assisted in the hanging of Lieutenant Patrick Ogilvy, Katherine Nairn's star-crossed lover, in 1765, he was expelled from the association and banished to Leith for five years.

Stirling witnessed shocking scenes before and after an execution when the hangman was forced to swim for his life. John Williams, the Edinburgh lockman, was hired to execute Robert Tennant, a 24-year-old Falkirk man, on 2 October 1833. Tennant had murdered an old man, William Peddie, on the road near Beancross, in the parish of Falkirk, two months earlier.

Although the jury at his trial had recommended mercy, Tennant's execution went ahead as planned. The wretched criminal was led trembling to the scaffold. Williams pulled the white cap over Tennant's head, adjusted the halter and pressed the signal handkerchief into his hand. But the hangman did not remove Tennant's neckcloth.

Williams would later defend his action by saying he had intentionally left the neckcloth around Tennant's neck 'to shorten the period of suffering'. But as this apparent oversight was pointed out to the hangman, Tennant dropped the signal handkerchief. The ensuing delay caused the condemned man to become extremely agitated. Williams finally removed the neckcloth and then began laboriously to readjust the noose. Tennant stood trembling on the drop, his hands uplifted and crying out: 'O God!' and 'O God, have mercy!' The drop fell at twenty-five minutes past eight and his body convulsed violently at the end of the rope. Half-an-hour later his body was lowered into a coffin that had been hidden under the scaffold.

The sad scene infuriated the spectators, whose anger was directed at Williams as he made his way to the Shore for the return trip by steamboat to Leith. He was recognized as he made his way through the Castlehill. The *Stirling Advertiser* takes up the story:

A crowd soon collected, and followed him till he reached some gardens near the bridge, into one of which he took shelter, to escape the vengeance of the low disorderly mob, who, by this time, had become quite outrageous. They pursued him into the garden, where they got hold of him, and struck and abused him. Seeing that his life was in imminent peril, he made a desperate effort to escape out of their hands, and having succeeded, he ran towards the river, followed by the crowd, who showered stones after him, several of which struck him.

On reaching the river he plunged in, and swam towards the opposite side, where, fortunately, a person happened to be standing who not only aided him in getting out of the water, but was serviceable in rescuing him from the crowd, who no sooner saw their victim swimming towards the opposite side, than they crossed the river by the bridge, and would in all probability, have taken the man's life, had not information of the outrage been early communicated to a number of High Constables, who instantly proceeded to the spot, drove off the crowd, and conveyed the man to the jail for safety. It was at first feared that he had been so

alarmingly injured as to endanger his life, but it is pleasant for us to have to state, that shameful as the affair has been, there is now no reason to apprehend that it will terminate so disgracefully for the parties concerned in it. The greatest praise is due to the High Constables for their prompt and active exertions. They have not only succeeded in rescuing the man, but in apprehending two men, still in custody and charged with being most actively engaged in the assault.

Edinburgh, too, had its high constables, officials responsible for monitoring, cleaning and policing the capital. The officers attended several notable executions and were out in force during the trial of Burke and Hare. Williams, according to some sources, was appointed the capital's hangman in March 1833, but did not carry out an execution in the capital until two years later. However, contemporary newspapers reported that the man who hanged William Burke in 1829 was called Williams, but they do not give his first name.

Shortly before he was taken to the gallows Burke ran into Williams in a room in Libberton's Wynd lock-up. 'I am not just ready for you yet,' he told the hangman. But Williams followed him and the condemned man returned wtih his arms pinioned. It was then Burke told the hangman that his neckcloth was tied at the back.

After the fiasco at Stirling the career of John Williams went downhill. On Monday 13 July 1835 he performed his last execution when he hanged soldier James Bell on the Lawnmarket gallows. Irishman Bell was born in 1809 – the same year his victim, Sergeant-Major Moorhead enlisted in their regiment, the 5th Dragoon Guards. Bell shot dead the non-commissioned officer in an incident at Piershill Barracks.

The hangman's irrational behaviour before the execution astonished and baffled witnesses. As Williams pinioned the prisoner in Libberton's Wynd lock-up 'he cried like a child, and made one or two abortive attempts before he could accomplish the task.' The *Edinburgh Evening Courant* reported: 'Whether this irresolution and incapacity, on the part of this functionary proceeded from a want of nerve, or from an over quantity of stimulants, we cannot say.'

Bell himself broke down but managed to compose himself enough to shake hands with some ministers before proceeding to the scaffold on the arms of two clergymen. The *Courant* continued:

The executioner proceeded to suspend the rope, which gave rise to yells and groans, expressions which the prisoner endeavoured to repress by turning round and beckoning with his hands to the crowd; and then ensued a most painful scene.

The executioner, to whose inefficiency we have already alluded, made one or two awkward attempts to adjust the rope, but not hitting the length, he tried to rectify his mistake, and was equally unsuccessful.

As 'loud and vehement cries of detestation' arose from the crowd, worried officials feared a repeat of the riotous behaviour at Robert Johnston's execution in 1818. 'But, fortunately, at this critical period,' the *Courant* went on:

Mr Brown, superintendent of public works, stepped forward, and with a firmness and presence of mind that does him the highest credit, pushed the executioner aside, and adjusted the rope to the scaffold with his own hand. The executioner then resumed his occupation, and placed the noose round the neck of the unfortunate culprit, who retained his wonted firmness during all this trying scene.

This lamentable course of bungling, however, had not terminated, for when the culprit jerked aside the fatal signal with which the drop should have given away almost simultaneously, a few moments dreadful suspense occurred, during which the miserable victim shook with a sort of convulsive tremor, at the same time stretching out his hands in the attitude of prayer as if to snatch the last moment of intercession. At last, however, the melancholy business terminated, and he died after one or two severe struggles.

Despite the hangman's blundering there was no crowd trouble, although a large stone was hurled at the scaffold and a handful of smaller stones thrown at Williams by boys as he retreated down Libberton's Wynd.

The press claimed the crowd was as large as that which attended Burke's execution, but there was no mention of Williams' role in that particular affair. In fact the *Courant* informed its readers that Bell's execution was the first performed in the city by Williams, although he had officiated at hangings in Stirling and at Greenlaw. He took no part in any other capital punishments. By the end of the month he had quit both his job and the city, and left the keys of his house with a neighbour.

Williams was succeeded by John Scott, the public hangman of

Aberdeen, who, although fairly reliable at his job, was nevertheless ill-fated. Scott had been hired by Aberdeen Town Council to hang Catherine Humphrey in 1830, after the death of veteran 'hangie' Johnny Milne. But Milne's widow, Christian Waters, had a score to settle, as the *Aberdeen Journal* reported in October 1831: 'Christian Waters, or Milne, relict of the late hangman, was once more brought before the Police Court on Wednesday charged with committing a breach of the peace at Hangman's Brae (the colloquial name for Castle Brae) and breaking a pane of glass in the house of her husband's successor. She was sent 60 days to Bridewell.' The reason for Christian's tantrums is unclear but she probably had a grudge against the new hangman or his employers.

Scott was lured south to Edinburgh by higher wages – 12 shillings weekly, with 5 pounds per annum from the exchequer. He was also paid extra for each additional hanging and flogging. His new job title was: official executioner to the City of Edinburgh and 'doomster' or dempster to the High Court of Justiciary. His regular wages and perquisites were paid by Edinburgh Corporation.

Scott also officiated at executions outside Edinburgh, and he appears to have been successful in his grim work. He earned plaudits after executing wife murderer William Perrie in front of Paisley County Buildings on 18 October 1837. 'The feelings of the crowd and the prisoner were saved from all unnecessary torture,' commented one reporter.

But Scott did not always please his employers. When he executed James Wemyss, an itinerant umbrella-maker, for wife murder, in Edinburgh on 16 April 1840, he pulled the wrong bolt. The crowd groaned and hissed as Scott tried stamping on the stubborn trapdoor with his heel. Still the drop did not budge, and an exasperated official darted up the steps of the scaffold to release the proper bolt. Scott was not sacked for his incompetence, but remained in office until he was attacked and slain by an alcoholic near his home on Thursday 12 August 1847.

The sensational news appeared in the following day's edition of the *Edinburgh Advertiser*:

SUPPOSED MURDER

Great commotion was created in the Cowgate and neighbourhood yesterday by a report that the common executioner for the city, John Scott, had been murdered. From the few contradictory and

inconclusive particulars we have been enabled to gather, it appears however, to be exceedingly doubtful whether Scott's death had really been occasioned by violence, or arose from natural causes.

As the case is undergoing investigation by the authorities, we forbear to record the name of the party accused, or the various criminating statements current against him. There can be no doubt, however, that Scott was yesterday forenoon carried into a shop near the foot of the Fishmarket Close in a state of insensibility and that he died in a few minutes after. Some people say he died in consequence of a blow he had just received from another man, who is said to have been under the influence of liquor, while others allege that it was a sudden visitation. The latter is, perhaps, the correct version, as Scott was a poor emaciated man, and it appears his body bears no external marks of violence.

By its next edition, four days later, the *Advertiser* had changed tack. Under a headline, 'THE LATE CASE OF MURDER OR CULPABLE HOMICIDE', the report revealed that James Edey (the paper gave his name as 'Edie'), broker and seller of watches in the Cowgate, was in custody in connection with Scott's death. Edey was said to have been a member of the Edinburgh Total Abstinence Society for several years, but had been induced four or five weeks before the incident 'to violate his pledge' and had been constantly under the influence of drink. Because of these excessive drinking bouts his behaviour became outrageous and force had to be used to restrain him. The *Edinburgh Advertiser* reported:

On Thursday his behaviour was of a most violent character. Notwithstanding the exertions of some of his neighbours, he proceeded up the Cowgate in an excited manner, threatening and assailing all he met.

His attention was unfortunately directed towards a man of the name of John Scott, who was standing at the bottom of the Fishmarket Cross, and who, it is presumed, was obnoxious to Edie [*sic*] from the odium which attached to his profession, as being the common executioner for the city. After a brief altercation [though it is also said that no words were exchanged], Edie assaulted him in the most violent manner, knocking him down by repeated blows on the breast; and on Scott being carried to an adjoining shop, he was pursued thither by his assailant, who again struck him on the head, which produced immediate insensibility, and resulted in the death of Scott in a few minutes afterwards.

Edey appeared at the High Court of Justiciary in Edinburgh on 5 November 1847. He pleaded not guilty to a charge of culpable homicide, even though medical evidence showed that Scott had died of brain and kidney damage as a result of heavy blows to his head or neck, and body. In his defence Edey said he had known Scott but bore no ill-will towards him. He had been so drunk that he had no recollection of the crime.

James McLevy, the celebrated Edinburgh detective, also gave evidence on Edey's behalf. He told the court he knew both the accused and the deceased, and described Edey as 'quiet, honest and sober'.

Evidence by McLevy that Scott had been severely assaulted by a man called Wilson a few weeks before the fatal attack was perhaps an attempt to show that Edey had not been entirely to blame for the hangman's poor condition.

(Scott's widow told the court that her husband had been in very delicate health for years, and confirmed Wilson's assault on Scott.)

But there was no doubt in the minds of the jury. Edey was found guilty and sentenced to nine months' imprisonment.

Mrs Scott successfully petitioned the town council to allow her to remain in her home until Easter. But her late husband's job was in fact never filled, Edinburgh preferring to hire a 'freelance' hangman whenever the need arose.

Scott might not have been the first public hangman to die at the hands of the public, but the authenticity of the other incident is doubtful. In 1833 the *Inverness Courier* reported that the Highland capital's own executioner had met a 'very untimely end' at the beginning of the nineteenth century: 'He had gone to Elgin on professional business, and was attacked on his return, about Forres, by a mob of mischievous boys and lads who maltreated him in so shameful a manner that he died on the spot. The most active of the mob were, however, very properly tried and transported.'

The incident is alleged to have happened in 1810, the year Alexander Gillan was hung in chains at Stynie Moor, but a report of his execution makes no mention of the hangman's fate. An old woman who witnessed a separate execution in Moray – that of William Noble, a deserter, hanged in front of Elgin Tolbooth in May 1834 – told a local author that 'the hangman was afterwards set upon by the soutars [shoemakers], who chased him out of the town, prodding him with their awls'. The hangman waded across the River Lossie above the Haugh, giving the spot the name of

'Hangman's Ford', and was so maltreated he died near Forres, where roadmen found his body in a drain 'and just covered him up'. The old woman may have confused the two incidents, but her memory of Noble's execution was perfectly lucid as she recalled 'seeing a crowd about the jail, and a man in a nightcap coming out of a window', which led on to the scaffold.

Scenes of immense confusion were common at public executions, with spectators jostling for an uninterrupted view of the scaffold. The swell of the crowd intensified as every available inch of ground became occupied. Pickpockets plied their trade as fellow criminals were dispatched. A blundering hangman could spark off a near riot.

In nineteenth-century Dundee the bizarre behaviour of the vast throng at a hanging was allegedly triggered off by supernatural forces. The prisoner was seaman David Balfour, who gave himself up to the turnkey at Dundee Jail after stabbing to death his unfaithful wife in her father's home in the Murraygate on 21 December 1825. Balfour, a native of Forfarshire, was persuaded by his lawyer to change his guilty plea when he appeared in the dock at the Court of Justiciary in Perth the following April. Balfour used the defence that he had been mentally deranged at the time of the murder. But he was found guilty, and despite a petition to King George IV for the death sentence to be commuted to transportation the execution was set for Friday 2 June 1826.

The gibbet was erected outside the Guild Hall, facing High Street, which served as Dundee's town hall and prison. Excitement gripped the town and when Balfour was led to the scaffold an estimated 18,000 spectators thronged High Street and surrounding streets and closes, a third of whom consisted of women.

Balfour showed great coolness. On hearing carpenters building his gallows he told his jailers: 'I suppose these people would rather be employed in another job.' On hearing the arrival of the coach from the south he commented: 'Now, the executioner will be arrived; I would not exchange situations with him.' Balfour remained calm even as he was about to be pinioned by the hangman. 'Come forward', he told the 'finisher of the law', 'you have nothing to fear.' Later on the scaffold as the hangman attempted to untie Balfour's neckcloth the condemned man said: 'My neckcloth is tied behind.'

With the noose fastened and the white nightcap pulled over his head, Balfour was positioned on the drop. As prayers were being

said by one of three ministers present the crowd was seized by a mysterious panic. The *Dundee Courier* reported:

> The stillness which pervaded the assembled multitude was interrupted in a manner as striking and fearful as it was unaccountable. On a sudden, a movement was observed, towards the west end of the High Street, as if a bomb-shell or some object of terror had fallen amongst the crowd. The panic was communicated in an instant to the whole of the dense mass, which became agitated like the waves of a tempestuous sea. The scene which the High Street presented at this moment, viewed from the adjoining windows, beggars description. The rush to every opening which presented an outlet from the imaginary danger was tremendous. Large spaces of the previously invisible causeway were cleared for an instant, and as quickly covered again by another wave of the undulating mass of human beings.
>
> Men, women and children were seen overturned, sprawling and screaming in all direction. The hats, caps and bonnets, separated from their owners, were countless. Several made their escape through the railing in front of the scaffold, and others were forced through head foremost.

Screams of pain rang out as feet trampled in blind panic. Pigeons and jackdaws took to the sky above the steeple. Incredibly no one was seriously injured in the stampede, a case of mass hysteria that was blamed on several things: pickpockets, the rumbling of a coach in nearby Castle Street, and, to quote Dundee historian A.H. Millar, 'supernatural imposition'. For many years after the hanging superstitious Dundonians believed psychic forces had been at work the day they hanged Balfour.

Not everyone wanted to see the city's first execution for a quarter of a century, and from early morning there was a mass exodus of inhabitants to the country. The ferry across the Tay reported a boost in revenue. Passengers did not return home until the 'awful engine of death' had been removed from High Street and Balfour's body sent under the watchful eye of a town officer to Dr Monro in Edinburgh.

8

The Last Drop

A death-like hush fell on the crowd of 2,000 as the condemned man, his arms pinioned, was positioned beneath the empty noose. Mothers with babies pushed forward to get an unobstructed view of the grim scene.

John Booth, a dark-browed hawker with piercing, quick eyes, was about to become the last man to be publicly hanged in Aberdeen. He had stabbed his mother-in-law to death in a domestic feud in the market town of Oldmeldrum. A drunken Booth, tortured by his wife's infidelity, had aimed a blow at her but the older woman had recklessly attempted to block his wild charge and was knifed through the heart.

There was a lot of sympathy for Booth, but when the official party stepped on the scaffold directly from an open window of the old burgh courtroom their mood changed to hatred. Their enmity was directed not at the condemned man, however, but at William Calcraft, the hangman. An eye-witness wrote:

> Booth stepped onto the block, and it was then that the crowd, for the first time, fairly got sight of Calcraft as he adjusted his gear, when a savage hiss greeted him. At this significant demonstration the executioner visibly cowered; and from the unenviable point of vantage at Booth's right hand on the scaffold, one could plainly perceive that, despite the dull phlegmatic contour of the official face, and the heavy under jaw, the man at heart of him was a coward.
>
> Calcraft pulled the white cap over Booth's face, finally adjusted the rope; for a few seconds his lips could be seen under the cap moving energetically in prayer.
>
> Then – the handkerchief falls from his hand, the bolts shoot back

with a stiff creak; a dull thud is heard – simply that – as the poor wretch falls, half out of sight of the crowd; the head turns to one side; a few convulsive struggles can be seen; and so is finished a scene such as one fervently desires never to witness the like again.

After Booth's corpse had hung for twenty minutes it was removed and buried in the precincts of the nearby East Prison, alongside three other killers: the Boyndlie poisoner James Burnett; James Robb, murderer and rapist, who had gained entry to his victim's home via the chimney; and double murderer George Christie. Both Robb and Christie were also hanged by Calcraft.

To label Calcraft a coward was unfair. In the days leading up to Booth's execution on 21 October 1857 the London hangman was a curious but familiar figure in Aberdeen. With grey beard and flowing long hair, he would stalk the granite streets, carrying a cane and wearing a buttonhole and a top hat – hardly the actions of a man who wished to hide from public view or shirk his duty.

Calcraft, a shoemaker by trade, was for fifty years the official London hangman before he was forced to retire, but during that time he also acted as a 'freelance' executioner. He was kept busy in Scotland, as local hangmen became redundant or died. As well as in Aberdeen, Calcraft hanged criminals in Ayr, Cupar, Dumfries, Edinburgh, Glasgow, Greenlaw, Linlithgow, Montrose, Paisley and Perth. His fee was usually £20 plus expenses. He sold pieces of the rope at 5 shillings to 1 pound an inch, depending on the notoriety of the felon.

In Scotland the most notable criminal he executed was the 'prince of poisoners', Dr Edward Pritchard, who in 1865 became the last man to be publicly hanged in Glasgow. Dr Pritchard was convicted of poisoning his wife and mother-in-law, and was probably responsible for the death of a maid in a fire at their home two years earlier. Before his arrest, the evil doctor with the roving eye ordered his wife's coffin to be opened so he might kiss her cold lips. A crowd of around 100,000 strained to catch a glimpse of the doomed man.

A barrage of cheers and hisses greeted Calcraft, although the *Edinburgh Evening Courant* noted that 'the cheers were more general than the hisses.' Calcraft had no small difficulty adjusting the halter around the doctor's neck because of Pritchard's long hair and shovel-shaped beard. The hangman steadied his victim by placing his hands on his back and breast, then, at ten minutes past eight, he activated the drop.

At Dumfries three years earlier Calcraft officiated at the hanging of Mary Timney, a dreadful and harrowing episode in the chronicles of capital punishment. Timney, the feeble-minded, 27-year-old wife of a Kirkcudbrightshire road surfaceman, battered a woman neighbour to death with a wooden mallet. At her trial at Dumfries Circuit Court she was convicted on circumstantial evidence and sentenced to die on 29 April 1862. In the condemned cell she admitted quarrelling with Ann Hannah but said she had not intended to kill her.

Strenuous efforts were made to get the death sentence quashed.

A local MP pressed for a reprieve, while two influential Dumfries ladies made a personal plea to the Home Secretary, Sir George Grey, at his home in Northumberland. By the eve of her execution Timney was reduced to a mental wreck, although she was still able to dictate some letters. On his last visit to jail, her husband brought the youngest of their four children. Her parting plea to him was: 'Remember the weans.'

Beyond the walls of the jail, crush barriers were being erected in Buccleuch Street and St David Street (now Irish Street) in expectation of the huge crowd. Onlookers began to gather at four in the morning as thick, heavy mist shrouded the town. The crowd intensified but maintained a dignified silence, latterly shattered by the ranting of a street preacher. The Provost, preceded by officers carrying halberds at the slope, walked in procession to the courthouse, where 200 special constables waited to be sworn in. There was a slight delay when a magistrate, Mr T.H. McGowan, a local draper, objected to Chief Constable Jones of Dumfriesshire Constabulary taking control of the special constables. To murmurs of approval, McGowan insisted council members should choose a captain from among themselves. Mr Pike, a surgeon-dentist and colour-sergeant of the Dumfries Rifles Corps, was appointed.

At twenty minutes to eight Provost Gordon and magistrates entered the adjoining prison, where the governor formally handed Mary Timney into the custody of the burgh. She stayed behind as the small group of dignitaries stepped outside. A military guard, with a bugler, and a posse of rural policemen reinforced the might of the law. The official party sang four verses of the 51st Psalm, known in hanging circles as the 'necking verse', and as eight struck on the town's clocks the last line of a hymn was being sung. They retraced their steps into the prison, where Calcraft had finished pinioning the wretched woman.

The black-timbered gallows had been erected overnight on

vacant space between the jail and St David Street. As Mary Timney was led into the prison courtyard she spied the gibbet on the far side of the wall, and emitted a terrifying shriek that echoed through the jail. She pleaded not to be hanged and cried: 'I am a young woman.' Between piteous wails she claimed she had not intended to commit murder and that 'it was Ann Hannah that struck first'.

It was eight-twenty when Mary, protesting her innocence and screaming for mercy at the top of her lungs, was dragged towards the scaffold, where Calcraft, squat, burly, his head a profusion of iron-grey locks, waited with his assistant. The second hangman was described as a 'seedy, swellish sort of barefaced fellow', who, according to the reporter from the *Dumfries Advertiser*, was a gentleman of private means who had taken to the execution business because he had a liking for it. It was rumoured he had hanged Dr William Palmer, the 'Rugeley Poisoner'.

Calcraft normally chose to work alone but sometimes he sought help from two friends, requesting that they either assist or take his place at executions. George Smith – 'Smith of Dudley' – executed Dr Palmer outside Stafford Gaol on 14 June 1856. Calcraft's other deputy was Welshman Robert Anderson, also known as Evans, who was the son of a lawyer and a bit of a rake. Anderson was probably Calcraft's assistant in Dumfries.

Mary Timney, her face ghastly pale and distorted with terror, was comforted by the prison chaplain, Mr Cowans. Her gaze took in the blue sky and the sea of faces before alighting on the scaffold. 'Oh, no, no! Oh no!' screamed the poor woman. 'Oh! My four weans! Oh, my four weans!' She was only a few steps from the scaffold steps when a commotion erupted in the prison yard.

A messenger waved a packet in Prison Governor Stewart's face. There was a breathless hush, and the suspense became almost unbearable as the governor hurriedly read the contents of a letter. Hope of a reprieve flashed into the minds of the spectators. But the governor's face hardened in anger as he tossed the letter aside. The message was from a London news agency, requesting a report on the execution in time for the evening papers.

On the scaffold a stone-faced Calcraft and his assistant completed the final preparations. 'Oh, my four weans,' cried Timney as Calcraft removed her cap and with equal dexterity placed the white hood over her head and adjusted the noose. Horrified cries rose from the spectators as the drop fell. In the prison yard behind the scaffold a gentleman almost fainted while

two militiamen stumbled from the ranks. It was noted that Timney's fingers twitched.

It was eight-thirty and Calcraft said her death had been painless and easy. The corpse presented a hideous sight on the calm, sunny morning, for the mist had lifted. At five to nine Mary Timney's body was lowered into the arms of prison officers and carried into the jail. The crowd quietly dispersed and the special constables handed back their batons. But the hangmen of England were not yet finished with the town of Dumfries – nor Scotland for that matter.

On a grey Monday, 11 May 1868, the 4.40 pm train from Carlisle, squirting and panting steam, clattered to a halt at Dumfries railway station. On the platform a crowd, comprised of an official welcoming party and curious onlookers, pressed forward. A cry went up: 'There he is!' All eyes focused on the face of a man glimpsed through the window of a second-class compartment. Fate had decreed that Dumfries, site of the last public hanging of a woman in Scotland, would also have the dubious distinction of staging the last public execution of a man in Scotland.

The arrival of Yorkshire hangman Thomas Askern was greeted with relief, as he had been expected in the town the previous Saturday. There was no sign of him on the Sunday either (he disliked travelling on the Sabbath), but at one o'clock on the Monday afternoon the authorities received a telegram. Askern had reached Carlisle after being delayed for two-and-a-half hours at a junction in Yorkshire. Who was Tommy Askern? He became the official executioner of York while imprisoned in the city's castle for debt. His first job was to execute wife murderer William Dove because the veteran Calcraft was busy hanging murderess Elizabeth Brown in Rochester on the same day, 9 August 1856.

Askern, who lived in the mining town of Maltby, near Rotherham, had a chequered career which ranged through the northern towns of England and the lower half of Scotland. At an execution in Durham the rope broke, while shortly after assuming his new profession he bungled an execution, the victim struggling long after the drop. In 1864 he made a hash of the execution of murderer George Bryce, the last man to be publicly hanged in Edinburgh. Askern miscalculated the drop and several minutes elapsed before a wriggling Bryce died. Askern was outlandishly dressed in velvet coat, corduroy knee breeches and leggins for his appearance on the gallows at the head of Libberton's Wynd. It was

said he resembled a 'rat catcher' and that his appearance was a
ruse to fool the crowd – for no one wearing such outlandish garb
was seen to leave Edinburgh.

But a sharp-eyed reporter from the local newspaper left a vivid,
if unflattering description, of Askern on the day he disembarked at
Dumfries railway station. To quote the *Dumfries and Galloway
Standard and Advertiser*:

> Askern is a tall man, with a kind of lounging gait, occasioned by a
> singular stoop in his shoulders. His arms are long, and the size of his
> hands and feet somewhat marvellous. His complexion is swarthy;
> and he evidently delights in endeavours to enhance the favours of
> his visage. Iron-grey is the colour of his hair, of which he has an
> abundant supply; a bushy moustache conceals his upper lips, and
> whiskers of the most fashionable cut – Dundreary-like – meet with a
> success little commensurate with the effort they make to give to
> their owner the air of a military gentleman.
>
> He has small greyish eyes, which peer with a dull expression from
> between overhanging eyebrows, his actions were controlled by
> some independent and invisible power and that he was more of a
> machine than a man – more automaton figure than an intelligent
> human being.

Askern was greeted on the platform by Superintendent Malcolm
of Dumfries Burgh Constabulary, who three months earlier had
arrested the man who was to be hanged for the Annandale
murder. Farmhand Robert Smith had just turned nineteen when
he raped and strangled ten-year-old Thomasina Scott in a wood
near the village of Cummertrees. He robbed her of 9 shillings and
11 pence – a penny short of the 10 shillings in silver given by her
mother to buy groceries and other items in Annan. Once a week
the girl, one of a family of eleven, walked three miles to Annan to
purchase goods to sell in her mother's humble shop at their cottage
home, where her father was a shoemaker.

Smith bumped into Thomasina at Longfords Cottage, the home
of the Crichton family, whom he knew. Later he accompanied the
little girl on her fatal journey. As they passed Croftshead Wood he
suggested they shelter from an impending February shower. He
raped her and strangled her with a cord, and afterwards cutting it
from around her throat and in the process leaving behind a vital
clue: a white-handled clasp-knife. But Smith still had murder on
his mind. He remembered he had been seen in his victim's

company at Longfords Cottage. Mrs Crichton's evidence could put a rope around his own neck, so he decided to shut her up.

Smith pressed on to Annan where he bought a pistol, powder, pellets and percussion caps at an ironmonger's. He returned to Mrs Crichton's cottage and shot her in the head as she scrubbed the flagstoned floor of her kitchen. Luckily the wound proved superficial. Smith then attempted to cut the woman's throat with another knife he used for cutting tobacco, but it proved too blunt. He dragged the screeching woman into a bedroom and tried to choke or break her neck by forcing her head between the bars of a chair. Fate intervened, for he was disturbed by two boys at the door. In the confusion Smith fled across the fields, as a blood-stained and terrified Mrs Crichton helped to raise the alarm.

A wide-scale hunt was launched involving a great number of police and civilians on horseback. Fears were raised for the safety of the missing girl and that night the grim truth was revealed in the beam of a lantern. Superintendent Malcolm tracked Smith to a lodging house in Dumfries, where he found the youth enjoying his pipe by the fireside while playing with a child on his knee.

On 21 April Smith was convicted at Dumfries Circuit Court of murder, rape and robbery. During the three weeks leading up to his execution Smith ate heartily in prison and put on six pounds. He read the Bible and other religious tracts given by the chaplain and Prison Governor Stewart, who had taken delivery of the heart-stopping letter that interrupted Mary Timney's execution six years before.

Meanwhile Provost Harkness was making strenuous efforts to have Smith's execution carried out behind the prison walls. The Private Execution Bill still awaited the seal of royal approval. In the end, the Provost's efforts failed, although the local MP suggested the scaffold be hidden 'as much as possible'. As it turned out, only the beam, rope and drop were visible to spectators.

Smith spent his last night writing a letter to a relative. He slept well, for the following morning he told the governor, 'never have I enjoyed a better night's rest'. He breakfasted on tea and toast then settled down to write more letters. At 8 a.m. on 12 May 1868 Smith was escorted to a room where he came face to face with Askern. As the hangman secured straps around Smith's wrists he asked: 'Does that hurt?' 'No sir' was the composed reply. Askern finished pinioning Smith who was then taken along a corridor leading to the scaffold.

Rain fell on the dismal scene. The condemned man's flushed

complexion turned sickly pale when he spotted the gallows, but he was able to walk unaided with a firm tread. Shadowing him was Askern, whose incongruous outfit of white vest and dark coat prompted the *Dumfries Advertiser* to suggest that the hangman was 'dressed for a wedding feast rather than for such an awful occasion as a public execution'.

Askern whipped the white hood from his pocket and covered Smith's head. The meagre crowd of 600 grew agitated. Sighs of despair filled the air and some spectators, who included a fair number of women, turned their backs on the terrible scene, while others faltered and fled. Smith stood statue-like on the drop as Askern placed the noose around his neck. But the hangman had miscalculated and removed the noose. Having made the necessary readjustment, Askern replaced the halter, an action which sent a terrible shudder through Smith's entire body. A chilling moment occurred as Askern insisted on shaking his victim's pinioned hands.

Smith's body all but vanished from sight of the crowd when the drop fell. It was just as well, perhaps. For nine harrowing minutes his chest and limbs shook violently. When his body was cut down half an hour later it was discovered that the noose had ended up in front of Smith's left ear instead of behind, and that his jawbone had snagged on the rope. Before the body was buried inside the prison a death mask was taken by Mr Rushfirth of Carlisle. The mask can be seen in Dumfries Museum, along with other grim relics, including the beam of the Dumfries gallows.

When Askern arrived at Dumfries a large crowd had trailed his cab to the jail, where the matron vacated her apartment to accommodate him. His departure after the execution attracted a number of curious onlookers at the railway station. At the ticket booth he was buttonholed by a man who told him sharply: 'Goodbye, sir. I hope we shan't see you again for a long time to come.' Askern smiled sardonically and replied in a rather weak voice: 'Goodbye, sir. Well, I hope you won't – on such an occasion as this.' The hangman was in an affable mood. He invited two policemen to join him in a drink in the refreshment room, then afterwards paced the platform as he waited for the train from Glasgow. When the train finally ground to a halt, he took his seat in a second-class compartment.

The composite carriage held three passengers: a maid and two valets of the Marquis and Marchioness of Anglesea and Lord Alfred Paget, all of whom were in the neighbouring first-class

compartment. The party was heading for the York races and was totally ignorant of the identity of their new fellow traveller. As the train rumbled out of the station some mischievous gawpers let the cat out of the bag, but there was nothing Askern's companions could do to escape his presence, even if they wanted to. Perhaps he was flattered by such goodly company, even if they were incapable of appreciating his. 'May there never be cause for his return,' intoned the *Dumfries Advertiser* in its next edition.

Britain's last public execution took place on 26 May 1868 when Michael Barrett was hanged for leading a Fenian raid on the Clerkenwell House of Detention in London, when twelve people were killed in an explosion. Three days after Calcraft hanged Barrett the new law was given royal approval, which meant that future executions would take place within the privacy of the prison walls.

Tollhouses were considered 'soft' targets by robbers during the last century. Several of these lonely outposts were raided for hard currency and other valuables, sometimes with tragic results. Just before Christmas 1869 the elderly tollkeeper at Blackhill Tollhouse, near Braco, Perthshire, met a bloody end while cooking his evening meal. Bachelor John Miller, who was sixty-four, lived alone and relieved the tedium by knitting socks. He was last seen alive in his tiny house by a shepherd, whom he told: 'I won't be so late in going to my bed tonight.'

Early morning callers at the tollhouse met with a locked door and shuttered windows. A local man who forced entry found Miller's battered body in a pool of blood and the murder weapon, a gore-smeared crowbar, behind the front door. The house had been ransacked and the victim's silver watch and other articles stolen. The murderer had even exchanged the old man's clothes for his own.

Suspicion fell on George Chalmers, a tramp who had been liberated from Alloa Jail the day before the crime. Chalmers, a native of Fraserburgh, Aberdeenshire, had an evil temper. Despite a £50 reward it was five months before police got their man. Chalmers was arrested by an off-duty policeman at Claypotts, near Dundee, but, on being charged, he replied: 'Na, na, there have been a few taken up for that already, you'll need to let me awa' also.' He protested his innocence at his trial at Perth Circuit Court but his explanation that the clothes left at the murder scene were not his failed to convince the jury.

Shortly after eight on the morning of Tuesday 4 October 1870

the Braco murderer was hanged in the County Prison at Perth. Chalmers, a small, broad-shouldered man with reddish whiskers, went to the gallows with a spring in his step. Indeed he reached the scaffold well ahead of Calcraft. After being hooded Chalmers called out to the official party, which included pressmen: 'I'm quite innocent, and I'll die for it like a man; goodbye to you all for ever more. I'm quite innocent – may God have mercy on me.' Beyond the prison walls the bell of St John's Church tolled, and a black flag was run up the jail's flagpole. The dead man was buried within the prison.

It was Scotland's first-ever private execution, and the last time the veteran 'finisher of the law' hanged anyone north of the border. But it was not the last occasion Calcraft was summoned to Scotland. He was brought to Dundee to hang a former soldier, Thomas Scobbie, a grotesquely ugly figure who was ironically dubbed 'Bonnie Scobbie'. Scobbie, a veteran of the Indian Mutiny, was found guilty of murdering an Angus gamekeeper in 1872. George Spalding attempted to arrest Scobbie after he had stolen flannel shirts from the washing-line at his home at Kingennie, in the parish of Monifieth, near Dundee. But Scobbie broke free after battering the gamekeeper to death with stones.

As police built up their case against Scobbie the accused man was taken to Kingennie for identification. In Spalding's cottage there took place a macabre incident that uncannily resembled the ancient 'ordeal by blood' superstition. He was forced to look on the dead man in the open coffin. 'Did you ever see that man before? Did you murder him?' he was asked. 'No, no: I'm bad and bad enough, as the polis ken, but I'm not a murderer!'

Scobbie's trial took place in Dundee on 8 April 1873, when, after being found guilty, with a recommendation for mercy, the judge, Lord Deas, made an incredible blunder. He ordered Scobbie to be detained in Dundee Prison and fed on bread and water until the date of the execution – 'Tuesday, the 29th day of April next to come'. But there would not be a 'Tuesday, the 29th day of April next to come' for six more years! The error was not immediately spotted, but it was said that the judge's slip of the tongue was the real reason why Scobbie's sentence was later commuted.

Calcraft had been in Dundee only a few hours when word of the reprieve was announced. Provost Cox broke the good news to Scobbie. The condemned man had lost weight and suffered from a boil on his neck. When the prison surgeon said he would lance the

furuncle Scobbie had told him it was not worth while as he had only days to live.

During his brief stay in the city Calcraft, described as a 'hale and hearty old man', never set foot outside the jail. His meals were delivered by staff of the Royal Hotel and he exercised in the prison yard. The grizzled hangman was said to be 'extremely gratified' that Scobbie had been reprieved as 'he felt exceedingly pained when called upon to perform the functions of his office'.

When he arrived in Dundee by early morning train Calcraft was met by one person, Prison Governor McQueen. But it was a far different story when he caught the Caledonian Railway's 6.30 train for London that evening. Half an hour before the train was scheduled a crowd gathered at the prison gates as Calcraft left in a cab, accompanied by McQueen. 'Curiosity seemed to be the only feeling which pervaded the crowd, for no demonstration occurred,' reported the *Dundee Advertiser*.

> A large carpet bag constituted the whole of Calcraft's luggage, and as many surmises were made as to its contents it may satisfy the morbid to be informed that there were in it the rope – a new one – a white cap, and the pinioning straps. The entrance to the West Station was quite besieged. Calcraft did not, however, manifest the slightest discomposure. He inquired of one or two bystanders what the people wanted to see, and was told that he was the object of their solicitation. Evidently anxious that all should have the fullest opportunity of inspecting him, after taking his seat in a second-class carriage he rose to the window, and kept his head out till the train left the station. There was no display of feeling, and he had the compartment of the train all to himself.

It was the last glimpse the Scottish public had of Calcraft.

There is an extraordinary footnote to the business of choosing a hangman in Dundee. When the Prison Board, including the Provost, Sheriff and magistrates, finalized arrangements for Scobbie's execution they had before them a letter from Calcraft offering to do the job 'at a reasonable price' – twenty guineas plus travelling expenses. The letter was passed round the table for closer inspection but somewhere along the line it vanished. The clerk of the board expressed consternation and threatened legal action if the document did not turn up. No one owned up at the meeting, but two days later the missing letter was returned by post, anonymously.

As Scobbie lounged in the death cell, and Calcraft prepared to

travel to Scotland, Mr McQueen, the Dundee Prison Governor, received another application to hang the prisoner. It was dated 22 April 1873 and the sender was a Lincolnshire cobbler, William Marwood, who would go down in the annals of capital punishment as inventor of the 'long drop', a method of hanging which ensured the culprit's neck was instantly dislocated. Marwood's letter, written in an unskilful hand, read:

> Sir, Pleas i beg your Pardon in riting to you again to Know if you are in the wants of a Man as Executioner at Dundee, as i understand that thear is a Prisoner to be Executied on the 29th inst. Sir, if my service is wanted on the 29th i have all Things Ready for the Execution if thea are wanted – Sir, Pleas will you be so Kind as to Look after this Matter for me, the sentence of the Law shall be Caried out in Due Form by me as Executioner. Pleas will you be so Kind as to send in a Anser Back by the Return of Post i shall Esteem it a great Favour For the Time is getting near for the Execution. Sir, Please i wait for your replie.
>
> Sir, i remain your Most Humble Servant, Wm. Marwood, South Street, Horncastle, Lincolnshire, England.

Of course, Marwood's application came too late but it was not apparently the first time he had applied to McQueen to carry out the execution.

Marwood was fifty-four when he eventually succeeded Calcraft, and whenever the name of his predecessor was mentioned in his company he would boast: 'He strangled 'em, I execute 'em!' Apart from the 'long drop', Marwood's other innovation was the introduction of a halter that saw the old-fashioned 'hangman's knot' replaced with a metal ring and washer.

Before his death in 1883 he hanged several notable criminals on both sides of the border, including Yorkshireman Charlie Peace, cat burglar-turned-cop killer, and French schoolmaster Eugène-Marie Chantrelle, who poisoned his young pretty wife Elizabeth at their Edinburgh home after insuring her life for £1,000. On the night before his execution in Calton Jail, Chantrelle, on being asked for a last request, proposed three bottles of Champagne and a woman! His wish was not granted. But he breakfasted heartily on coffee, bread and butter and eggs, and just before Marwood pinioned him he was given a 'nip' of whisky.

Marwood hanged Chantrelle on 31 May 1878, the first execution to take place inside the jail, and he used the same rope when he returned to Scotland in the autumn to perform the last execution

in Cupar, the county town of Fife. The culprit was William Macdonald, a St Andrews fisherman who shot his wife in a drunken quarrel over an unpaid dog licence. After blasting her with a double-barrelled shotgun Macdonald turned the gun on himself. Doctors nursed him back to health after extracting 100 lead pellets from his body.

As the prisoner's arms were being pinioned by Marwood with a broad leather strap he cried out in pain. 'Oh, don't pull it so tight,' he complained. 'I have a sore side.' Marwood loosened the belt.

Macdonald was hanged against the east wall of the old jail. While digging his grave the skull of one of the Scanlan brothers, two Irish murderers and robbers, executed twenty-six years before, was unearthed, as well as their tombstone.

Marwood was eventually succeeded by an old friend, James Berry, a former Bradford policeman, with whom he had several interesting discussions about hanging at the supper table. In his memoirs, published in 1892, Berry claimed he applied for the job of hangman because he was not earning enough money as a boot-salesman to keep his wife and family. His first application was ignored but soon after, Marwood's immediate successor, Bartholomew Binns, was sacked for incompetence. On 13 March 1884 Berry wrote to the Edinburgh magistrates offering his services. The previous December two gamekeepers on Lord Rosebery's estate were shot dead by two Gorebridge coalminers they had caught poaching.

Robert Vickers and William Innes were convicted of murder at the High Court of Justiciary in Edinburgh and sentenced to die in the Calton Jail on 31 March 1884. The magistrates had already accepted Berry's offer, on condition he arrived in the capital no later than three days before the execution and that he brought an assistant. The terms were agreed – 10 guineas to Berry for each person hanged, £2 for his assistant and second-class rail fares for both of them.

Berry and his assistant, Richard Chester, were lodged in the jail in the same room occupied by Marwood when he hanged Chantrelle six years earlier. In his bags Berry had ropes and straps inherited from Marwood. Berry and his assistant carried out rigorous tests on the equipment, substituting bags of cement for the two malefactors. Berry selected a noose of Italian silk hemp, five-eighths of an inch in thickness. He worked out the required calculations for the drop (Berry introduced a series of graduated drops according to the weight of the condemned criminal).

Berry was a deeply religious person and experienced qualms about his ability to go through with the executions. His appetite deserted him. Vickers and Innes appear to have been in a calmer frame of mind for they believed they would be spared. But no reprieve came and Berry performed the hangings in a skilful and professional manner. He earned glowing testimonials signed by the prison governor, surgeons and magistrates.

Berry was so upset by the event that he could not eat his breakfast preferring a cup of coffee instead. Meanwhile beyond the castellated walls of the old prison the seething masses on Calton Hill and neighbouring streets were given notice of the double execution – a black banner fluttering on the prison flagstaff.

Sources

Adams, Norman, *Hangman's Brae* (Tolbooth Books, Banchory, 1993)
—— *Haunted Valley* (Tolbooth Books, Banchory, 1994)
Anderson, James, *The Black Book of Kincardineshire* (Lewis Smith, Aberdeen, 1879)
Andrews, William, *Old-Time Punishments* (William Andrews & Co., Hull, 1890)
Balfour-Melville, E.W.M., *James I, King of Scotland* (London, 1936)
Berry, James, *My Experiences as an Executioner* (Percy Lund & Co., London, 1892)
Bland, James, *The Common Hangman* (Ian Henry Publications, Hornchurch, 1984)
Chambers, Robert, *Domestic Annals of Scotland from the Reformation to the Revolution* (Edinburgh, 1859)
—— *Traditions of Edinburgh* (W.R. Chambers Ltd, Edinburgh, 1980)
Cockburn, Lord, *Circuit Journeys* (David Douglas, Edinburgh, 1888)
Cramond, William, *Annals of Cullen* (Banff, 1880)
—— *The Annals of Banff* (Banff, 1891)
Davidson, Thomas, *Rowan Tree and Red Thread* (Oliver & Boyd, Edinburgh, 1940)
Fleming, J.S., *Old Nooks of Stirling* (Munro & Jamieson, Stirling, 1898)
Gibson, Robert, *An Old Berwickshire Town* (Oliver & Boyd, Edinburgh, 1905)
Grant, James, *Old and New Edinburgh* (Cassell, London, 1887)
Innes, Cosmo, *The Black Book of Taymouth* (Edinburgh, 1855)
Kennedy, William, *Annals of Aberdeen* (Edinburgh and Aberdeen, 1818)
Lawrence, John, *A History of Capital Punishment* (Sampson Low, Marston & Co. Ltd, London, 1932)
McDowall, William, *History of the Burgh of Dumfries* (Edinburgh, 1873)
MacIntosh, Herbert, *Elgin Past and Present* (J.D. Yeadon, Elgin, 1917)
Mackenzie, Peter, *Old Reminiscences of Glasgow* (James P. Forrester, Glasgow, 1890)
McPherson, J.M., *Primitive Beliefs in the North-east of Scotland* (Longmans, Green & Co., London, 1929)

Marwick, James D., *High Constables of the City of Edinburgh* (Edinburgh, 1865)

Maxwell, Alexander, *Old Dundee Prior to the Reformation* (Edinburgh, 1891)

Millar, A.H., *The Black Kalendar of Scotland* (London, 1884)

—— *Haunted Dundee* (Malcolm C. MacLeod, Dundee, 1923)

Pitcairn, Robert, *Criminal Trials in Scotland from 1488 to 1624* (Edinburgh, 1833)

Rayner, J.L. and Crook, G.T., *The Complete Newgate Calendar* (Navarre Society, London, 1926)

Robertson, Joseph, *The Black Kalendar of Aberdeen* (James Strachan, Aberdeen, 1871)

Roughead, William, *Rogues Walk Here* (Cassell, London, 1934)

—— *The Riddle of the Ruthvens* (The Moray Press, Edinburgh and London, 1936)

—— *Classic Crimes*, (Cassell, London, 1951)

Smith, Alexander, *Dreamthorp* (Strahan & Co., London, 1863)

Tod, T.M., *The Scots Black Kalendar* (Munro & Scott, Perth, 1938)

Whittington-Egan, Richard, *William Roughead's Chronicles of Murder* (Lochar, Moffat, 1991)

New Statistical Account of Scotland, Vol. XV (Perthshire) (Edinburgh, 1845)

Proceedings of the Society of Antiquities of Scotland (Edinburgh, various dates)

Records of Old Aberdeen (1157–1891) (Spalding Club, Aberdeen)

Index